We'C
Gaia Ri

Portals, Three © *Diane Lee Moomey 2008*

GROWING EDGE
44ᵀᴴ Edition of We'Moon
published by
Mother Tongue Ink

WE'MOON 2025: GAIA RHYTHMS FOR WOMYN
SPIRAL, STURDY PAPERBACK BINDING, UNBOUND & SPANISH EDITIONS
© MOTHER TONGUE INK 2024

Mother Tongue Ink
Estacada, OR 97023
All Correspondence:
P.O. Box 187, Wolf Creek, OR 97497
www.wemoon.ws

We'Moon Founder: Musawa, *Special Editor:* Bethroot Gwynn
We'Moonagers: Sue Burns, Barb Dickinson *Graphic Design:* Sequoia Watterson
We'Moon Creatrix/Editorial Team: Bethroot Gwynn, Sequoia Watterson, Sue Burns, Claire Paczkowski, Barb Dickinson *Production Coordinator:* Barb Dickinson *Production Assistant & Retail Sales:* Claire Paczkowski
Proofing: EagleHawk, Sandra Pastorius, Amber Fragione, Kathryn Henderson
Promotion: Claire Paczkowski, Sue Burns, Susie Schmidt, Barb Dickinson
Accounts Manager: Sue Burns *Order Fulfillment:* Susie Schmidt, Maya Lila diVento

This eco-audit applies to all We'Moon 2025 *products:*

Hansol Paper — Environmental Benefits Statement:
We'Moon 2025 is printed on Hansol paper using 60% recycled content: 50% pre-consumer waste, 50% post-consumer waste, with Solvent-free Soy and Vegetable Based inks with VOC levels below 1%.
By using recycled fibers instead of virgin fibers, we saved:
116 fully grown trees
46,415 gallons of water
32 million BTUs of energy
2,736 pounds of solid waste
8,189 pounds of greenhouse gasses

As a moon calendar, this book is reusable: every 19 years the moon completes a metonic cycle, returning to the same phase, sign and degree of the zodiac.

We'Moon is printed in South Korea by Sung In Printing America on recycled paper using low VOC soy-based inks.

Green America — APPROVED FOR PEOPLE AND PLANET

Order directly from Mother Tongue Ink
For more information see p. 235.
Retail: 877-693-6666 or 541-956-6052 Wholesale: 503-288-3588

2025

JANUARY

S	M	T	W	T	F	S
			1	2	3	4
5	6	7	8	9	10	11
12	13	14	15	16	17	18
19	20	21	22	23	24	25
26	27	28	29	30	31	

FEBRUARY

S	M	T	W	T	F	S
						1
2	3	4	5	6	7	8
9	10	11	12	13	14	15
16	17	18	19	20	21	22
23	24	25	26	27	28	

MARCH

S	M	T	W	T	F	S
						1
2	3	4	5	6	7	8
9	10	11	12	13	14	15
16	17	18	19	20	21	22
23	24	25	26	27	28	29
30	31					

APRIL

S	M	T	W	T	F	S
		1	2	3	4	5
6	7	8	9	10	11	12
13	14	15	16	17	18	19
20	21	22	23	24	25	26
27	28	29	30			

MAY

S	M	T	W	T	F	S
				1	2	3
4	5	6	7	8	9	10
11	12	13	14	15	16	17
18	19	20	21	22	23	24
25	26	27	28	29	30	31

JUNE

S	M	T	W	T	F	S
1	2	3	4	5	6	7
8	9	10	11	12	13	14
15	16	17	18	19	20	21
22	23	24	25	26	27	28
29	30					

JULY

S	M	T	W	T	F	S
		1	2	3	4	5
6	7	8	9	10	11	12
13	14	15	16	17	18	19
20	21	22	23	24	25	26
27	28	29	30	31		

AUGUST

S	M	T	W	T	F	S
					1	2
3	4	5	6	7	8	9
10	11	12	13	14	15	16
17	18	19	20	21	22	23
24	25	26	27	28	29	30
31						

SEPTEMBER

S	M	T	W	T	F	S
	1	2	3	4	5	6
7	8	9	10	11	12	13
14	15	16	17	18	19	20
21	22	23	24	25	26	27
28	29	30				

OCTOBER

S	M	T	W	T	F	S
			1	2	3	4
5	6	7	8	9	10	11
12	13	14	15	16	17	18
19	20	21	22	23	24	25
26	27	28	29	30	31	

NOVEMBER

S	M	T	W	T	F	S
						1
2	3	4	5	6	7	8
9	10	11	12	13	14	15
16	17	18	19	20	21	22
23	24	25	26	27	28	29
30						

DECEMBER

S	M	T	W	T	F	S
	1	2	3	4	5	6
7	8	9	10	11	12	13
14	15	16	17	18	19	20
21	22	23	24	25	26	27
28	29	30	31			

● = NEW MOON, PST/PDT

○ = FULL MOON, PST/PDT

Tantric Union
© Gaia Orion 2022

3

COVER NOTES

Spirit Weavers © *Dana Lynn 2016*

I created this piece as an art entry for the Spirit Weavers Gathering in 2016. It is a depiction of our ancestors weaving the threads of time into a geometric mandala pattern. Mother Earth is represented as Turtle Island. She holds nourishing and nurturing plants upon her back and gazes out with eyes that contain the universe.

Celestial Voyage © *Carolyn Sato 2012*

Tenderly cradled in the arms of the Universe, the earth continues its wondrous celestial voyage throughout eternity. Connected but untethered, the earth is also protected and nourished by the Great Mother and Her river of life and hope. Mirroring the earth's journey, our soul too travels through Time embraced and nurtured.

DEDICATION

Every year we dedicate We'Moon to an organization that is enhancing the lives of women and the planet. This year, we are pleased to shower support on Planet Women. This dedicated team really puts their mission to work, engaging in hands-on projects that protect nature and support community, transforming the culture of conservation in the process. Planet Women centers women and marginalized folks, balancing science with intuitive wisdom. "We are restoring and protecting the forests and waters that are critical to a healthy planet, using solutions that are co-created and led by women in the communities most affected by environmental degradation."

Planet Women exists in the center of the venn diagram of overlapping movements for environmental, racial, social and economic justice. They are working that growing edge, innovating environmental repair that increases sustainable gender equity and justice.

Learn more, become a member, donate at planetwomen.org and interact on IG: @planetwomenorg

Barbara Dickinson © Mother Tongue Ink 2024

Inner Algorithm © *Nissa Jordan 2022*

TABLE OF CONTENTS

INTRODUCTION

Title Page 1
Copyright Info 2
Year at a Glance 2025 3
Cover Notes/Dedication............... 4
What is We'Moon?...................... 6
How to Use This Book 7
Astro Overview 2025 8
Astro Year at a Glance Intro....... 11
Eclipses/Mercury Retrograde.......12

Year of the Snake........................ 13
Taking Our Place in Space............ 14
Decolonizing Witchcraft 16
Tarot for 2025 18
Introduction to the Holy Days ..20
The Wheel of the Year 21
Herbs for the Growing Edge........22
Introduction to We'Moon 2025 ..23
Invocation 25

MOON CALENDAR: GROWING EDGE

0 Gibbous 27
II Change Comes................. 33
II Swell of Promise 43
III Creatrix 55
IV Sacred Earth 69
V Brimful79
VI Weaving Harmonies..........91

VII The Wild 103
VIII Harvest of Healing.......... 115
IX Smashing Patriarchy 127
X The Gone-Befores 137
XI Beyond the Veil.............. 149
XII Journey........................... 161
XIII Shadow Work................. 171

APPENDIX

We'Moon Evolution................180
We'Moon Land181
We'Moon Tarot........................180
Staff Appreciation....................182
We'Moon Ancestors184
Contributor Bylines/Index186
Errors/Corrections...................197
We'Moon Sky Talk...................198
Astrology Basics......................200
Signs and Symbols at a Glance 203
Constellations of the Zodiac....204
Moon Transits205

Know Yourself206
Goddess Planets207
Ephemeris 101208
Planetary Ephemeris209
Asteroid Ephemeris215
Month at a Glance Calendars ...216
2025 Lunar Phase Card............228
Conventional Holidays230
World Time Zones231
Year at a Glance 2026................232
Available from We'Moon233
Become a We'Moon Contributor 236

WE'MOON 2025 FEATURE WRITERS:

We'Moon Wisdom: Musawa; **Astrologers**: Monisha Holmes; Melissa Kae Mason, "MoonCat!"; Heather Roan Robbins; Sandra Pastorius; Susan Levitt; Beate Metz; **Introduction to the Theme**: Bethroot Gwynn; **Holy Days**: Mahada Thomas; **Lunar Phase Card**: Susan Baylies; **Herbs**: Karen L. Culpepper; **Tarot**: Joanne M. Clarkson.

What Is *We'Moon*? A Handbook in Natural Cycles

We'Moon: Gaia Rhythms for Womyn is more than an appointment book: it's a way of life! We'Moon is a lunar calendar, a handbook in natural rhythms, and a collaboration of international womyn's cultures. Art and writing by wemoon from many lands give a glimpse of the great diversity and uniqueness of a world we create in our own images. We'Moon is about womyn's spirituality (spirit-reality). We share how we live our truths, what inspires us, and our connection with the whole Earth and all our relations.

Wemoon means "we of the moon." The Moon, whose cycles run in our blood, is the original womyn's calendar. We use the word "wemoon" to define ourselves by our primary relation to the cosmic flow, instead of defining ourselves in relation to men (as in woman or female). We'Moon is sacred space in which to explore and celebrate the diversity of she-ness on Earth. We come from many different ways of life. As wemoon, we share a common mother root. We'Moon is created by, for and about womyn: in our image.

We'Moon celebrates the practice of honoring the Earth/Moon/Sun as our inner circle of kin in the Universe. The Moon's phases reflect her dance with Sun and Earth, her closest relatives in the sky. Together these three heavenly bodies weave the web of light and dark into our lives. Astrology measures the cycle by relating the Sun, Moon and all other planets in our solar system through the backdrop of star signs (the zodiac), helping us to tell time in the larger cycles of the universe. The holy days draw us into the larger solar cycle as the moon phases wash over our daily lives.

We'Moon is dedicated to amplifying the images and voices of wemoon from many perspectives and cultures. We invite all women to share their work with respect for both cultural integrity and creative inspiration. We are fully aware that we live in a racist patriarchal society. Its influences have permeated every aspect of society, including the very liberation movements committed to ending oppression. Feminism is no exception—historically and presently dominated by white women's priorities and experiences. We seek to counter these influences in our work. We do not knowingly publish oppressive

content of any kind. Most of us in our staff group are lesbian or queer—we live outside the norm. At the same time, we are mostly womyn who benefit from white privilege. We seek to make We'Moon a safe and welcoming place for all wimmin, especially for women of color (WOC) and others marginalized by the mainstream. We are eager to publish more words and images depicting people of color, *created by* WOC. We encourage more WOC to submit their creative work to We'Moon for greater inclusion and visibility (see p. 236).

Musawa © Mother Tongue Ink 2019

HOW TO USE THIS BOOK
Useful Information about We'Moon

Refer to the **Table of Contents** to find more detailed resources, including: World Time Zones, Planetary and Asteroid Ephemeris, Signs and Symbols, Year at a Glance, and Month at a Glance Calendars.

Time Zones are in Pacific Standard/Daylight Time with the adjustment for GMT and EDT given at the bottom of each datebook page.

The **names and day of the week and months** are in English with four additional language translations: Bengali, Spanish, Irish and Croatian.

Moon Theme Pages mark the beginning of each moon cycle with a two-page spread near the new moon. Each page includes the dates of that Moon's new and full moon and solar ingress.

Susan Baylies' **Lunar Phase Card** features the moon phases for the entire year on pp. 228–229

There is a two-page **Holy Day** spread for all equinoxes, solstices and cross quarter days, from a Northern Hemisphere perspective. These include writings by a different feature writer each year.

Astro Overview gives a synopsis of astral occurrences throughout the year from one of our featured astrologers, Heather Roan Robins, on pp. 8–10.

Read the **Astrological Prediction** for your particular Sun sign at the beginning of the year. They are meant to give you insights for the entire year. Find yours in the calendar pages on or near your birthday.

Astrological Overview: 2025

Choose love, choose peace, choose not to polarize; keep your heart open to compassion even though the heat turns up this year. Between 2024–2026, Pluto, Neptune, Uranus, and Saturn all travel from introspective yin water and earth signs to enter active yang fire and air signs that demand action.

2025 begins a major shift from a backdrop of Pisces energy to an Aries era, with all the gifts of trouble that could bring; both Saturn and Neptune enter abrupt Aries this spring, then dance back into dreamy Pisces in the fall for a few months. Uranus enters nervy, electrical, communicative Gemini this summer then backs into Taurus in November. This two-step, into the new active era and back to more introverted, emotional signs, can help us remember and integrate what we've learned in the last cycle and bring that hard-fought wisdom into an age of action, potential conflict, and transformation.

Neptune enters Aries March 30, retrogrades July 4–December 10, backs into Pisces October 22 and re-enters Aries 2026–2038. Saturn walks into Aries on May 24, retrogrades July 12–November 27, then backs into Pisces September 1 until early 2026.

Neptune symbolizes a wide continuum—from our spiritual path and what we find beautiful and magical; through pragmatic attention to how we treat our waters and are affected by our weather; to our escapism and addictions. Neptune in watery Pisces, from 2011 through the beginning and end of 2025, reminds us that water is life, for real, inspiring a new movement toward water sovereignty. Spiritually, Water is the very symbol of our inner oceanic consciousness. Neptune also points to our favorite illusions used to avoid the harsh realities of a complex world. These years with Neptune in Pisces have brought a time of religious wars and big lie delusion on one side, and political idealism with a renewed connection to our intuition and imagination on the other.

Neptune and Saturn shifting into Aries will demand we be direct and honest, but we can simplify truths and leave people polarized. Aries idealizes action. These planets in Aries can idealize conflict, inspiring us to rattle the spears of war, or to boldly break our addictions to fossil fuels and take heroic action on climate change.

Glorious © Paula Love 2021

Aries offers us an engine, but we need to steer it wisely. This shift can also catalyze weather extremes; take fires and storms seriously.

Solar cycles are unpredictable, but they form the volume control on all astrological aspects; our present solar cycle 25 is in its active phase, creating aurora borealis and cranking the volume on history for the last few years, but it could calm down as the year progresses.

Pluto is now firmly in Aquarius where it decentralizes power and shifts it into the hands of the people, the crowd, the labor unions, and community organizations. Let's educate and grow our communal wisdom; wise crowds make better decisions.

As 2025 begins, some stalemates around an old wound or resentment could demand a shift in power dynamics in our relationships and organizations, as stubborn retrograde Mars in Leo opposes Pluto in Aquarius early in January while Saturn semi-squares Pluto on January 26. We need to move past polarized thinking and into creative solutions.

Uranus and Jupiter start off 2025 retrograde then turn direct in late January and early February, respectively, which could bring some temporary turbulence but then help us adjust to rapid transformations. A total lunar eclipse March 13 and a partial solar eclipse March 29 demand we let go of what's outdated in our lives and open into compassionate action. Saturn enters Aries on May 24, and Jupiter enters nurturing Cancer on June 9. They form a dynamic T-square in cardinal signs with Neptune mid-May, triggering arguments over old concepts of truth, and conflict between conservative and liberal policies—it could also instigate innovative pragmatic compassion.

Uranus enters Gemini July 7 and kicks in an era of technological advances, potentially instigating some truly lifesaving shifts. Uranus in Gemini also brings the transformative power of true communication, so keep talking—keep the lines of communication open and flowing. Watch for clashes that may occur due to Gemini nerviness and double-think, cognitive dissonance, and the ability to sit with paradox.

After an exciting taste of the future, we need to go back and retrieve some of our hard-won internal wisdom. Saturn retrogrades back in to Pisces early September. A total lunar eclipse September 7, and partial solar eclipse September 21, ask us to deal with permeable legal, emotional, technological, or immunological borders. Uranus retrogrades back into Taurus in November which can help us look at our financial security and clutter—compost what is needed and get right with the material world.

Neptune retrogrades back in to Pisces October 22, asking us to clarify old lies or illusions, and signals us to review our spiritual practice. In this new action-packed, externally focused era with Aries-Neptune, Gemini-Uranus, and Aquarian-Pluto, we will need to build in healthy habits of grounding and introspection, because it won't come as naturally.

Many relationships, loving families or community circles will be called to transform and adapt to changes this year. We need to empower our beloveds to honor their calls to action rather than push them to make a choice between relationships and a new direction. Nurture emotional intimacy and do personal homework even as we activate.

Use this transition year to prepare for a busy decade. Let's get right with ourselves, allow our personal relationships and community connections to evolve and build resilience. Build good psychic hygiene, spiritual practice, and deeply embodied connection to our Mother Earth into our daily lives. Integrate and savor what we've learned over the last decade. Prepare to roll with a flood of new ideas, technologies and attitudes pouring in over the next few years—steer the change in a good direction.

Heather Roan Robbins © Mother Tongue Ink 2024

ASTROLOGICAL YEAR AT A GLANCE INTRODUCTION

Commitment is easy when you're sure about yourself. This year begins in the afterglow of the new moon in Capricorn. New moons are a time for setting intentions, laying down the blueprint for manifestations, and demonstrating a willingness to sign on to lasting decisions. Decisiveness reaps more rewards than fickle efforts. Slow and steady is a timeless and relevant mantra for the start of 2025. Lacking complete clarity about the future—stagnancy, even—is part of the process. Permit yourself to believe in the promise of self-improvement.

As winter turns to spring, transformative Pluto makes its home in the experimental domain of Aquarius. Find the connection between insanity and resilience. How many times did you have to jump in before learning to swim? Can you appreciate your willingness to try, fail, try, fail, and try again until you succeed as tenacity, not foolishness? Hope for social mobility may seem fraught or riddled with authoritarian opposition, but note that at the darkest hour, little lights shine the brightest. During 2025, focus less on precision and begin to think more like a scientist– someone who makes a profession out of learning from mistakes. On this Springtime journey, garner lessons from past follies—perhaps our missteps produced what we needed in the long run. When working on your Growing Edges, emerge into the idea that your past is to be accepted and that your unconventional methods were catalysts to transformative innovations.

Go with what's weird this summer. Reflect on what makes you strange. Is it that you're abnormal, or have we falsified normalcy? Embrace the spices of life. Growing Edge means choosing to exist because you deserve to, despite adversity. Permit yourself to walk on this Earth with unconditional love for yourself. Celebrate the delightful quirkiness of those around you. Enjoy the beginning of the summer by embracing your all-natural—cherish every stretch mark, wrinkle, perfect imperfection, and burden you carry in a culture that may make you feel less than lovely.

≈ p. 39
ℋ p. 53
♈ p. 65
♉ p. 75
♊ p. 89
♋ p. 101
♌ p. 113
♍ p. 125
♎ p. 139
♏ p. 151
♐ p. 163
♑ p. 173

At the end of the year, focus your sharp wit and glowing esteem on solid execution. Utopia is built through collective efforts, communal hopes, united resilience. The beginning of 2025 posited the opportunity to commit to your manifestations. Set down a blueprint for an ideal future. Collaborate to shift paradigms unconventionally.

Monisha Holmes © Mother Tongue Ink 2024

To learn more about astrological influences for your sign,
find your Sun and Rising signs in the pages noted to the right.

ECLIPSES: 2025

Solar and Lunar Eclipses occur when the Earth, Sun and Moon align at the Moon's nodal axis, usually four times a year, during New and Full Moons, respectively. The South (past) and North (future) Nodes symbolize our evolutionary path. Eclipses catalyze destiny's calling. Use eclipse degrees in your birth chart to identify potential release points.

March 13: Total Lunar Eclipse at 23° Virgo focuses our attentions on healing. Allow any insights to bring good medicine forward, and apply generously to address your health concerns. Educate your body.

March 29: Partial Solar Eclipse at 8° Aries fires up our desires for self expression. Allow the returning light to bring forward fresh energy and grounded courage, then go ahead and make a difference.

September 7: Total Lunar Eclipse at 15° Pisces releases memories of the past. Go by feel to access the lessons learned. Allow wisdoms with the returning light to guide your next steps.

September 21: Partial Solar Eclipse at 28° Virgo helps us sort out the left over "chaff" from the "wheat" that nourishes our lives. Ask the Goddess of the Harvest to provide for wise choices, and new recipes.

MERCURY RETROGRADE: 2025

Mercury, planetary muse and mentor of our mental and communicative lives, appears to reverse its course three or four times a year. We may experience less stress during these periods by taking the time to pause and go back over familiar territory and give second thoughts to dropped projects or miscommunications. Get proactive with mechanical safety and maintenance. It's time to "recall the now" of the past and deal with underlying issues. Leave matters that lock in future commitments until Mercury goes direct.

Mercury has three retrograde periods this year in Fire Signs:

March 14–April 7: Spring slows as Mercury retrogrades in Aries, and back into Pisces. What have we forgotten? Look into underlying motivations and beliefs that limit your confidence and self forgiveness. Open up more space for taking unimpeded steps as Mercury goes direct.

July 17–August 11: Summertime heats up as Mercury takes us back through Leo. Time to keep your cool, step back from the limelight and watch others. Let a deeper self awareness feed your creative self expression. Feed your genuine inner child, and reclaim the play.

November 9–November 29: Mercury retrogrades in Sagittarius as Autumn gives us pause. Look for missteps and lost causes that need review. You can't cover all the bases, so make choices based on a grounded approach. Form alliances that offer balance and insight.

Sandra Pastorius © Mother Tongue Ink 2024

YEAR OF THE SNAKE: 2025

Lunar New Year is a spring festival that begins on the second new Moon after Winter Solstice. In your We'Moon calendar, it's when the Sun and new Moon are conjunct in Aquarius. The new Moon on Jan 29, 2025 at 4:36 am PST begins the year of the Snake.

Snake is a symbol of wisdom, making Snake year the time to coil up, contemplate, and reflect. 2025 is the year of the Wood Snake. Of the 5 elements—Fire, Earth, Metal, Water, and Wood—the element Wood symbolizes growth, like a plant in

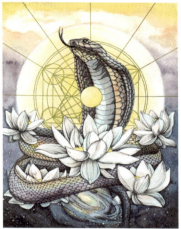

Divine Feminine Rises
© *Lindsay Carron 2017*

springtime. This Wood Snake year offers the unique opportunity to quickly shed skins of the past, creatively express what is in the shadows, and move forward covering much ground. Yang Wood is a pine tree. Yin Wood is bamboo. Snake is a Yin animal who benefits from being flexible like bamboo, easily adapting to change.

Wemoon born in Snake years (2025, 2013, 2001,1989, 1977, 1965, 1953, 1941, 1929) are sensitive, powerful, and creative souls. Some Snake wemoon enjoy a quiet spiritual life, while others are more outwardly determined and strive for success. Snake wemoon are often a mix of both, spending part of their life engaged in worldly success and the other part engaged in the realm of spirituality. The fields of shamanism, midwifery, and hospice are often attractive to Snake wemoon because of their innate powers of perception and depth of understanding.

Snake loves and appreciates beauty. Therefore, creativity in the arts can flourish. This is the year to support all wemoon artists, and become an artisan or artist yourself if that has been a life goal. The mystical nature of Snake means that it is a fortunate time to learn divination and magical arts. Solitary Snake can be a loner, so gather with others in spiritual and creative activities. Do not hibernate, even during winter. A Wood year is time to be engaging and grow with others, to become involved in a spiritual community or enjoy spiritual pastimes such as yoga. Snake wemoon are most compatible with another Snake, Ox, Monkey, and Phoenix (Chicken).

Susan Levitt © Mother Tongue Ink 2024

TAKING OUR PLACE IN SPACE

Life keeps ushering forth from the Big Birth of the Universe,
ever expanding throughout time and space.
Riding the waves of Creation's life force,
all Earth beings become artists of emergence,
offering up each generation to evolution's growing edge
—the very lip of the Universe.

Astrology is a right brained science that Earth beings have developed over time into an elaborate and integrated symbolic language. As we explore correspondences between the celestial rhythms and our own—"as above, so below"—- we may become participants in the flow of the cosmos. We can use our imaginations to zoom out, and reflect upon the predictable planetary orbits and cycles, bringing the planets into our inner view.

Planetary Dialogues 2025

Let's imagine that some of the Planets in our Solar system answer my queries about the cosmic interplay of their current transits. Digest these planet offerings throughout the year, and voice your own truths.

Sandra: "Saturn and Neptune, you will both soon be moving from the sign of Pisces into Aries——what messages do you have for us? Jupiter, Uranus and Pluto: you are also entering new Signs this year. Will you share your perspectives for our fresh canvas of ideas?"

Saturn: "Hello Earth beings, I am the guide and mentor for each human generation that leaps into embodiment, offering lessons on taking responsibility to build integrity on the Earthly journey. Over the past two years while in the sign of Pisces, I've been churning up the collective unconscious, and uncovering a crisis of credibility that is gripping the human conscience. Can you relate? Through Aries' fiery chi, look for pockets of spontaneous truthfulness to empower alliances, deconstruct yourselves, and heal backwards with ancestral allies. Learn to temper your own fire."

Neptune: "I am the guide and mentor for kindling collective memory, and psyche's dreamtime potential. While I journey through Aries, I implore you to plant fresh seeds where you laid down your burdens and emptied your cups during Pisces' transit years of ego surrender. Approach renewal of the Earth as a sacred task, offering

up for the highest good of all what has been soiled and broken. Let water inform your ritual intentions to heal personal and collective trauma, nurture humane egos and re-enchant your ailing planet with aliveness. Be witnesses for each other. Look for the Mother light. Reflect love."

Drawn Beyond ▢ *Hope Reborn 2023*

Uranus: "I am the guide and mentor for human boundary-breaking behaviors and for engendering connectivity. I am a catalyst this year for Gemini's dancing mind to question assumptions, and think outside the box. A conceptual revolution is underway: AI is pushing sentient boundaries, even as humanity's innate Authentic Intelligence is liberating fresh waves of energy. As we twirl in the uncertainty, team up. Seek awe."

Jupiter: "I am the guide and mentor for expanding knowledge and the capacity for social inclusivity. As I leave Gemini and enter Cancer, sign of the Great Mother, I send a call to all kin: remember there are no sides, only changing perspectives. Bring forward *view point diversity* to offer a way through societal dysfunction, and center well-being into the collective heart. Work your own edge to awaken from the illusion of separateness."

Pluto: "I am the guide and mentor for insight into the unseen, for both letting go and embracing the farthest shores. This year, as I begin to spread the frequencies of Aquarius in earnest, human cultures transform their communications tools, spreading both credibility and confusion. Aquarius' collective connectivity is reflected in the growing awareness of a thinking layer that envelopes the Earth called—the Noosphere. Humanity itself generates the Noosphere, a realm where human minds interconnect, becoming a conscious planetary nervous system. Consider the Whole, first—-then take Your place in space."

"We are stardust on a mission:
to enchant the world alive, and mate with its mystery."

Sandra Pastorius © Mother Tongue Ink 2024

DECOLONIZING & DESETTLING WITCHCRAFT:
FREEING OUR WITCHY WAYS FROM EUROCENTRIC SETTLER COLONIALISM

White Christian Europeans are the most aggressive and widespread colonizers in recorded history. Their values and social organizing principles—capitalism, patriarchy, individualism, white supremacy—have permeated almost every aspect of modern society, including witchcraft. Colonialism manifests in the witchcraft community overtly as commercialization, consumerism and overuse of natural resources, and, perhaps more covertly, as racism, patriarchy and cultural appropriation. For Indigenous Peoples, decolonialization means weeding out settler biases and assumptions, revitalizing Indigenous knowledge, and valuing that wisdom. For non-Indigenous people like myself, this means re-examining our beliefs about Indigenous cultures and desettling or dismantling the worldview of settler colonialism in all of our practices.

Commercialization, patriarchy, individualism are hallmarks of capitalism. Some witches go to market, turning spiritual resources into commodities, trying to show off how "witchy" they are. Lurking in the shadows lie the most insidious forms of colonialism. White supremacy has infiltrated the pagan community, hiding in the language that we use, such as *black* versus *white* magic. Patriarchal individualism discourages collaboration and community building, and promotes undermining the work of sister witches. Social media's witchy popularity contests demoralize and cheapen actual magic. Colonialism also promotes the desecration of the natural world, encouraging us to "use" objects without regard to the spirit within. Cultural appropriation manifests as the stealing and misuse of sacred Black and Indigenous practices, such as hoodoo and smudging, commodifying them into marketable spirituality without so much as a thank you to those from whom they were stolen. Even worse is that many of these ideas are forcefully (and incorrectly) attributed to ancient European cultures as a way to "authenticate" or justify their use. So, what can we do about these patterns of disrespect? How can we desettle our practice? Those of us born from majority white culture can:

1. Honor our roots and ancestors. Ancestor work is a way to take responsibility for the actions of our forebears to break generational cycles of hate and trauma. Magic is at the heart of all cultures. You do not need to appropriate other cultures to practice witchcraft. Seek out your rich ancestral roots to restore a sense of belonging.

2. Embrace the belief that all objects resonate with Spirit. Animism is directly incompatible with capitalism, dualism, and patriarchy. Respecting and honoring all of the natural world means *working with* instead of *using* objects in our practices, asking for consent, only using what we need, and rejecting the ideas of *good* versus *evil*. As such, the terms "black magic" and "white magic" no longer hold any weight and are therefore no longer useful.

3. Engage shadow work. Regularly reflect on your own biases, privileges, and assumptions, and be open to unlearning harmful narratives and behaviors. Explore feelings of discomfort if someone calls you out for racism, cultural appropriation, and other colonial bias. Do the work to desettle your practice.

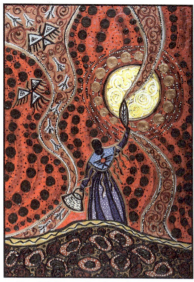

Red Thunderbird Woman
© Leah Marie Dorion 2010

4. Build community. Colonialism promotes scarcity and individualism, pitting us against each other in a never-ending race for resources. It tells us not to trust each other and that everyone is inherently out to get you. This couldn't be further from the truth. Build community by creating inclusive spaces and centering Black, Indigenous, People of Color (BIPOC) voices. Speak out against harmful rhetoric. Collaborate with practitioners who are actively decolonizing witchcraft.

5. Give reparations. Advocate for affordable access to education, housing, infrastructure, and therapy. Donate, volunteer, educate. Promote BIPOC community members and their businesses. Give over your mic, your soap box. Until white people renounce their spoils, their privilege, there can be no end to white supremacy.

This list is by no means totally comprehensive, but it's a good start. Decolonizing and desettling witchcraft is an ongoing process that challenges colonial influences, reclaims cultural identity, and empowers diverse voices. By honoring Indigenous spirituality, challenging Eurocentric narratives, and fostering inclusive community, we can work toward a more equitable and authentic understanding of witchcraft. We owe each other and ourselves that much.

Autumn Willow © Mother Tongue Ink 2024

Tarot for 2025: The Hermit's Wishes

My psychic grandmother's favorite card was the 9 of Cups in Tarot, the one she called The Wish Card. When it appeared, what the client wanted most was coming true.

But Grandma's realm was never simple. Nines carried great responsibility. This card invited not one, but 3 wishes: one for the world, one for another and the final one for self. Not taking these wishes seriously had dire consequences.

2025 in numerology adds up to nine, a year of near completion, of urgent possibility, one worthy of the desires of an opening heart. The archetype of the coming months is 9 Major, The Hermit.

Many fear this reclusive figure since they think she represents isolation, ostracism, even rejection. In a Love reading this symbol can appear especially disheartening, seeming to condemn someone to being alone. But this is not her true influence at all!

Following 8 Major, Courage, and coming just before 10, The Wheel of Fortune, the brave Hermit commits to forsaking everything to journey deeply into the last shadow of her soul. She is seeking her purpose for our Earth, for those closest to her. And she is trying to find out how best to bring to light the tools, talents and gifts she was born with in this lifetime. We are encouraged

to follow her into the barren mountains, the sands of the desert to formulate not only our hopes but also plans for making them come true.

The nines of the minor arcana re-enforce this quest, each with its own brand of advice. In addition to the loving 9 of cups, there are three more.

Ceremony
© Hope Reborn 2021

Nine of Pentacles tells about professional achievement and abundance. The success earned through this card comes from dedication and hard work. Not only have we brought a project almost to completion, more importantly, we have achieved a new level of self-mastery. This is an exciting card because other doors have been cracked open. We are sensing how to help a friend. We are becoming fired up about a new environmental cause. Our self confidence is growing.

At first it seems more difficult to divine the helpfulness of the 9 of Swords. The art on this card often looks threatening. Yet often this is exactly what we need to prompt us into action. We may feel like we are on a pilgrimage into the most desolate landscape. Here we have only our fears, unworthiness, vulnerability, failures and regrets for companions. If we are wise, we don't send them away. We walk with them, learn to love and forgive them. Then offer them to mother Earth to be purified and transformed. We are freed to choose the last perfect piece to heal and complete our soul.

The mystic 9 of Wands contains a double, almost contradictory message. The first is "Don't give up!" Too many of us quit when we are closest to our goal! Trust feelings to reveal the final step. Trust higher wisdom and the whispers of spirit. The second part of the message urges caution. There is an element of overwhelm in every spiritual awakening. The wise person knows to leave something yet to be revealed. Learning in manageable stages is best. Wish for more wishes!

But that's not all! 2025 is also ruled by 18 Major of the Tarot, The Moon, since this number resolves to a 9. She is Guardian of all who take the Hermit's journey. Her gentler light. Her shifting curves. The way she cradles and then releases Earth. Imagine yourself alone on a beach. The moon's face is reflected in the ripples of the waves. Her gaze is more direct than a profile, looking at us while glancing ahead. All around us are ringed stones, the ones for wishing. What is our mission for the health of planet Earth? How can we be a better mother, daughter, friend? And what do we wish to receive and become at the edge of moonlight this year?

Joanne M. Clarkson © Mother Tongue Ink 2024

INTRODUCTION TO THE HOLY DAYS

Celebrate the wheel of the year: Come into deep resonance with Earth. Inhale spring sprouts, expand in summer's bloom, exhale autumn leaves, settle into winter's stillness. The Holy Days invite us to step away from the mundane, to slip between the worlds, connect with Spirit and make Magick. They are portals of potential. Flow through the seasons. Return to your roots. Ground deep in the dark. Listen. Mother Earth calls for our immediate attention.

Earth asks us this year to outgrow our own selves. To reach beyond our righteous rage and ascend into forgiveness. She offers to hold healing space for us and the suffering world. Here in her arms we find Wisdom, Hope, and Beauty. She commands change. Now. Seek your growing edge and lean into it. Here, find your greatest transformation. As acorn becomes oak, our personal transmutations affect All our Relations.

We are the seeds we are cultivating. During this year of emergence, call on Rainbow Warriors to rise and lead in love. Become a mosaic of cultures. Share your medicine ways. Let the edges blur. Honor and embrace each other. We are one tribe. On one earth, under one sun, guided by the same stars and moon. As we cycle through time, let us find common ground to sow our Soul-seeds.

Circle with SiStars in ceremony. Sink into sacred space and dream a new reality into being. Winds of change are blowing. It is our breath. Our prayers. Our songs. We become a force, a Storm, when we gather together. Our light becomes brighter, our love, stronger, our power—undeniable.

Elevate each other as we embark on this incremental evolution. Go beyond turning the wheel of the year, and assist Earth in turning this world right side up. Remember who we are: Powerful Creators, Intuitive Leaders, Master Gardeners. Plant yourself like a community garden, delight in diversity. Together we will heal this planet one seed at a time.

Mahada Thomas © Mother Tongue Ink 2024
Elementals *© Francene Hart Visionary Artist 2019*

The Wheel of the Year: Holy Days

The seasonal cycle of the year is created by the Earth's annual orbit around the Sun. Solstices are the extreme points as Earth's axis tilts toward or away from the sun—when days and nights are longest or shortest. On equinoxes, days and nights are equal in all parts of the world. Four cross-quarter days roughly mark the midpoints in between solstices and equinoxes. We commemorate these natural turning points in the Earth's cycle. Seasonal celebrations of most cultures cluster around these same natural turning points:

February 2, Imbolc/Mid-Winter: celebration, prophecy, purification, initiation—Candlemas (Christian), New Year (Tibetan, Chinese, Iroquois), Tu Bi-Shevat (Jewish). Goddess Festivals: Brighid (Celtic), Yemanja (Brazilian).

March 20, Equinox/Spring: rebirth, fertility, eggs—Passover (Jewish), Easter (Christian), Norooz/New Years Day (Persian). Goddess Festivals: Eostare, Ostara, Oestre (German), Astarte (Semite), Persephone (Greek), Flora (Roman).

May 1, Beltane/Mid-Spring: planting, fertility, sexuality—May Day (Euro-American), Walpurgisnacht/Valborg (German and Scandinavian), Root Festival (Yakama), Ching Ming (Chinese), Whitsuntide (Dutch). Goddess Festivals: Aphrodite (Greek), Venus (Roman), Lada (Slavic).

June 20, Solstice/Summer: sun, fire festivals—Niman Kachina (Hopi), Tirgan (Persian). Goddess Festivals: Isis (Egyptian), Litha (N. African), Yellow Corn Mother (Taino), Ishtar (Babylonian), Hestia (Greek), Sunna (Norse).

August 2, Lammas/Mid-Summer: first harvest, breaking bread, abundance—Green Corn Ceremony (Creek), Sundance (Lakota). Goddess Festivals: Corn Mother (Hopi), Amaterasu (Japanese), Hatshepsut's Day (Egyptian), Ziva (Ukraine), Habondia (Celtic).

September 22, Equinox/Fall: gather and store, ripeness—Mabon (Euro-American), Mehregan (Persian), Sukkoth (Jewish). Goddess Festivals: Tari Pennu (Bengali), Old Woman Who Never Dies (Mandan), Chicomecoatl (Aztec), Black Bean Mother (Taino), Epona (Roman), Demeter (Greek).

October 31, Samhain/Mid-Fall: underworld journey, ancestor spirits—Hallowmas/Halloween (Euro-American), Dia de Muertos (Mexico), All Souls Day (Christian). Goddess Festivals: Baba Yaga (Russia), Inanna (Sumer), Hecate (Greek).

December 21, Solstice/Winter: returning of the light—Kwanzaa (African-American), Soyal (Hopi), Jul (Scandinavian), Cassave/Dreaming (Taino), Chanukah (Jewish), Christmas (Christian), Festival of Hummingbirds (Quecha), Shabeh Yalda/Birth Night (Persian), Koliada (Slavic). Goddess Festivals: Freya (Norse), Lucia (Italy, Sweden), Sarasvati (India).

* Note: Traditional pagan Celtic / Northern European, Jewish and Muslim holy days start earlier than the customary Native / North American ones—they are seen to begin in the embryonic dark phase: e.g., at sunset, the night before the holy day—and the seasons are seen to start on the Cross Quarter days before the Solstices and Equinoxes. In North America, these cardinal points on the wheel of the year are seen to initiate the beginning of each season.

© *Mother Tongue Ink 2003 Sources:* The Grandmother of Time *by Z. Budapest, 1989;* Celestially Auspicious Occasions *by Donna Henes, 1996 &* Songs of Bleeding *by Spider, 1992*

Herbs for the Growing edge

Plantain
© Lorinda Peel-Wickstrom 2020

Inhale. Inhale deeper. And Exhale. Inhale. Inhale deeper. And exhale. May our hearts sync and serve as the drums that call us into action under the waxing gibbous moon. The curtain is almost ready to rise. Our collective dream seeds have sprouted. It is their birthright to bloom and thrive. Our blossoms will continue to grow, flower and move towards the light. Be unapologetic about this moment in time. Your purpose-aligned work will be summoned soon. Is your contribution ready? Emergence is just around the corner, and we will cross the thresholds soon because we have advanced well beyond critical mass. Know that there are blessings that are only for you on the other side.

Gather by the cast iron cauldron for our digestive infusion. May our plantcestors push us through to new perspectives. Gently we roast the coriander seeds, black pepper, cardamom, fennel seeds and ginger to awaken their magic. Blessed infusion, keep our digestive fire and creative centers ready for the pleasure and bounty that is ahead of us. Help us absorb what we have accomplished up to this point; keep us in large mind and improve upon our plans in the coming days.

Dear one, bring forth your beautiful vessel; fill it with our aromatic infusion and add your voice to the choir. Lift your vessel to the moon, call out your biggest fears in this moment and take a sip. Let your body and our collective alchemy transform those fears into rich compost. Call in any resources and support you need in this creative space and take a sip. Know that your requests have been expedited and lifted to the highest of realms. Finally, call in your rebirth from your biggest imagination. Do not deny us the greatness of your contribution at the edge of this pivotal, liminal space.

Soon we will mark the completion of this phase of new perspective. All that is coming to the light is worthy to be praised. Healed ancestors open the way and continue to illuminate our paths. Help us heal from collective harm and planetary dysbiosis.

A new day. A new chapter. A different world in a configuration that serves the collective. May it be so.

Karen L. Culpepper © Mother Tongue Ink 2024

Introduction to We'Moon 2025: Growing Edge

We'Moon 2025 contains an astonishing collection of art and writing that can take you on deep soul journeys to and beyond the Growing Edges of your imagination. It's my job each year to introduce you to the new datebook. It is always a privilege to honor these treasures that women have created and we editors have chosen, with the help of hundreds of discerning women in our Selection Circles (in webinar format, and sometimes in person, in which you are invited to participate). My songs of praise for *We'Moon 2025* are especially fervent. This calendar book is an extravagance of joy, a banquet of wisdom. Its rages are eloquent; its sorrows are poignant. Its radical grief and grace mingle, and overlay, and take turns, and bow to one another in the quintessential posture of paradox: The Both/And. It's All True. The light and dark of it. "There is no difference/ in the deep well/ between the bright clear waters of love/ and the dark muddy waters of love/ no difference between us, my friend/ no difference at all" (Ann Filemyr, p. 170).

The Moon is all about Light and Dark, and it cycles through eight varied phases each lunar month—waxing, waning, glowing full, growing dark again—as its earth-orbiting positions reflect different amounts of sunlight. We have chosen these lunar phases to guide us as inspiration for We'Moon datebook themes in the eight years 2022–2030. For this 4th year, 2025, we invoke the 4th phase, the Waxing Gibbous Moon, as our thematic keynote.

Whoever concocted the word "gibbous"? What indeed does it mean? Convex, rounded in a hump. In exquisite Both/And fashion, the Moon is gibbous in its waxing phase just prior to Full, *and* in its waning phase just after Full. Gibbous is *almost* full as it grows, and then *almost* full again as it decreases. For this *We'Moon 2025* Waxing Gibbous Moon theme, the light is growing toward full on the edge of a dark presence, a thick crescent at this almost time. The shadow curves its mouth wide, keeping us mindful of Dark's hunger.

These artful datebook pages glow with confident radiance, as the pregnant-with-light Moon grows toward full. Titles of several themes reflect this maturation: Swell of Promise (Moon II), Creatrix

(Moon III), Brimful (Moon V). Weaving Harmonies (Moon VI) articulates the vision that Dana Lynn's cover invokes: the cosmic knitting of love, peace, community, grounded on a fertile, albeit edgy, Earth.

As the Moon goes through her changes every night, every month, Change becomes the name of this dance, and Earth's turning seasons become its music. The cycle of Holy Days (Imbolc, Beltane, Lammas, Samhain, the Solstices and Equinoxes) gives us a rhythm of ceremony to mark Earth's stories of growth and decay, the full and the lean. "The Earth is a holy book we open and fall into every day" (Jennifer Pratt-Walter, p. 77).

Other Moon chapter themes turn up the volume of our Earth adorations: Sacred Earth (Moon IV), The Wild (Moon VII), Harvest of Healing (Moon VIII). And for that matter, Smashing Patriarchy (Moon IX)! Yes, this year's theme Growing Edge calls Earth-loving women right now to rescue and repair, "as we grow a forest of the Feminine/ to restore balance to our planet/ and honor the sacredness of life" (Rosalie Kohler, p. 133). How do we do that? "Hum your happiness/ out to the parched places/ where sorrow or violence/ have smothered joy with bitterness or fear" (Susa Silvermarie, p. 78). And "You have a wisdom-warrior/ within you/ that needs no weapon/ only creativity/ to weave the new world dawning" (Lena Moon, p. 41).

I am especially grateful for those word-images that worship the wild, and catch us up in its essence. "Muse...come into my skin/ inhabit these fingers, this body, these bones/ let us grow feathers and fur and learn/ to be wild things in the forest" (Helen Smith, p. 54). This identification with the wild, with Earth, can soothe us as we move into the late months of a closing year, where the Moon chapter titles reflect that curve of darkness. The Gone-Befores (Moon X), Beyond the Veil (Moon XI), Shadow Work (Moon XIII). This material can be piercing, and it can be restorative. "In this Time of Almost/ the world waits as the/ Dying Ways and the New/ pass one another/ under the waxing moon" (Nan Brooks, p. 166). Be prepared to weep with these pages. Be prepared to rejoice.

Bethroot Gwynn © Mother Tongue Ink 2024

Breath is the Horse That Magic Rides
© *Melissa Stratton Pandina 2020*

O Moon! Great Mother in the Sky
Swollen and teeming with Light!
Your glowing, growing wonder shines strong,
fires our determination, ripens our plans.
You are a beacon of Revolution
guiding us beyond fear, weariness, futility.
Now cresting, now brimfull—
Come! Inspire us with Fertile Promise:
Yes, we **can** tame the toxins infecting our precious world.
We **can** create new harmonies among our peoples.
Watching your nightly, exactly-paced parade of Change,
we learn to trust the swell of Possibility,
rejoice in your fluid certainties
Hanhepi Europa Ix Chel
Moon Mother Goddesses
Sarpandit, pregnant with Moonsilver
Gleti, Mother of stars
You of countless names!
All praise to Mama Moon!
All love.

© Bethroot Gwynn 2023

From the Dark Crescent

Luna Moon, waxing toward fullness,
might you have in your thin dark crescent gifts for us?

Whisper to us the best ways to fulfill our life's purpose
to serve the Goddess and her daughters.
Reveal to us a path to foster justice, bring healing.
Light the way to sisters of like heart and mind
so that we may conspire and create.

May your growing light shine on our many colors,
many bodies as varied as the blossoms of Earth.
May your growing light guide us
 to our own fullness, clear of intention and lovingkindness
 guide us to grace as women of power.
Grant wisdom to all of us who long to make the world new,
 safe for women and children and everywhere,
Grant us deep knowing of the blessed cycles,
 as the burning Earth turns
toward fertility and balance.

 Grant us strength and joy as we
 work and dance together,
 bathed in your darkness
 and your
 silvery light.

© Nan Brooks 2023

Thirteen Moons © Gaia Orion 2021

0. GIBBOUS
Moon 0: November 30–December 30
New Moon in ♐ Sagittarius Nov. 30; Full Moon in ♊ Gemini Dec. 15; Sun in ♑ Capricorn Dec. 21

Moon Weaver © Tamara Phillips 2021

December 2024
prosinac

Monday
16

☽△♄ 10:34 am

Tuesday
17

☽✶♅ 5:02 am
☽△♆ 10:33 am v/c
☽→♌ 3:39 pm
☽☍♇ 4:50 pm

Wednesday
18

☽♂♂ 1:13 am
☽△♅ 4:14 am
☉□♆ 6:28 am
☽☍♀ 4:10 pm
☽✶♃ 6:40 pm

Thursday
19

☽□♅ 12:04 pm
♀△♃ 6:10 pm
☉△☽ 9:19 pm
☽→♍ 11:37 pm

Friday
20

☽□♅ 3:46 pm

The Waxing Gibbous Moon

Too stirred to sleep? Everyone who belongs to the Moon knows when she waxes gibbous, there is more light after dusk, more rustling in the undergrowth. These are the nights to rove, and discover what our imaginations can be for us.

Tonight I can hear foxes in the woods next to my cottage. Their gekkering is loud.

The cloud thins. I see the moon, her burgeoning curve; her light closes the distance between us. All interfaces disappear; it's just my face glowing in hers and my soul unable to hold back from running into her arms.

excerpt © Debra Hall 2023

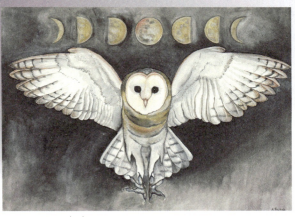

Night Eagle Flies Silently
© *Abby Buchold 2019*

ᚻᚻᚻ subota

♍

Saturday
21

⊙→♑ 1:20 am
☽☍♄ 2:38 am
☽□♃ 3:55 am
☽△♅ 10:49 pm

Winter Solstice

⊙→♑

Sun in ♑ Capricorn 1:20 am PST

⊙⊙⊙ nedjelja

♍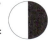
♎

Sunday
22

☽☍♆ 5:27 am v/c
☽→♎ 11:07 am
☽△♇ 12:44 pm
⊙□☽ 2:18 pm
☽⚹♂ 7:59 pm

Waning Half Moon in ♎ Libra 2:18 pm PST

December 2024

Ogrohaeon

 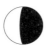

Monday
23

☽✶♅ 8:22 am
☽△♃ 3:51 pm
♀✶♇ 4:46 pm
☽ApG 11:21 pm

Tuesday
24

☽△♀ 2:44 am v/c
♃□♄ 1:59 pm
☉⚻♂ 9:00 pm

Wednesday
25

☽→♏ 12:06 am
☽□♇ 1:51 am
☽□♂ 7:44 am
☉✶☽ 8:59 am

Thursday
26

☽△♄ 4:30 am
☿☍♃ 2:48 pm
☽□♀ 9:08 pm
☿□♄ 11:29 pm
☽☍♅ 11:34 pm

Friday
27

☽△♆ 6:24 am v/c
☽→♐ 11:46 am
☽✶♇ 1:36 pm
☽△♂ 5:50 pm
♀□♅ 11:41 pm

ALL ASPECTS IN PACIFIC STANDARD TIME; ADD 3 HOURS FOR EST; ADD 8 HOURS FOR GMT

My Friend Looks at the Moon

My friend sees the moon and tells me about her vision. She had viewed the moon thousands of nights before. "But this time," she reveals, "I *really* saw it. And it looked back at me. No, into me." As if the moon was a great Eye, or a great Soul affirming a sister-spirit. It was nearly full, but not quite. Whole, but with a sliver of darkness, shadow to learn from, to face. "Because I saw it this way once," my friend continues, "I can never un-see. Revelations, our conversations, are endless." My friend confides truth about craters, the moon's wounds, and about the enticing nature of change.

© Joanne M. Clarkson 2023

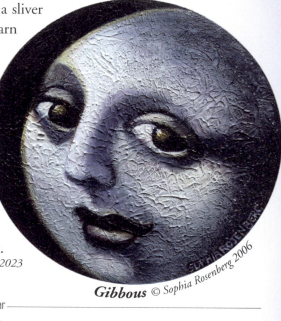

Gibbous © *Sophia Rosenberg 2006*

Saturday
28

☽☍♃ 1:50 pm
☽□♄ 3:15 pm
☽☌☿ 7:01 pm

☉☉☉ robibar

Sunday
29

☿D 11:53 am
☽⚹♀ 12:03 pm
☽□♆ 3:34 pm v/c
☽→♑ 8:37 pm

Changing Women

We are Changing Women.

As the moon begins to swell, we lift our faces up
we turn from the chaos, madness and sadness that dominate
we turn to lift up our power again, at the coming of dawn
the rising of the moon, in rain, wind, snow, and heat.

We lift up our feet to dance
to all the directions: North, South, East and West
dancing with mystery, dancing with darkness, dancing with dust.
Dancing with the Seasons
we plant the three Sisters of corn, beans and squash
taught by the women who came before us on the trails of time.

We dance in this time of changing
of fires, floods, hurricanes and drought
watching the world we know fade and another world appear.

We dance to remember what we have always known.
We dance our way back with spirits and ancestors
through cornfields, red rock canyons, forests, mountains and rivers,
passing the petroglyphs which call out to us
passing the ancient ones who come as sandhill cranes
passing pinon, yucca, tumbleweeds, all reminding us who we are.

We dance in this time of deep change and deep listening.
We dance to remember the lost song that reminds us we are
the poets, singers, storytellers, painters, and medicine women,
and the world needs to hear what we have been saying.

We are Changing Women because we are rooted in this earth,
because we are connected to our bodies.
We hold gourds, feathers, shells and sage.
We invoke the flame within to sear this world with Change.
No matter what this life brings,
we can be transformed again and again.
We dance to bring all of life together,
through beauty, through loss, through truth. Through Change.

I. CHANGE COMES

Moon I: December 30–January 29

New Moon in ♑ Capricorn Dec. 30; Full Moon in ♋ Cancer Jan. 13; Sun in ♒ Aquarius Jan. 19

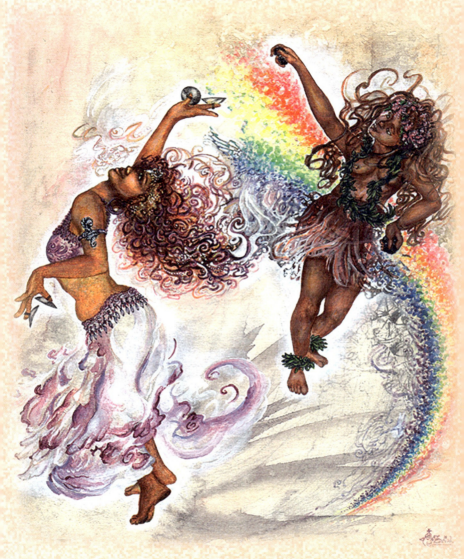

Sister Spirit Dance:
Sounding Through the Barriers
© *Zariah Art 2008*

Dec. 2024 / Jan. 2025
Mí na Nollag / Mí Eanair

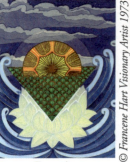

Emerging
New Moon in ♑ Capricorn 2:27 pm PST

ᗞᗞᗞ Dé Luain ──────

♑

Monday
30

☉☌☽ 2:27 pm
☽⚹♄ 11:02 pm
☿△♅ 11:41 pm

───── ♂♂♂ Dé Máirt ─────

♑

Tuesday
31

☽△♅ 3:30 pm
☽⚹♆ 10:02 pm v/c

───── ☿☿☿ Dé Céadaoin ─────

♑
≈

Wednesday
1

☽→≈ 2:50 am
☽☌♇ 4:44 am
☽☍♂ 5:53 am

January

───── ♃♃♃ Dé Ardaoin ─────

≈

Thursday
2

☽△♃ 1:51 am
☽⚹♀ 6:33 pm
☉⚼♃ 7:18 pm
♀→♓ 7:24 pm
☽□♅ 8:13 pm v/c
♂☍♇ 11:21 pm

───── ♀♀♀ Dé Haoine ─────

≈
♓

Friday
3

☽→♓ 7:21 am
☽☌♀ 8:21 am
☿⚼♅ 11:19 am
♀⚼♂ 3:41 pm

ALL ASPECTS IN PACIFIC STANDARD TIME; ADD 3 HOURS FOR EST; ADD 8 HOURS FOR GMT

As We Are

Tell me your visions of the future of fire and flood.
Your prophecy is safe here with another disheveled prophet.
Let's not get stuck here in the undertow of a dying civilization.
We float like feathers on fireweather's draft.

We're the midwives with a sack of magic
on our wide hips, swaying. We have remedies, dear sister.
We hold a dying art being reborn of fire and dust and flood.
Nurturing seed under cover of moonlight,
we speak owl into the forest for the trees.
We slip slender fingers 'neath the damp rotting leaves.
We witch water from hillside springs.
Though it is too dry/wet, too windy/still,
still we nourish fallowed grounds
with hallowed words for a harvest still being dreamt into being.
Things fall apart and things come together often at the same time.
We are fitting the pieces together in the dark, but not blind.
We have each other's light. So go ahead and cry.
Unburden yourself here, for we are in cahoots.
We are the same, you and I. We watch as old worlds fall.
We provide hands to catch that which is being born.
We'll welcome at first light the tender sproutling of a new age.

excerpt ◻ Earthdancer 2022

––––––––––––– ⊃⊃⊃ Dé Sathairn –––––––––––––

♓ 🌓 Saturday
4

 D□♃ 5:33 am
☉⚹D 8:31 am
D♂♄ 8:56 am
☉⚹♄ 2:36 pm
D⚹♅ 11:56 pm

––––––––––––– ☉☉☉ Dé Domhnaigh –––––––––––––

♓
♈ 🌓 Sunday
5

D□♉ 3:57 am
D♂♆ 6:30 am v/c
D→♈ 11:01 am
D△♂ 11:25 am
D⚹♇ 1:06 pm

January
enero

♈

Monday
6

♂→♋ 2:44 am
☿□♆ 5:56 am
☽⚹♃ 8:38 am
☉□☽ 3:56 pm

Waxing Half Moon in ♈ Aries 3:56 pm PST

♈
♉

Tuesday
7

☽△☿ 12:49 pm
☽□□♂ 1:16 pm v/c
☽→♉ 2:11 pm
☽PrG 4:36 pm
☽□♇ 4:22 pm
☿⚻♂ 4:27 pm
☽⚹♀ 11:23 pm

♉

Wednesday
♉

☿→♑ 2:30 am
☽⚹♄ 3:56 pm
☉□♅ 5:54 pm
☉△☽ 10:53 pm

♉
♊

Thursday
9

☽♂♅ 6:00 am
☽⚹♆ 12:46 pm
☽⚹♂ 2:50 pm v/c
☽→♊ 5:06 pm
☽△♇ 7:24 pm

♊

Friday
10

☽□♀ 6:18 am
☽♂♃ 2:01 pm
☽□♄ 7:15 pm

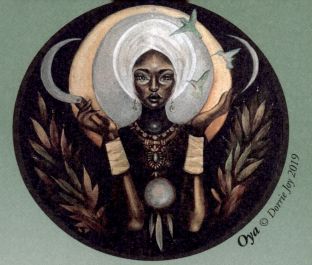

Oya © Dorrie Joy 2019

Welcome Mat

I'll sweep the stoop and place a mat
A welcome mat to the force of Change
That Change, itself, be honored
To cross my threshold
Arriving in robes flowing with challenge
Sparkling with jewels of revelations
So magnificent is the glory of this guest
Offering gifts of growth to accept
Though pain and joy herald the occasion
I bow in grace as Change enters

¤ *Louie Laskowski 2023*

───────── ♄♄♄ sábado ─────────

♊
♋

Saturday
11

☽□♆ 4:03 pm v/c
☽→♋ 8:24 pm

───────── ☉☉☉ domingo ─────────

♋

Sunday
12

♂PrG 5:37 am
☽☍♅ 6:53 am
♂△♆ 1:16 pm
☽△♀ 1:56 pm
☽△♄ 11:30 pm

January
siječanj

Human Nation

--- ☽☽☽ ponedjeljak ---

♋ ○ ## Monday
13

☉△♅ 12:13 am
☽✶♅ 1:21 pm
☉☌☽ 2:27 pm
☽☌♂ 7:48 pm
☽△♆ 8:45 pm v/c

Full Moon in ♋ Cancer 2:27 pm PST

--- ♂♂♂ utorak ---

♋
♌ ○ ## Tuesday
14

☽→♌ 1:12 am
☽☍♇ 3:53 am
♀□♃ 11:48 am
☽✶♃ 10:58 pm

--- ☿☿☿ srijeda ---

♌ ## Wednesday
15

☉☍♂ 6:38 pm
☽□♅ 8:10 pm v/c

--- ♃♃♃ četvrtak ---

♌
♍ ## Thursday
16

☿⚻♃ 4:51 am
☽→♍ 8:46 am

--- ♀♀♀ petak ---

♍ ☽ ## Friday
17

☉✶♆ 3:20 am
☽□♃ 7:33 am
☽△♅ 11:27 am
☽☍♀ 1:46 pm
☽☍♄ 3:43 pm

ALL ASPECTS IN PACIFIC STANDARD TIME; ADD 3 HOURS FOR EST; ADD 8 HOURS FOR GMT

2025 Year at a Glance for ♒ Aquarius (Jan. 19–Feb. 18)

2025 is the year to focus on your self-worth, Aquarius. Before you can charge forward with certain relationships, you are being challenged to assess what you bring to your partnerships. Have you fully taken stock of your value? You must do the necessary work of respecting yourself to avoid falling into the trap of undervaluing yourself. It may feel like 2025 is wearing on your body, so when Jupiter enters Cancer on June 9th, consider keeping a journal that tracks your moods and overall wellness. You may feel tender and crabby at the beginning of the year as you contemplate how best to move forward. Acknowledge when you need time to rest and avoid neglecting your emotional body. Try to recognize the source of your lack of ease in moments of pain or discomfort. There may be times when you want to push past the pain; however, it's always worth the time to evaluate how your choices might make your condition worse. Of course, we cannot completely predict the future. So, as you make risk and benefit assessments, accept that there is no promised outcome. Experiencing loss is a part of receiving gain. At best, you can recognize loss as a much-needed experience, thoroughly enjoying your bounty. While abundance may sound excellent, theoretically, too much of anything can harm your well-being. Consider 2025 a year of temperance.

Monisha Holmes © Mother Tongue Ink 2024

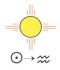

Mécanismes inconscients
© Nolween LM 2022

━━━━━━━ ♄♄♄ subota ━━━━━━━

♍
♎

Saturday
18

☽△♅	6:13 am	☉△☽	6:01 pm v/c
☽⚹♂	9:53 am	☽→♎	7:33 pm
☽☍♆	2:48 pm	☽△♇	10:51 pm
♀☌♄	5:26 pm	☿⚹♄	11:38 pm

━━━━━━━ ☉☉☉ nedjelja ━━━━━━━

♎

Sunday
19

☿⚹♀	8:32 am
☉→♒	12:00 pm
☽△♃	7:06 pm

Sun in ♒ Aquarius 12:00 pm PST

January
Poush

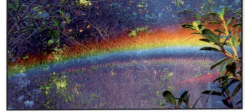

Rainbow Sprinkler © *Barbara Landis 2020*

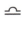 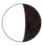

Monday
20

☽□♅ 8:23 am
☽□♂ 8:33 pm v/c
☽ApG 8:47 pm

Tuesday
21

☿□♄ 12:06 am
☉♂♇ 4:29 am
☽→♏ 8:20 am
☽□♇ 11:50 am
☉□☽ 12:31 pm

Waning Half Moon in ♏ Scorpio 12:31 pm PST

Wednesday
22

☽△♄ 5:39 pm

Thursday
23

☽△♀ 12:50 am ☿☍♂ 12:49 pm
☽⚹☿ 6:10 am ☿△♅ 2:07 pm
♂⚹♅ 7:07 am ☽△♆ 4:03 pm v/c
☽△♂ 7:12 am ♇ApG 8:01 pm
☽☍♅ 7:12 am ☽→♐ 8:29 pm

Friday
24

☽⚹♇ 12:01 am
☉⚹☽ 5:55 am
☽☍♃ 6:45 pm

ALL ASPECTS IN PACIFIC STANDARD TIME; ADD 3 HOURS FOR EST; ADD 8 HOURS FOR GMT

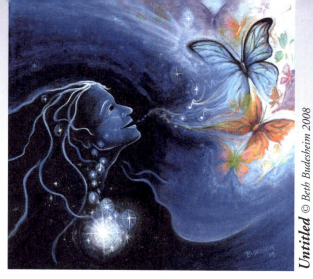

Untitled © Beth Budesheim 2008

Comfort

we must awaken
the artists inside us
we need them now
to dream into being
new ways
of trading and gathering
and growing and sowing
and seeding
all kinds of wild new wonders

this could be a good time
this eleventh hour
hail-mary swan song

you have a wisdom-warrior
within you
that needs no weapon
only creativity
to weave the new world dawning

excerpt © Lena Moon 2020

 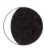 ♄♄♄ sonibar

♐

Saturday
25

☽□♄ 4:51 am
☽□♀ 3:34 pm
♀△♂ 3:54 pm

⊙⊙⊙ robibar

♐
♑

Sunday
26

☽□♆ 1:39 am v/c
☽→♑ 5:42 am
☿✶♆ 10:32 am
♀✶♅ 3:11 pm

Out of the darkness is born the light of all possibility.
The child of promise sits upon the crone's shoulders.

Standing in the pre-dawn looking out from my winter cave
Over the wheel of the year,
The stars bright with Mystery,
The sun not yet dimming their vastness of potential,
I breathe in the cold night air.

What possibility is coursing through my veins?
How am I an agent of Mystery?
What beauty will I weave in this turn around the sun?

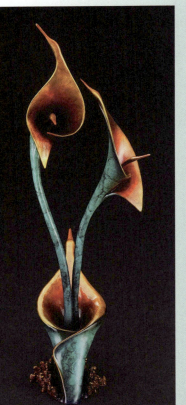

This is the time we,
Like willows in moonlight,
Feet rooted in the sweet dark earth,
Are moved and breathed by the Muse.
Like a gentle wind she touches,
Seeing and loving
Our every bud of soul
Beauty and longing.

In this threshold
Between potential and action,
What seed is swelling in your deep?
What has the Beloved sown in you
That is gestating,
Awaiting the irresistible
Life force of spring to birth?

© *Jonah Ruh Roberts 2023*

Rebirthed Flight © *Carolyn Sato 2010*

II. SWELL OF PROMISE

Moon II: January 29 – February 27

New Moon in Aquarius Jan. 29; Full Moon in ♌ Leo Feb. 12; Sun in Pisces Feb. 18

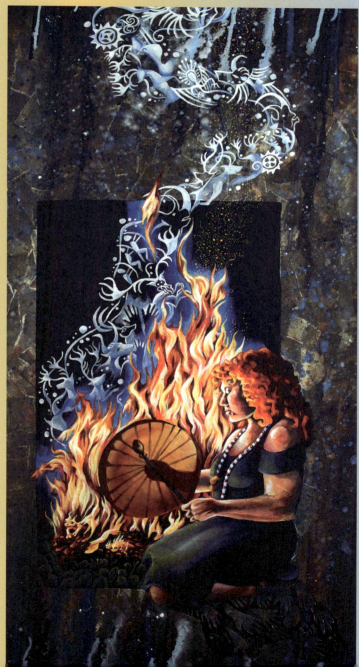

Ancestors Call © *Melissa Stratton Pandina 2022*

January
Mí Eanair

────── ⅅⅅⅅ Dé Luain ──────

♑
Monday
27

☽✳♄ 12:33 pm
☿→♒ 6:53 pm
☽☍♂ 8:52 pm
☽△♅ 11:42 pm

────── ♂♂♂ Dé Máirt ──────

♑
♒
Tuesday
28

☽✳♀ 1:53 am
☽✳♆ 7:48 am v/c
☽→♒ 11:31 am
☽☌☿ 1:45 pm
☽☌♇ 2:56 pm
☿☌♇ 11:52 pm

────── ☿☿☿ Dé Céadaoin ──────

♒
Wednesday
29

Lunar Imbolc

☉☌☽ 4:36 am
☽△♃ 7:08 am

New Moon in ♒ Aquarius 4:36 am PST

────── ♃♃♃ Dé Ardaoin ──────

♒
♓
Thursday
30

☽☐♅ 3:29 am v/c
♅D 8:22 am
☽→♓ 2:52 pm
☉△♃ 2:59 pm

────── ♀♀♀ Dé Haoine ──────

♓
Friday
31

☽☐♃ 9:52 am
☽☌♄ 8:09 pm

ALL ASPECTS IN PACIFIC STANDARD TIME; ADD 3 HOURS FOR EST; ADD 8 HOURS FOR GMT

Imbolc

Imagine yourself as a seed resting in the earth. Dormant. Dreaming. There comes a stirring. A Knowing of what you are meant to be. Something cracks. A root births in the fertile dark, inching deeper, so you may grow into the Light.

As we slowly feel our way through the dark, we may bump against the barriers of our own resistance. This is the shell of the old. Hold yourself here with gentleness, compassion, and patience. These edges will soften and make way for new growth.

When facing our Shadow within and without, call on Goddess Bridget to light the Way. Her heart is so bright she can illuminate the darkest of dark in the darkest night. We ask her to bless our creative inspirations with new possibilities. Welcome her Graceful guidance into our healing hearts. Remember her promise of spring flowers. For she walks in blessed beauty, flower petals between her toes, and a dusting of golden pollen on her nose. She will nurture the patient seed held in the bosom of the earth.

Mahada Thomas © Mother Tongue Ink 2024

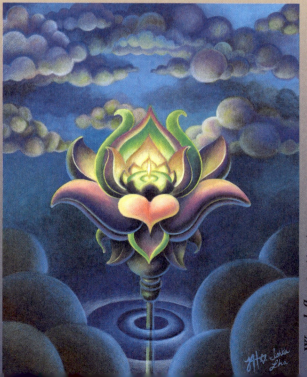

Wondeflor © Ishka Lha 2018

Stone Cailleach

I ride storm winds, scouring the world.
I am the hag of winter—
I am not an ancient crone, tho I aspire to be.
I am no fresh-faced ingenue, I have lived and loved—
I wear the tracks of my experience proudly
as both laugh and worry lines. I am a crone with crone's feet.
In autumn, I am the grain-mother.
I know the blood and gore and viscera of birth.
I know the exultant exhaustion
of growing a tiny human in one's womb,
the shifting of bones and ligaments,
the wild hormonal surges, and the primal,
guttural dance of gestation.
I know the joys, the challenges, the traumas and ordeals
of nourishing a growing being with the substance of my flesh—
with my milk, my wisdom and my experience.

I know the grief of loss; cherished people,
places and things are lost to time and transformation.
Children grow to leave;
outgrow the womb and nest, stretching/flying/leaving
to build their own adventures.

In the deep winter, as my wolves howl,
and the temperature flirts with negative numbers,
I turn to stone, hibernating,
holding and protecting the light and life of spring.

The glacier melt running across my stony face
wakes me to the impending spring.
Drinking the wild sweet water of the sacred well
brings back my youthful seeming.
Then I am the May Queen,
Bridget: goddess of smith craft and word craft.
Then I wear my maiden's face.
But I am always the hag.

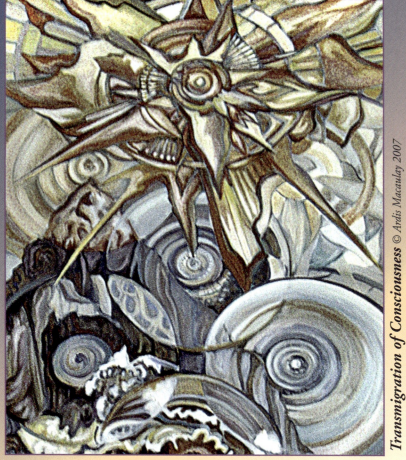

Transmigration of Consciousness © Ardis Macaulay 2007

——————————— ᚼᚼᚼ Dé Sathairn ———————————

♓
♈

Saturday
1

February

☽△♂	1:02 am	☽♂♀	2:06 pm v/c
☽⚹♅	5:54 am	☽→♈	5:10 pm
♀♂♆	8:33 am	☽PrG	6:42 pm
☿ApG	9:37 am	☽⚹♇	8:40 pm
☽♂♆	1:48 pm		

——————————— ☉☉☉ Dé Domhnaigh ———————————

♈

Sunday
2

Imbolc

☽⚹☿	8:35 am
☽⚹♃	12:03 pm
☉⚹☽	5:23 pm

MOON II

February
febrero

───── ☽☽☽ lunes ─────

♈
♉

Monday
3

☽□♂ 2:19 am v/c
☿△♃ 1:51 pm
♂□♇ 6:44 pm
☽→♉ 7:33 pm
☽□♇ 11:12 pm
♀→♈ 11:57 pm

───── ♂♂♂ martes ─────

♉

Tuesday
4

♃D 1:40 am
☽□♉ 6:06 pm

───── ☿☿☿ miércoles ─────

♉
♊

Wednesday
5

☉□☽ 12:02 am
☽⚹♄ 1:59 am
☽⚹♂ 4:16 am
☽☌♅ 11:10 am
☽⚹♆ 7:29 pm v/c
☽→♊ 10:44 pm

───── ♃♃♃ jueves ─────

Waxing Half Moon in ♉ Taurus 12:02 am PST

♊

Thursday
6

☽⚹♀ 1:17 am
☽△♇ 2:34 am
☽☌♃ 6:16 pm

───── ♀♀♀ viernes ─────

♊

Friday
7

☉⚻♂ 12:41 am
♀⚹♇ 4:14 am
☽△♉ 5:11 am
☽□♄ 6:14 am

☉△☽ 7:57 am
☿⚻♂ 8:14 pm
☉⚹♄ 10:22 pm
☽□♆ 11:52 pm v/c

ALL ASPECTS IN PACIFIC STANDARD TIME; ADD 3 HOURS FOR EST; ADD 8 HOURS FOR GMT

Something Mothering

I trust a pulse
that pulls me onwards,
that lifts me gently
from my sorrow.

What's been lost
does not demand
fidelity—

I rise to find
the growing light
of what is next!

I follow something mothering,
a moon of swelling hope.

© Susa Silvermarie 2022

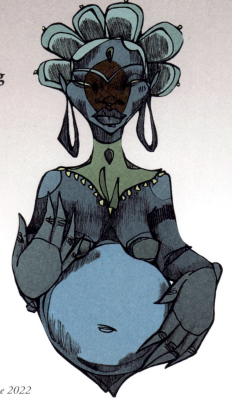

The Future of the Human Race
is in the Hands of Pregnant Women
© Qutress 2023

⟶ ♄♄♄ sábado ⟵

♊
♋

Saturday
8

☽→♋ 3:04 am
☽□♀ 8:28 am
☿⚹♄ 11:21 am

⟶ ☉☉☉ domingo ⟵

♋

Sunday
9

☉☌☿ 4:08 am
♂△♄ 5:15 am
☽☌♂ 11:48 am
☽△♄ 11:57 am
☽⚹♅ 8:49 pm

February
veljača

────── ☽☽☽ ponedjeljak ──────────────────

♋
♌

Monday
10

☽△♆ 5:49 am v/c
☽→♌ 9:00 am
☿□♅ 11:28 am
☽⚺♇ 1:20 pm
☽△♀ 5:21 pm

────── ♂♂♂ utorak ──────────────────

♌

Tuesday
11

☽✶♃ 5:59 am
☉□♅ 11:30 am

────── ☿☿☿ srijeda ──────────────────

♌
♍

Wednesday
12

☽□♅ 4:26 am
☉⚺☽ 5:53 am
☽⚺♉ 11:12 am v/c
☽→♍ 5:07 pm

────── ♃♃♃ četvrtak ────────── Full Moon in ♌ Leo 5:53 am PST

♍

Thursday
13

☽□♃ 3:10 pm

────── ♀♀♀ petak ──────────────────

♍

Friday
14

☽✶♂ 3:14 am
☿→♓ 4:06 am
☽⚺♄ 5:53 am
☽△♅ 2:34 pm

Life Calls

Sometimes the call is quiet, like the soft afternoon sky in winter. It invites you to open, to sit back into its grey cocoon, rest until it's time to move. The invitation has no demand. You can answer when you're ready. It will be there to catch you.

Sometimes the call is wild, like a tribe of warrior women, with shimmering spears, unafraid to pierce what threatens them, hundreds of strong backs, gathered together, bringers of fire and fury. This call stirs you awake, shakes you down to your own molten core and demands nothing short of your breath and your life.

Sometimes the call is like a sensuous river. All you must do is step in, and it will carry you along from one dream, to the next, buttery and smooth, filled with fantasy and delight. It requires surrender, but the kind your body gives to a warm rose-petaled bath, relieved and almost ecstatic.

Sometimes the call is community, declaring that you are done with being alone. The answer is to join with your heart and your song, to join with your dance, to see the earth and every being as your mother, your grandmother, and to love it all tenderly and fully.

What is the call in your life right now? How is it calling you? Will you answer?

© Jennifer Nevergole 2022

ħħ subota

♍︎
♎︎

Saturday
15

☽☌♆ 12:35 am v/c
☽→♎ 3:45 am
☽△♇ 8:45 am
☽☍♀ 6:19 pm

☉☉☉ nedjelja

♎︎

Sunday
16

☽△♃ 2:51 am
☽□♂ 2:37 pm

February
Magh

 Monday
17

☉△☽ 3:24 pm v/c
☽→♏ 4:19 pm
☽ApG 5:02 pm
☽□♇ 9:34 pm

 Tuesday
18

☉→♓ 2:06 am
☽△☿ 7:55 am

☉→♓

Sun in ♓ Pisces 2:06 am PST

 Wednesday
19

☽△♂ 3:07 am
☽△♄ 7:58 am
☽☍♅ 3:47 pm

 Thursday
20

☽△♆ 2:05 am v/c
☽→♐ 4:54 am
☉□☽ 9:32 am
☽✶♇ 10:12 am
☿□♃ 12:13 pm
☽△♀ 11:28 pm

Waning Half Moon in ♐ Sagittarius 9:32 am PST

 Friday
21

☽☍♃ 4:08 am
☽□☿ 6:53 am
☽□♄ 7:50 am

ALL ASPECTS IN PACIFIC STANDARD TIME; ADD 3 HOURS FOR EST; ADD 8 HOURS FOR GMT

2025 Year at a Glance for ♓ Pisces (Feb. 18–March 20)

What an excellent time to be yourself! As 2025 begins, you will have experiences that give you all the more reason to embrace your true nature. If tapping into your sense of mysticism and magic seems unnatural, take it with a sense of humor and curiosity. Feel free to laugh while tapping into your intuition, and giggle when you explain to people that you need time for meditation—you need not take yourself too seriously. Your ability to move forward with a sense of comedy may enhance your charm. There is no need to frown or cringe when you align your chakras or cleanse your aura. If it feels silly to you, embrace that sensation. This year is about developing a grounded sense of yourself, which could be challenging, especially during Pluto's retrograde which occurs May 4th through October 13th. In your process throughout the year, you may feel you have more questions than answers, which is a great sign! You have your entire life to satisfy your curiosity. Finding reasons to question the universe is a sign that you are learning and alive. Take each day of this

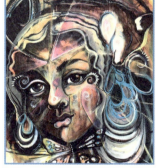

Legendary
© Kelly Beth Bonsall 2018

year with a healthy dose of self-compassion. You may experience personal hardships or feel angst due to unmet expectations. Taking each challenge with the occasional grin can help you find momentary relief, even if a few tears follow closely behind the smiles.

Monisha Holmes © Mother Tongue Ink 2024

―――――― ♄♄♄ sonibar ――――――

♐
♑

Saturday
22

☽□♆ 12:38 pm v/c
☽→♑ 3:08 pm

―――――― ☉☉☉ robibar ――――――

♑

Sunday
23

☉✶☽ 12:26 am
☿△♂ 8:58 am
☽□♀ 9:52 am
♂☽ 6:00 pm
☽☍♂ 10:32 pm

invocation to the muse

muse, come into my heart
I dare you to take me by the hand and twirl me
through the night
let us paint our skin with stars
come into my life, come into my skin
inhabit these fingers, this body, these bones
let us grow feathers and fur and learn
to be wild things in the forest
leaves in our hair and soil on our toes
sing the brave initiation of the owl
and the soft voice of blossom
where the river is queen
travel with me, flow with me
muse, become liquid in my veins
together let us listen to the awen and weave
a blanket of soul fire
wrap ourselves in morning
we have buried our hurts
in a Samhain grave, laid them to rest
under yew trees and roses
muse, help me say a prayer for their passing
plant a headstone of willow—lest we forget
paint ash on our cheeks, salt-softened
by the years, the tears
and open wide our arms to the sun
I dare you to dance with me
I dare you to rustle your skirts
and let the petals fly
dare I follow? I must, under hare-bright moon
muse, become me, come with me
and tread the path of healing

© *Helen Smith 2021*

III. CREATRIX

Moon III: February 27 – March 29

New Moon in Pisces February 27; Full Moon in ♍ Virgo March 13; Sun in ♈ Aries March 20

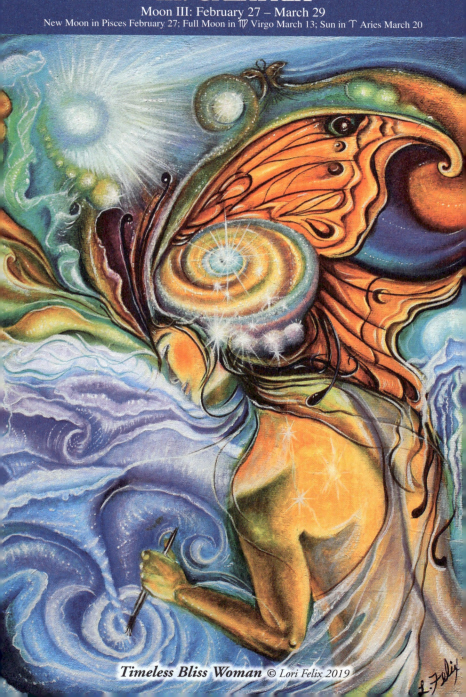

Timeless Bliss Woman © *Lori Felix 2019*

February / March

Mí Feabhra

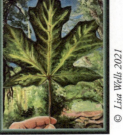

© Lisa Wells 2021

Maple Leaf

───── ꒱꒱꒱ Dé Luain ─────

 ♑
♒

Monday
24

☽⚹♉ 12:41 am
☽⚹♄ 4:10 am
☽△♅ 10:14 am
☽⚹♆ 7:28 pm v/c
☽→♒ 9:40 pm

───── ♂♂♂ Dé Máirt ─────

♒

Tuesday
25

☽☌♇ 2:32 am
☿☌♄ 4:02 am
☽⚹♀ 3:54 pm
☽△♃ 6:33 pm

───── ☿☿☿ Dé Céadaoin ─────

♒

Wednesday
26

☽□♅ 2:04 pm v/c

───── ♃♃♃ Dé Ardaoin ─────

♒
♓

Thursday
27

☽→♓ 12:46 am
☿⚹♅ 1:37 am
☉☌☽ 4:45 pm
☽□♃ 8:54 pm

New Moon in ♓ Pisces 4:45 pm PST

───── ♀♀♀ Dé Haoine ─────

♓

Friday
28

☽△♂ 4:57 am
☽☌♄ 10:42 am
☽⚹♅ 3:32 pm
☽☌☿ 8:19 pm

───────────────────

ALL ASPECTS IN PACIFIC STANDARD TIME; ADD 3 HOURS FOR EST; ADD 8 HOURS FOR GMT

Emergence

Our cells understand, but cannot speak it back.
The world of art,
home of prayer.
Seeds of creation arising and dissolving.

The artist dips her ladle into this cauldron,
scoops out what she finds
and puts a frame around it,
so the rest of us can peer into the space
where Mystery plays hide and seek with herself.

excerpt © Maureen Sandra Kane 2022

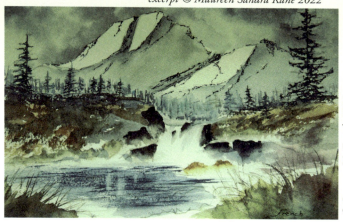

© *Jeanette M. French 2020*

Mountain Stream

--- ᚻᚻᚻ Dé Sathairn ---

♓︎
♈︎

Saturday
1

March

☽☌♆	12:05 am v/c	♀R	4:36 pm
☽→♈︎	1:52 am	☽☌♀	7:25 pm
☽⚹♇	6:34 am	☽⚹♃	9:55 pm
☽PrG	1:33 pm		

--- ⊙⊙⊙ Dé Domhnaigh ---

♈︎

Sunday
2

☽□♂	5:52 am v/c
♅☌♆	8:22 am
⊙□♄	10:18 am

March
marzo

Monday
3

♈
♉

☿→♈ 1:03 am
☽→♉ 2:37 am
☽□♇ 7:27 am

♉

Tuesday
4

☉⚹☽ 1:47 am
☽⚹♂ 7:25 am
☽⚹♄ 1:37 pm
☽☌♅ 5:56 pm

♉
♊

Wednesday
5

☽⚹♆ 2:53 am v/c
☽→♊ 4:29 am
☿⚹♇ 5:13 am
☽△♇ 9:36 am
☽⚹♅ 10:01 am
☽⚹♀ 10:21 pm

♊

Thursday
6

☽☌♃ 2:17 am
☉□☽ 8:32 am
☽□♄ 5:23 pm

Waxing Half Half Moon in ♊ Gemini 8:32 am PST

♊
♋

Friday
7

☽□♆ 6:57 am v/c
☽→♋ 8:29 am
☽□☿ 7:05 pm
☉△♂ 9:13 pm

ALL ASPECTS IN PACIFIC STANDARD TIME; ADD 3 HOURS FOR EST; ADD 8 HOURS FOR GMT

Of Paper Moons, Glimmered Words

Each night I stand
under the cheese-white moon,
utter orisons to
pin-pricked starlight
beneath the maple
leaning in full swoon.
I want to gather
blossomed words to write
bud and bloom,
bird-seeded words
taking flight, landing,
a flurry of moth wings, on page
high sun chasing moon
beyond darkness,
circled stage of
lush green earth,
cursive script,
madly spun.

© Kersten Christianson 2023

Writing it into Existence © *Qutress 2023*

ꜗꜗꜗ sábado

Saturday
♉

☽□♀	2:20 am
☽♂♂	4:52 pm
☉△☽	6:16 pm
☽△♄	11:40 pm

☉☉☉ domingo

Sunday
♌

☽⚹♅	4:39 am
☽△♆	2:32 pm v/c
☽→♌	3:59 pm
☽☍♇	9:48 pm

Daylight Saving Time Begins 2:00 am PST

March
ožujak

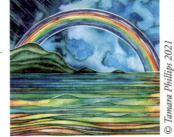

© Tamara Phillips 2021

Rain Water

ᛞᛞᛞ ponedjeljak

♌

Monday
10

☽△♅ 6:56 am
☽△♀ 9:21 am
☽✳♃ 4:46 pm

♂♂♂ utorak

♌

Tuesday
11

☽□♅ 1:16 pm v/c
♅♂♀ 3:55 pm
♄ApG 11:44 pm

☿☿☿ srijeda

♌
♍

Wednesday
12

☽→♍ 12:55 am
☉♂♄ 3:29 am

♃♃♃ četvrtak

♍

Thursday
13

☽□♃ 3:13 am
☽✳♂ 1:45 pm
☽☍♄ 8:40 pm
☉☍☽ 11:54 pm

Total Lunar Eclipse 8:58 pm PDT*
Full Moon in ♍ Virgo 11:54 pm PDT

♀♀♀ petak

♍
♎

Friday
14

☽△♅ 12:06 am
☉✳♅ 2:16 am
☽☍♆ 10:47 am v/c
☽→♎ 11:59 am
☽△♇ 6:27 pm
☿R 11:46 pm

*Eclipse visible in Europe, Americas, much of Australia, Africa, Asia, the Pacific & Atlantic, and Antarctica.

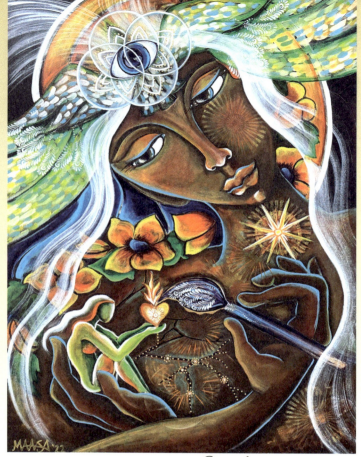

Creatrix © *Maasa Craig 2023*

ꜛꜛꜛ subota

♎ ☽ **Saturday**
15

☽☌♀ 2:24 am
☽☌☿ 7:12 am
☽△♃ 3:38 pm

☉☉☉ nedjelja

♎ ☽ **Sunday**
16

☽□♂ 2:53 am v/c

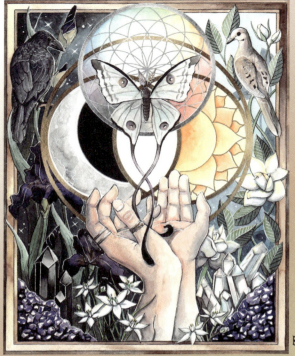

Transmute © Dana Lynn 2020

Spring Equinox

We call to our own Awakening. Feel the returning Sun shine in our hearts. Listen as songbirds sing the Earth awake. Look with newfound clarity conceived in winter's cave. As rivers and streams rush high, we wash away the debris gathered on our banks. Open the blinds, shake out the carpets, dust out the cobwebs. The thaw has come.

In spring we burst through our old shells. We replace resistance with the determination of a dandelion growing through a crack in concrete. The old melts away with the snow. New ideas, like delicate sprouts, need attention and protection. As we set intentions, we delicately hold in our hands both our needs and those of our Human Family.

Our hearts are budding branches as we tend to All life. Turn the Earth, and prepare the garden bed for whatever work you grow. Wait for the Divine Moment to plant your seeds. We cannot hasten our gardens or our growth. Surrender to Earth's wisdom. Stand in balance at the Equinox between open anticipation and reverent patience

Mahada Thomas © Mother Tongue Ink 2024

Hope

Have hope, dear friend.
Seeds are made with all ways of being tucked inside.
Clinging, pricking, wafting, sinking, reaching,
bursting, luring, floating, rolling,
breaking
they start by breaking. It is their end and their beginning.
Count the days
Count the nights,
Orion slips behind a cloak of day.
Women sigh and Venus takes coins from her purse
to relieve the poverty of the long winter.
The ground gasps and gushes
Venus smiles her trap smile.
She knuckles her way forward, spring, Ostara, lips wrap around
seeds, and sleep is no master, slurp the curves of a brimming world.
Let her lure you back with the tang of dandelion and young mint.

March
Falgun

Bee Medicine

— ☽☽☽ sombar —

 ♎︎ ♏︎

Monday
17

☽→♏︎ 12:30 am
☽□♇ 7:11 am
☽ApG 9:37 am

— ♂♂♂ mongolbar —

♏︎

Tuesday
18

☽△♂ 4:56 pm
☽△♄ 11:02 pm

— ☿☿☿ budhbar —

 ♏︎ ♐︎

Wednesday
19

☽☌♅ 1:38 am
☉△☽ 12:07 pm
☽△♆ 12:28 pm v/c
☽→♐︎ 1:17 pm
☉☌♆ 4:25 pm
☽✶♇ 7:59 pm
☽△♀ 10:09 pm

— ♃♃♃ brihospotibar —

♐︎

Thursday
20

☉→♈︎ 2:01 am
☽△♅ 4:56 am
♆ApG 2:12 pm
☽☌♃ 6:01 pm

Spring Equinox

☉→♈︎

Sun in ♈︎ Aries 2:01 am PDT

— ♀♀♀ sukrobar —

♐︎

Friday
21

☽□♄ 11:23 am
♀✶♇ 2:32 pm
☽□♆ 11:53 pm v/c

ALL ASPECTS IN PACIFIC DAYLIGHT TIME; ADD 3 HOURS FOR EDT; ADD 7 HOURS FOR GMT

2025 Year at a Glance for ♈ Aries (March 20–April 19)

Aries, 2025 is a beautiful year to practice listening and using what you overhear to help set new goals. From the end of 2024 until February 23rd, the galactic bodies laid down the prompt to think through how you want your work and career to be perceived by the world. Your aspirations are subject to ebb and flow with each burst or decline of energy. This lifetime, at least this next decade, is dedicated to you doing life your way. As unconventional and unique as your life path is, it is yours alone. While tip-toeing in someone else's footprints can seem comfortable, you'll find much more satisfaction blazing your own path. Of course, achieving goals can feel a bit intimidating. The clues dropped from success can leave you in a state of contemplation. "So what if I succeed? Will my self-esteem heighten? Will I prove critics (including my own inner judge) wrong? Or, most importantly, do I recognize my ability to make myself happy?" As Spring persists, you will come into yourself: imperfections, inaccuracies, and iconic discoveries. Chin up, Aries. You have an incredible ability to rally. When you step into action, there is no holding you back. Be decisive about what you plan to do. Some manifestations only have one opportunity, one lifetime to actualize. When in doubt, turn to faith, the support of friends and community, or look to the stars to motivate you through the unknown.

You have an impressive ability to create fun–lean on that. All your experiences charging bravely through life surely come with benefits.

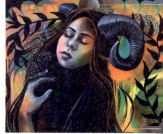

Monisha Holmes © Mother Tongue Ink 2024

Aries *© Koco Collab 2021*

━━━━━━━━━━ ♁♁♁ sonibar ━━━━━━━━━━

♐
♑

Saturday
22

☽→♑ 12:28 am
☉□☽ 4:29 am
☽□♀ 6:10 am

♀PrG 8:42 am
☽□♉ 12:13 pm
☉♂♀ 6:07 pm

━━━━━━━━━━ ☉☉☉ robibar ━━━━━━━━━━ Waning Half Moon in ♑ Capricorn 4:29 am PDT

♑

Sunday
23

☉⚹♇ 12:32 pm
☽☍♂ 4:22 pm
☽⚹♄ 8:41 pm
☽△♅ 10:17 pm

March
Mí Márta

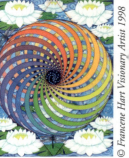

KA (life force)

ꓷꓷꓷ Dé Luain

Monday
24

☽✶♆	8:01 am v/c
☽→♒	8:24 am
☽✶♀	11:15 am
☉♂☿	12:48 pm
☽♂♇	2:34 pm
☽✶♅	4:06 pm
☉✶☽	4:36 pm

♂♂♂ Dé Máirt

Tuesday
25

☽△♃	11:00 am
☿✶♇	3:02 pm

☿☿☿ Dé Céadaoin

Wednesday
26

☽□♅	3:15 am v/c
☽→♓	12:31 pm
♂□♄	1:13 pm

♃♃♃ Dé Ardaoin

Thursday
27

♀→♓	1:40 am
♀♂♆	6:13 am
☽□♃	1:56 pm
☿PrG	10:16 pm

♀♀♀ Dé Haoine

Friday
28

☽△♂	1:27 am	☽♂♆	1:30 pm v/c
☽♂♄	4:03 am	☽→♈	1:36 pm
☽✶♅	4:55 am	☽♂♅	3:02 pm
☽♂♀	12:16 pm	☽✶♇	7:12 pm

*Eclipse visible in Europe, North Asia, North and West Africa, the Atlantic, and much of the America.

The Shift

something moves on the wind now
star patterns show us a sign
a rhythm pulses from the sun
 keeping time with the heart-beat of the earth
tidal waves and firestorms come swiftly to shake us awake

 we are wizards of wonder
 we employ joy as our weapon
 we make love, we make music,
 as acts of resisDance
 we take what is waste
 revive it with our creativity

we must look on our world:
 with the inspiration of an artist,
 the love of a mother

omens implore us
come conscious! Rise up!!
"Are you here? Are you aware?
There is a Shift happening! You must face it with care!!"

excerpt © Lena Moon 2012

ᚼᚼᚼ Dé Sathairn

♈ 🌑 Saturday
29

☉☌☽	3:58 am
☽✶♃	2:32 pm
☿→♓	7:18 pm
☿☌♆	7:46 pm
☽PrG	10:16 pm

Partial Solar Eclipse 1:50 am PDT*
New Moon in ♈ Aries 3:58 am PDT

☉☉☉ Dé Domhnaigh

♈
♉ 🌑 Sunday
30

☽□♂	2:18 am v/c
♆→♈	4:59 am
☽→♉	1:16 pm
☽□♇	6:53 pm

Birds Dream the World

Birds stitch the sky to the land and the water and then the water to the leaves and the moss to the shade. Birds connect the mountains to the clouds and the rain to the trees. And while they're doing that a vast mycelium ghost network passes through soil faster than the old clipper ships through oceans and then pops up as mushrooms in damp forests.

This energy connects through the earth to find its way to the webbed feet of ducks and the dorsal fins of dolphins. And then filters through the whales' baleen, and the thin coat of ice on shallow water where you might also see it shook off the wings of osprey, even swans and geese. The energy honks through the fog where moisture is suspended like diadems on trees lighting the way for birds who slide past pointed holly leaves or cactus needles or jagged edges of cliffs or the wave's cold tips in the middle of a wide ocean. An ocean pushed by winds forming waves that roll for miles and days moving toward the shore, ranging through rivers and low-lying salt marshes. Where it's met by cavities for birds' nests or otter dens and the bowl of the river that the eagle oversees. The river reflects the sky where the eagle reluctantly welcomes the osprey in the spring who follow the largest school of menhaden coming from the south.

All of this pulled together, like the last stitch holding the fabric, by the dragons who ride the dreams of birds because they find them beautiful and know they hold the sky to the sand at the water's edge and the ocean to the dome of the earth that covers our home and

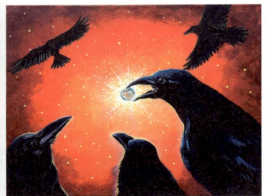

reaches across wide places for the waves to tell stories and bring the call of the birds, love from their far home. The largest living organism is the world. Birds dream the world.

© freda karpf 2023

Murder of Crows
© Visual Lifesavers Art 2018

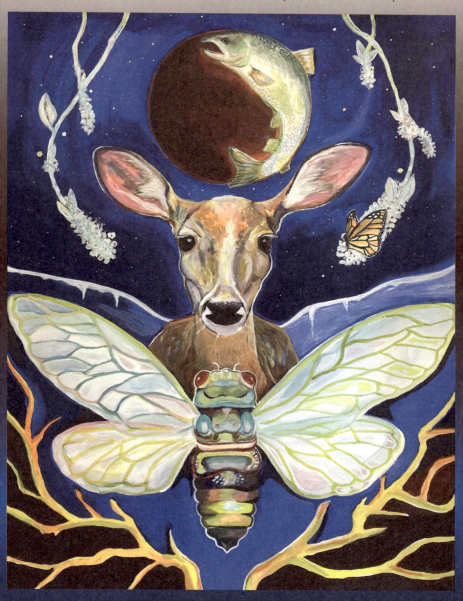

From Life into Life
© *Lisa Wells 2021*

March / April
marzo / abril

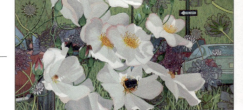

Eros © *Nancy Watterson 2016*

— ☽☽☽ lunes —

 ♈

Monday
31

No Exact Aspects

— ♂♂♂ martes —

 ♉
♊

Tuesday
1

April

☽✶♂	3:15 am		☽✶⚷	10:43 am v/c
☽✶♄	4:33 am		☽→♊	1:25 pm
☽♂♅	4:56 am		☽✶♆	1:34 pm
☽✶♀	8:54 am		☽△♇	7:17 pm

— ☿☿☿ miércoles —

 ♊

Wednesday
2

☉✶☽ 11:20 am
☽♂♃ 4:25 pm

— ♃♃♃ jueves —

 ♊
♋

Thursday
3

☽□♄ 6:52 am
☽□♀ 9:37 am
☽□⚷ 11:26 am v/c
☽→♋ 3:50 pm
☽□♆ 4:07 pm

— ♀♀♀ viernes —

 ♋

Friday
4

♄✶♅ 9:21 am
♂✶♅ 4:05 pm
♂△♄ 6:08 pm
☉□☽ 7:15 pm

Waxing Half Moon in ♋ Cancer 7:15 pm PDT

ALL ASPECTS IN PACIFIC DAYLIGHT TIME; ADD 3 HOURS FOR EDT; ADD 7 HOURS FOR GMT

Gaia Gardening in the 'Hood

In most urban communities there are little spits of fallow soil framed by concrete and asphalt, home to plantain, dandelion, wild violet, creeping Charlie, ignored and unappreciated except by local dogs. What was almost dead dirt becomes loam with the help of sand from the beach, worm castings from my kitchen and horse manure from the stables, transforming one corner at a time into bursts of color: daffodils, hyacinths and tulips, followed by globes of purple amaryllis, day lilies; orange and red, white trumpet Asiatic lilies perfuming the air for blocks, anise hyssop with bumblebees landing on purple bouquets, goldfinch flitting among the sunflowers.

Curious neighborhood children gather and learn how to deadhead, where to cut on a stem and why waiting for bulbs to spring after a long winter is worthwhile. The Pandemic did connect many of us with our greater selves where unknown neighbors stepped up and have helped maintain their corners since.

Meanwhile, from the Herban Rose Corner, Nigerians accept bundles of mint for tea, Afghani mothers bring roses into their new homes, and Mexican families learn about making oregano pesto.

Mother Nature just needs a little help and support, and when given, can work wondrous transformations in little spaces. We may not be able to address the whole planet, but at least in our spit of a neighborhood, people from all over this great world can come together and feed their souls.

© MBE OLE 2023

ᚼᚼᚼ sábado

♋︎
♌︎

Saturday
5

☽⚹♅ 12:20 pm
☽△♄ 12:29 pm
☽☌♂ 12:49 pm
☽△♀ 1:36 pm

☽△♉ 3:54 pm v/c
☽→♌ 9:34 pm
☽△♆ 10:02 pm

☉☉☉ domingo

♌︎

Sunday
6

☉⚹♃ 2:44 am
☽☍♇ 4:19 am
♀△♂ 5:13 am

April
travanj

♌ ## Monday
7

♀♂♄	4:01 am
♂D	4:08 am
☽⚹♃	5:36 am
☉△☽	7:30 am
☽□♅	9:08 pm
♀⚹♅	9:47 pm v/c

♌
♍ ## Tuesday
8

☽→♍	6:40 am

♍ ## Wednesday
9

☽□♃	5:04 pm

♍
♎ ## Thursday
10

☽☍♀	7:39 am
☽△♅	8:36 am
☽☍♄	9:25 am
☽⚹♂	12:19 pm
☽☍♀	12:49 pm v/c
☽→♎	6:12 pm
☽☍♆	7:03 pm

♎ ## Friday
11

☽△♇	1:37 am
⚷ApG	5:18 pm

rooted to the sky

i'm happiest
among trees
near water
or woods
by a meadow
or a thicket

by a bog
or a bush
of maple trees
tapped for
spring sap

i belong in the
wild woods

i'd gladly
become
a paper birch

with a nest
of baby robins
in my leafy hair

my unfurling buds
stretching sunward
for sweet kisses

my roots
exploring rich depths
of loamy soil

filaments and tendrils
communing
with poplars and sumac

i'd swing and sway
through the seasons
my heartwood
rooted to the sky
¤ *Chris Cavan 2022*

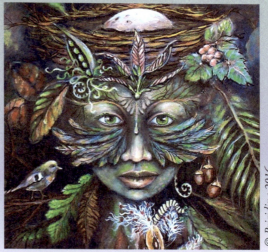

© *Brigidina 2016*

Gaia, Green Woman Rising

— ᚺᚺᚺ subota —

♎︎

Saturday
12

☽△♃ 6:20 am
☉☌♀ 9:00 am
☉☍☽ 5:22 pm
♀D 6:02 pm

Full Moon in ♎︎ Libra 5:22 pm PDT

— ⊙⊙⊙ nedjelja —

♎︎
♏︎

Sunday
13

☽□♂ 3:01 am v/c
☽→♏︎ 6:54 am
☽□♇ 2:27 pm
☽ApG 3:44 pm

April
Choitro

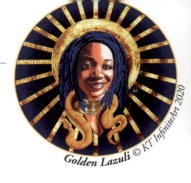
Golden Lazuli © KT InfiniteArt 2020

———— ☽☽☽ sombar ————

♏

Monday
14

No Exact Aspects

———— ♂♂♂ mongolbar ————

♏
♐

Tuesday
15

☽△♀	9:04 am
☽☍♅	10:31 am
☽△♄	12:00 pm
☽△♂	5:51 pm

☽△☿	7:23 pm v/c
☽→♐	7:37 pm
☽△♆	8:50 pm
☿→♈	11:25 pm

———— ☿☿☿ budhbar ————

♐

Wednesday
16

☽⚹♇	3:08 am
☿♂♆	9:11 pm

———— ♃♃♃ brihospotibar ————

♐

Thursday
17

☽☍♃	9:11 am
♂→♌	9:21 pm
☽□♀	9:40 pm

———— ♀♀♀ sukrobar ————

♐
♑

Friday
18

☽□♄	12:20 am
☉△☽	4:38 am v/c
☽→♑	7:12 am
☽□♆	8:33 am
☽□☿	10:50 am

ALL ASPECTS IN PACIFIC DAYLIGHT TIME; ADD 3 HOURS FOR EDT; ADD 7 HOURS FOR GMT

2025 Year at a Glance for ♉ Taurus (April 19–May 20)

Taurus, the year begins with a thirst for knowledge. With Saturn briefly entering Aries at the end of June, you may stumble upon a much-needed breakthrough toward self-empowerment. Depriving yourself of indulging in that curiosity may cause cognitive dehydration or a more profound challenge to your ability to focus. Have you developed an appreciation for how what you are learning can inform your sense of logic or creativity? None of us can predict the future, and if you try, I suggest practicing foresight with flexibility and embracing a little bit of uncertainty. Focus on finding pleasure in the present, even if you are wishing for a bit of excitement. Sometimes, the most ordinary and mundane parts of life are the moments you love the most. For 2025, try to let go of the need to have absolute truths and concrete answers— maybe this year, you'll learn that life will rarely provide you with satisfying theories. The world around you changes, grows, and evolves with each inhale and exhale you take. Lean into the possibilities of what could be, rather than becoming fixated on what is not. You halt your development when you become entrapped by expectations. In life, when there are moments in which you turn out to be correct, consider yourself wise. Even the most intuitive and sensory-aware individuals benefit from allowing life to unfold and people to reveal themselves. Welcome an openness to new outcomes.

Monisha Holmes © Mother Tongue Ink 2024

───── ♄♄♄ sonibar ─────

♑

Saturday
19

☉→♉ 12:56 pm
♂△♆ 3:53 pm

☉→♉

Sun in Taurus 12:56 pm PDT

───── ☉☉☉ robibar ─────

♑
♒

Sunday
20

☽✶♀ 8:23 am
☽△♅ 8:26 am
☽✶♄ 10:21 am v/c
♀✶♅ 11:21 am
☿✶♇ 2:40 pm
☽→♒ 4:22 pm

☽✶♆ 5:47 pm
☉□♂ 6:34 pm
☽☍♂ 6:35 pm
☉□☽ 6:35 pm
☽♂♇ 11:19 pm

Waning Half Moon in ♒ Aquarius 6:35 pm PDT

April
Mí Aibreán

Monday
21

☽⚹☿ 12:00 am

Tuesday
22

☽△♃ 4:04 am
☽□♅ 2:55 pm v/c
☽→♓ 10:06 pm

Wednesday
23

☉⚹☽ 4:14 am
☉□♇ 10:10 am

Thursday
24

☽□♃ 8:10 am
♀☌♄ 5:02 pm
☽⚹♅ 5:50 pm
☽☌♄ 7:53 pm
☽☌♀ 7:57 pm v/c

Friday
25

☽→♈ 12:24 am
☽☌♆ 1:53 am
☽△♂ 5:29 am
☽⚹♇ 6:34 am
☽☌☿ 3:04 pm

ALL ASPECTS IN PACIFIC DAYLIGHT TIME; ADD 3 HOURS FOR EDT; ADD 7 HOURS FOR GMT

Holy Mother Earth

The Earth is a holy book we open and fall into
every day. All the tales of Gaia, Ancient Mother,
life-kindler, miracle-maker are in this Album of
Life, magic elements and spirit born of our sacred planet.

Dear Earth,
your unspeakable
wonders of life—
compassion, abundance,
healing and wisdom—
connect us for
all time.
May our hands
do your work,
even when
we falter.

excerpt
¤ Jennifer Pratt-Walter 2023

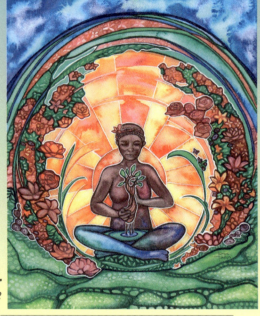

Caretaker
© *Tamara Phillips 2022*

ᚻᚻᚻ Dé Sathairn

 ♈

Saturday
26

☽✶♃ 9:18 am v/c
♂☍♇ 6:05 pm

☉☉☉ Dé Domhnaigh

 ♈
♉

Sunday
27

☽→♉ 12:17 am
☽□♇ 6:16 am
☽□♂ 6:38 am
☽PrG 9:24 am
☉♂☽ 12:31 pm

New Moon in ♉ Taurus 12:31 pm PDT

Happiness Practice

Do you have a Happiness practice?
The world is so thirsty
for your petals of happiness.
In any moment of contentment
(or in the evening
after a full fat day of play),
on your inbreath, smile broad.
Then *hummm* your happiness out,
breath by breath.
Hum your happiness
out to the parched places
where sorrow or violence
have smothered joy with bitterness or fear.
Hum your happiness,
resolutely smiling,
out to corners of crying and despair.
You can do this,
you were born for this,
you who are not in the crossfire
or in the line of refugees along the road.

You forgot you are made of vibrations?
You forgot that energy is real?
Quick! Remember.
Practice happiness every day.
Dedicate your practice
for the merit of all beings.
Hum your happiness out
to the hard, sharp places.
It takes as long as writing a check.
You can do this,
you can make your contribution
to quenching the world's great thirst.

V. BRIMFUL

Moon V: April 27 – May 26

New Moon in ♉ Taurus April 27; Full Moon in ♏ Scorpio May 12; Sun in ♊ Gemini May 20

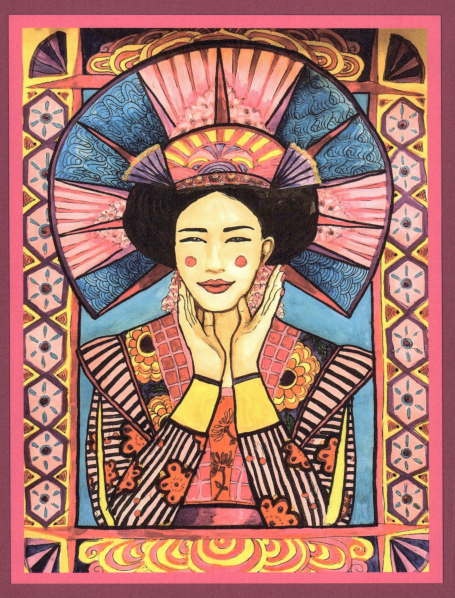

Uzume, Japanese Goddess of Laughter and Joy
© Anna Lindberg Art 2022

April / May

abril / mayo

Through & With

The only way out
is through
The only way home
is with

□ *L. Sixfingers 2023*

─── ☽☽☽ lunes ───

♉
♊

Monday
28

☽ ☌ ♅ 5:33 pm
☽ ✳ ♄ 7:51 pm
☽ ✳ ♀ 10:18 pm v/c
☽ → ♊ 11:34 pm

─── ♂♂♂ martes ───

♊

Tuesday
29

☽ ✳ ♆ 1:14 am
☽ △ ♇ 5:39 am
☽ ✳ ♂ 7:28 am
☽ ✳ ♅ 10:50 pm

─── ☿☿☿ miércoles ───

♊

Wednesday
30

☽ ☌ ♃ 9:58 am
♀ → ♈ 10:16 am
☽ □ ♄ 8:49 pm v/c

─── ♃♃♃ jueves ───

♊
♋

Thursday
1

☽ → ♋ 12:23 am
☽ □ ♀ 12:57 am
☽ □ ♆ 2:14 am
☉ ✳ ☽ 8:45 pm

May
Beltane

─── ♀♀♀ viernes ───

♋

Friday
2

☽ □ ♅ 6:37 am
♀ ☌ ♆ 10:07 am
☽ ✳ ♅ 10:06 pm

─────────────────────────────────

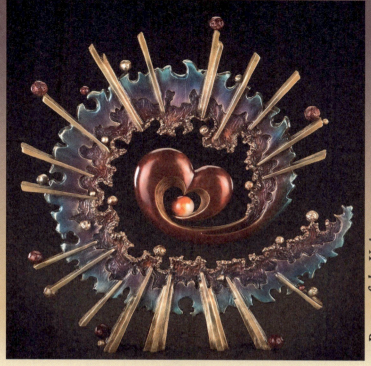

Power of the Universe © Carolyn Sato 2018

Beltane

At Beltane we celebrate the connection between above and below. Rain and Sunshine pour down from the sky to kiss Earth. Together they fertilize the seeds planted in our garden of ideas and intentions. A time of opening. Arms open wide, we dance the wild ecstasy of Earth's fecundity. Throats open, we sing freely. Yonis open like early spring blossoms for us to explore sexual magic. Welcome the Creative Life Force into our growing dreams and manifestations!

As we expand into the waxing light of the sun, we fill with passion. Ignite with joy. Revel in pleasure. Our pulsing hearts become Beltane's fire of purification. We burn away all that no longer serves. We celebrate our right relationships with each other, Earth, and all her creatures. We relish the healing nourishment of our stone friends, our plant allies, the creepy crawlers, the finned, the furred, and the winged ones. Share this sense of deep connection into the world, and help repair the illusion of separation. Embrace all with a curious and open heart.

Mahada Thomas © Mother Tongue Ink 2024

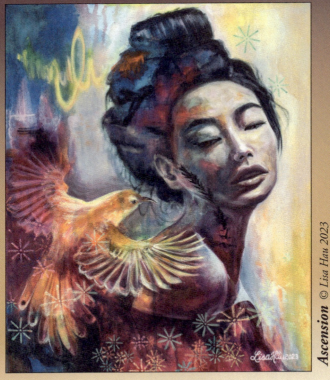

Ascension © *Lisa Hau 2023*

Angel Wings

As if there were a spot
Along the spine where wings would go
Your healing touch smoothed
Gently prodding an open space
Who knew the back of my heart was so clearly labeled
Insert here
An arrow pointed
Connecting earth and sky
Spread wide
Stand tall
You are made whole
I have been wanting wings
Angel muse
You sent me away
Ready for flight

¤ *Jacqueline Lois 2016*

nourished

watery almond eyes
creamy almond thighs
dripping a sweet nutritional milk
carrot and ginger juicy lips
grapefruit & raw sugar exfoliating hips
nourishing sips, avocado dips
crimson red raspberry elixir
drips from your heart center
leafy green let-us wrap
in each other's honey face embrace
a bath tea brew to share with you
sweet vanilla bean, coconut cream
spicy cinnamon stick
euphoric maca root trip
luscious ripe mango
licking flesh from its pit
as we blend, deep, rich
healing green smooth-ease
just breathe

© Tamu Mosley 2023

ħħħ sábado

Saturday
3

☽△♄ 1:02 am v/c	☽△♀ 7:32 am
☽→♌ 4:29 am	☽⚋♇ 11:25 am
☽△♆ 6:36 am	☽♂♂ 5:12 pm

☉☉☉ domingo

Sunday
4

☉□☽ 6:52 am	
℞℞ 8:27 am	
☽△♅ 8:14 pm	
☽⚹♃ 9:43 pm	

Waxing Half Moon in ♌ Leo 6:52 am PDT

May
svibanj

I want to fall to my knees
in gratitude, not grief.
Who is to say that grief
has not softened my heart,
a marinade of bittersweet spices
soaking all the way through?
excerpt ©Wendy Brown-Baez 2023

───── ☽☽☽ ponedjeljak ─────

♌︎
♍︎

Monday
5

☽□♅ 6:03 am v/c
☿✶♃ 10:21 am
☽→♍︎ 12:40 pm

───── ♂♂♂ utorak ─────

♍︎
Tuesday
6

♀✶♇ 2:31 pm
☿♂♅ 6:48 pm
☉△☽ 9:50 pm

───── ☿☿☿ srijeda ─────

♍︎
Wednesday
7

☽□♃ 9:30 am
☽△♅ 5:30 pm
☽☍♄ 9:11 pm v/c

───── ♃♃♃ četvrtak ─────

♍︎
♎︎
Thursday
8

☽→♎︎ 12:06 am
☽☍♆ 2:45 am
☽△♇ 7:48 am
☽☍♀ 10:22 am
☽✶♂ 7:07 pm

───── ♀♀♀ petak ─────

♎︎
Friday
9

☽△♃ 11:17 pm v/c

Us All

I stand in the gates of gratitude, unaware of the giver and the given
Blind with my longings, my frettings, my "What if-ings."

Who am I,
Spirits of the Universe,
To have such as these?
Love.
Life.
Shelter.
Warmth of touch.
Companionship.
Want that is filled each day.

Thy gifts are blinding.

If I were to notice them all
My breath would
Truly be stalled
With wonder at what
Is flowing in the world
Through and to us all.
 □ *Chylene Crow 2018*

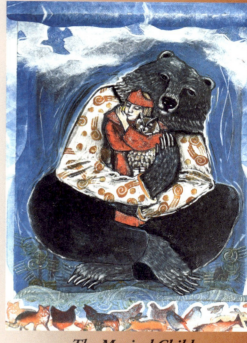

The Magical Child
© *Denise Kester 2023*

ᚻᚻᚻ subota

♎
♏ ◐

Saturday
10

�8→ᛏ 5:15 am
☽→♏ 12:58 pm
☽☌ᛏ 2:15 pm
☽ApG 5:50 pm
☽□♇ 8:42 pm

☉☉☉ nedjelja

♏ ○

Sunday
11

☽□♂ 10:39 am

May
Boishakh

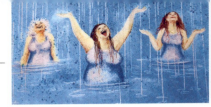

Starting Fresh © *Jakki Moore 2018*

────── ☽☽☽ sombar ──────

 ♏︎

Monday
12

☉☍☽ 9:56 am
☿□♇ 10:23 am
☽☍♅ 7:35 pm
☽△♄ 11:37 pm v/c

Lunar Beltane
Full Moon in ♏︎ Scorpio 9:56 am PDT

────── ♂♂♂ mongolbar ──────

 ♏︎ ♐︎

Tuesday
13

☽→♐︎ 1:35 am
☽△♆ 4:29 am
☽⚹♇ 9:11 am
☽△♀ 7:48 pm

────── ☿☿☿ budhbar ──────

 ♐︎

Wednesday
14

☽△♂ 1:27 am

────── ♃♃♃ brihospotibar ──────

 ♐︎ ♑︎

Thursday
15

☽☍♃ 1:54 am
☽□♄ 11:28 am v/c
☽→♑︎ 12:58 pm
☽□♆ 3:55 pm

────── ♀♀♀ sukrobar ──────

 ♑︎

Friday
16

☽△♅ 10:29 am
☽□♀ 10:45 am

ALL ASPECTS IN PACIFIC DAYLIGHT TIME; ADD 3 HOURS FOR EDT; ADD 7 HOURS FOR GMT

Drawing Down

I extend my arms and reach towards
the love and light of the moon above
scoring the skyscrapers. I peek
and see her light between the trees of the land
that has welcomed me.

Cradled in the water, her reflection stills my heart
just as she ripples the tides high,
high as she who watches us all.

Selene, Moon Goddess,
Cybele, Great Mother
Inanna, Moon Daughter

I reach
and invite
your power to ignite in me

Gratitude
Is all I am, all I have to say.

And welcome,
if you choose to stay.

© Elyse Welles 2023

─────── ♄♄♄ sonibar ───────

♑
♒

Saturday
17

☉☌♅	4:32 pm	☽✶♄	9:27 pm v/c
☽△♅	5:24 pm	☿□♂	9:36 pm
☉△☽	5:28 pm	☽→♒	10:29 pm
♅ApG	8:08 pm		

─────── ☉☉☉ robibar ───────

♒

Sunday
18

☽✶♆	1:27 am
☽☌♇	5:34 am
♃✶⚷	6:44 am
☽✶♀	11:18 pm

May
Mí Bealtaine

Monday
19

☽☌♂ 1:23 am
☽□♅ 5:00 am
☽△♃ 9:13 pm

Tuesday
20

☽□♅ 12:53 am
☉⚹♄ 2:38 am
☉□☽ 4:59 am v/c
☽→♓ 5:28 am
☉→♊ 11:54 am

Waning Half Moon in ♒ Aquarius 4:59 am PDT
Sun in ♊ Gemini 11:54 am PDT

Wednesday
21

☽⚹♉ 7:20 pm

Thursday
22

♀△♂ 12:41 am ☽→♈ 9:25 am
☽□♃ 2:27 am ☽☌♆ 12:15 pm
☽⚹♅ 5:19 am ☉⚹☽ 12:42 pm
☉⚹♆ 5:40 am ☽⚹♇ 3:42 pm
☽☌♄ 9:06 am v/c

Friday
23

☽△♂ 1:13 pm
☽☌♀ 2:13 pm

2025 Year at a Glance for ♊ Gemini (May 20–June 20)

How you handle yourself during 2025 will set the foundation for developing your career or future collaborations. With Venus applying an exact conjunction to Neptune on the weekend of January 31st, then to the North Node of Fate the next day on February 1st, you will experience opportunities to actualize your desired image—if you practice self-preservation. This year, make necessary cuts and breakups for your personal development. Having the confidence to recognize that you need to surround yourself with only kind and respectful people will support your long-term goals. To achieve all you desire, be sure to review your intentions optimistically. Sometimes, we can fall into the habit of excitedly taking notes on all of our dreams, ideas, and whimsical ideas, only to neglect our focus. Gemini, support your goals and manifest your desires by reviewing your work! Each doodle, sketch, and quote you pencil into your journal is your labor of love. For whatever reason, you love your objective enough to believe it deserves to be pursued. Whether social justice, personal peace, or self-care, permit yourself to cringe at your past inner workings. Looking back can be a humbling experience. Recognizing how far away we are from where we want to be can feel highly uncomfortable, which is precisely why we must constantly reflect on how much we have grown—this is part of respecting the process. You must walk down memory lane to fully appreciate your development and show appreciation for where you are on the Growing Edge now.

Monisha Holmes © Mother Tongue Ink 2024

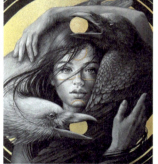

Paradox *© Autumn Skye 2022*

───── ♄♄♄ Dé Sathairn ─────

♈
♉

Saturday
24

☾⚹♃ 4:44 am v/c
☉△♇ 8:55 am
☾→♉ 10:38 am
♀☌♅ 4:15 pm
☾□♇ 4:36 pm
♄→♈ 8:35 pm

───── ☉☉ Dé Domhnaigh ─────

♉

Sunday
25

☾□♂ 3:06 pm
☿→♊ 5:59 pm
☾PrG 6:21 pm
☿⚹♄ 6:45 pm

The Peace Process is Like Making a Basket

The Peace process is like making a basket. Beginning in the middle of the discord, the first weavers have been procured and prepared. It needs to begin, and this is the hardest part. Patience is needed. Intention to understand facilitates the hands to create the center. At the heart of the basket is the interdependence of all things. Nature provides the materials for this basket project, and it teaches us that we need each other to survive.

The plants and trees which interact with air, water, sun and soil exemplify this knowing. Coiled into this knowing is respect for all and to do no harm.

Mutuality to come together will create a strong, beautiful basket. The spokes speak of the promise of solidarity and unity. The interconnectedness with others influences the integrity of the whole of this basket.

Begin with olive branches, mythological symbols of peace and mutual cooperation. They are not the most pliable choice but peace making isn't easy either. The Basket Maker imbues the basket with a prayer for negotiation, agreement and an end to conflict. She weaves in strands of respectful dialogue, cooperation, self care, trust building, healthy boundaries and de-escalation if necessary for all involved. Interweavings of kindness and understanding embellish the aesthetics.

The center of the basket may not be perfect, but a basket of peace has begun.

excerpt ¤ Diane Suzuki 2023

VI. WEAVING HARMONIES

Moon VI: May 26–June 25

New Moon in ♊ Gemini May 26; Full Moon in ♐ Sagittarius June 11; Sun in ♋ Cancer June 20

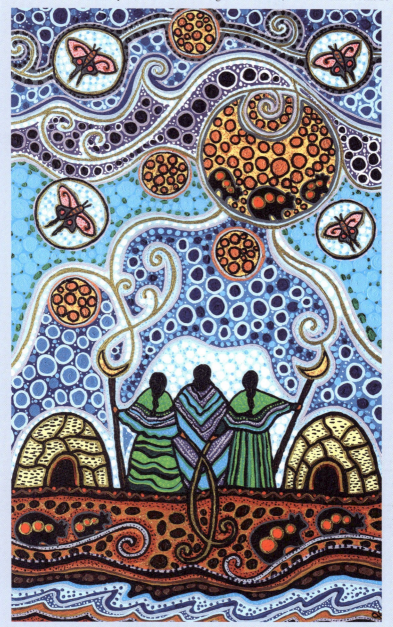

Moon Lodge Prayer © *Leah Marie Dorion 2020*

May / June
mayo / junio

━━━━━━ ☽☽☽ lunes ━━━━━━━━━━━━━━━━━━━━━━━━

♉
♊

Monday
26

☽♂♅	6:52 am v/c
☽→♊	10:21 am
☽✶♄	10:32 am
☽♂☿	1:05 pm

☽✶♆	1:09 pm
☿✶♆	1:37 pm
☽△♇	4:14 pm
☉♂☽	8:02 pm

New Moon in ♊ Gemini 8:02 pm PDT

━━━━━━ ♂♂♂ martes ━━━━━━━━━━━━━━━━━━━━━━

♌

Tuesday
27

☿△♇	10:56 am
☽✶♂	4:34 pm
☽✶♀	8:21 pm

━━━━━━ ☿☿☿ miércoles ━━━━━━━━━━━━━━━━━━━━

♌
♋

Wednesday
28

☽♂♃	6:01 am v/c
☽→♋	10:33 am
☽□♄	10:58 am
☽□♆	1:30 pm

━━━━━━ ♃♃♃ jueves ━━━━━━━━━━━━━━━━━━━━━━━

♋

Thursday
29

☿ApG	6:52 am
☉♂☿	9:13 pm

━━━━━━ ♀♀♀ viernes ━━━━━━━━━━━━━━━━━━━━━━

♋
♌

Friday
30

☽□♀	1:45 am
☽✶♅	9:50 am v/c
☽→♌	1:16 pm
☽△♄	2:00 pm
☽△♆	4:31 pm
☽☍♇	7:43 pm

ALL ASPECTS IN PACIFIC DAYLIGHT TIME; ADD 3 HOURS FOR EDT; ADD 7 HOURS FOR GMT

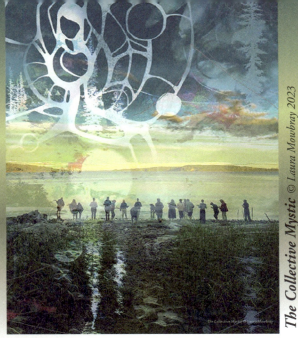

The Collective Mystic © Laura Mowbray 2023

The Power of Women's Circles

I want to live in a world where women support each other and lift each other up, a world where we know there is enough for us all and we can help each other to find what we need. Gathering in women's circles is one of the most important stepping stones on the path to that world.

excerpt © Kaitlin Ilya Wolf 2022

ᚻᚻᚻ sábado

♌

Saturday
31

⊙⚹☽ 7:46 am
☽⚹☿ 11:38 am

⊙⊙⊙ domingo

♌
♍

Sunday
1

June

☽☌♂ 3:41 am
☽△♀ 11:52 am
♀☌♇ 1:11 pm

☽□♅ 4:32 pm
☽⚹♃ 4:38 pm v/c
☽→♍ 8:00 pm

June
lipanj

♍

Monday
2

☉□☽ 8:41 pm

Waning Half Moon in ♍ Virgo 8:41 pm PDT

♍

Tuesday
3

☽□☿ 8:23 am

♍
♎

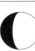

Wednesday
4

☽△♅ 3:14 am
☽□♃ 4:11 am v/c
☽→♎ 6:38 am
☽☍♄ 8:04 am
☽☍♆ 10:30 am
☽△♇ 1:52 pm
♀⚹♃ 7:32 pm

♎

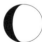

Thursday
5

☉△☽ 1:46 pm
☿⚹♂ 3:10 pm
♀→♉ 9:42 pm

♎
♏

Friday
6

☽⚹♂ 7:19 am
☽△☿ 9:56 am
☿⚹♄ 4:55 pm
☽△♃ 6:04 pm v/c
☽→♏ 7:23 pm
☽☍♀ 9:22 pm

ALL ASPECTS IN PACIFIC DAYLIGHT TIME; ADD 3 HOURS FOR EDT; ADD 7 HOURS FOR GMT

Potent Marvels

If you are looking for a hopeful sign among the
crumbling dissonant experiences of humans
on this Earth, I can tell you this: every year,

tempting tiny violets bloom in abundance on
my green lawn. The solemn hum of winter takes
backstage, and it feels like long gone friends
have reappeared from languid lost years.

Nature has a way, nature is this way, as more foliage
emerges and marks rotational transitions of time—

Just as friends materialize when all seems bleak
and you didn't realize how much you needed them.

A flower will even bloom in between the cracks
of pavement. What a marvel to know the potent medicine
 of flowers.

 What a lesson it is to receive
 without guilt.

© Helen N Hill 2023

────────── ♄♄♄ subota ──────────

♏

Saturday
7

)□P 2:37 am
)ApG 3:43 am

────────── ☉☉☉ nedjelja ──────────

♏

Sunday
8

♉☌♃ 1:12 pm
☿→♋ 3:58 pm
)□♂ 10:57 pm

June
Joishtho

Monday
9

☿□♄	3:48 am
☽⚹♅	5:06 am v/c
☽→♐	7:55 am
☽△♄	9:56 am
♀□♇	10:20 am

☽△♆	11:55 am
♃→♋	2:02 pm
☽⚹♇	2:57 pm
☿□♆	3:54 pm

———— ♂♂♂ mongolbar ————

Tuesday
10

♂△⚳	12:36 am
☿⊼♇	10:13 am

———— ☿☿☿ budhbar ————

Wednesday
11

☉⚹☽	12:44 am
☿⚹♀	12:41 pm
☽△♂	12:58 pm v/c
☽→♑	6:55 pm
☽⚹♃	7:54 pm
☽□♄	9:07 pm
☽□♆	10:51 pm

———— ♃♃♃ brihospotibar ———— Full Moon in ♐ Sagittarius 12:44 am PDT

Thursday
12

☽△♀	7:22 am
☽⚹☿	8:56 am

———— ♀♀♀ sukrobar ————

Friday
13

No Exact Aspects

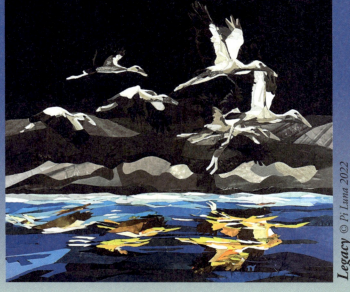

Legacy © Pi Luna 2022

Forgiveness

Forgiveness is letting go of perceptions that divide us. The hardened shell of separation cracks open. We have created invisible prisons of self-importance that we can only see once we are free.

The truth is, we cannot be divided from our indivisible nature. We created the mind that dreamt up the world of differences, flying solo in the sadness of searching for what we already have. Forgiveness is taking flight with many wings all at once—like the phenomenon of thousands of Starlings intricately forming patterns as One.

excerpt © Maasa Craig 2023

───────── ♄♄♄ sonibar ─────────

♑
♒

Saturday
14

☽△♅	1:51 am v/c	☽⚹♆	7:51 am
☽→♒	4:00 am	☽☌♇	10:27 am
☽⚹♄	6:21 am	☽□♀	8:57 pm

───────── ☉☉☉ robibar ─────────

♒

Sunday
15

| ♂□♅ | 2:47 am |
| ♃□♄ | 7:36 am |

Summer Solstice

Oh, Radiant and Glorious Sun! Illuminate my body, mind, soul. Show us how to bloom where we are planted. Bless our seeds of growth and change. Help us to be whole, and we will rise like you, in full Glory.

Time speeds as summer calls us to action. Much work has been done; we can expect more when flower becomes fruit. In our busy-ness, make space for sacred pause. Allow yourself to stop, simply to Be. Bask in the moment. Harness Sun's energy to fuel the activities ahead.

Expand in summer; contemplate a Higher Consciousness. Keep faith. Pray for rain where there is drought. Pray to temper the wild fires. Pray over your gardens. Pray for the salmon. Pray for the waters of the world. Pray for the suffering. Pray for peace. Your prayers are compassion in action. We have the power to direct the storm, focusing our energy for the Highest Good.

Welcome Sun into your heart to ignite Inner Light. Shine on SiStars. The world needs your unique, radiant Beauty.

Mahada Thomas © Mother Tongue Ink 2024

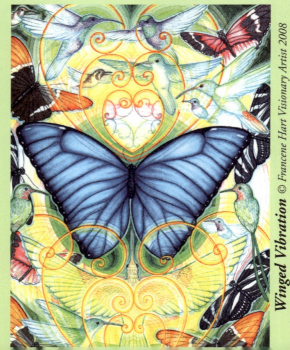

Winged Vibration © Francene Hart Visionary Artist 2008

Butterfly

Today I saw a butterfly
her blue speckled wings
glistened in the sunlight
the magic
of her metamorphosis
danced around
in the winds.

She flew over the sagebrush
and landed on red sandy soil
resting awhile
opening and closing
her wings
a silent rhythmic drumbeat
sending wave after wave
of the knowledge she holds
about naturally transforming.

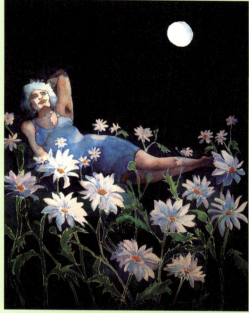

Moon Bathing *© Jakki Moore 2023*

Today I am following the path of the butterfly
together we can join the dance of the butterflies
in passionate pursuit of the becoming
of all we are here to be
creating sacred space for transformation
sheltering, dissolving, dismantling what has been
knitting fibers of connection
shaping new forms, reweaving the web of life
within us, between us, and all around.

When it is time
according to our inner knowing, our ancestors and lineages
and the wisdom living in the earth and the stars
we'll open the doorway, step through the threshold
warm our wings in the sun and fly
into the magic of our own metamorphosis
into a beautiful, loving world
beyond our wildest dreams.

excerpt © JoAnne Dodgson 2020

June
Mí Meitheamh

——— ꬉꬉꬉ Dé Luain ———

Monday
16

☉△☽ 3:02 am
☽□♅ 9:18 am
☽☍♂ 10:30 am v/c
☽→♓ 11:08 am
☽△♃ 2:01 pm

——— ♂♂♂ Dé Máirt ———

Tuesday
17

☉⚹⚷ 12:16 am
♂→♍ 1:35 am
☽⚹♀ 8:02 am
☽△♅ 5:09 pm

——— ☿☿☿ Dé Céadaoin ———

Wednesday
18

☉□☽ 12:19 pm ☽□♃ 7:45 pm
☽⚹♅ 2:34 pm v/c ☽☌♆ 7:46 pm
☽→♈ 4:08 pm ♃□♆ 8:16 pm
☽☌♄ 6:38 pm ☽⚹♇ 9:57 pm

Waning Half Moon in ♓ Pisces 12:19 pm PDT

——— ♃♃♃ Dé Ardaoin ———

Thursday
19

♂⚼♄ 5:08 pm

——— ♀♀♀ Dé Haoine ———

Friday
20

☽□♅ 3:32 am
☉⚹☽ 6:49 pm v/c
☽→♉ 6:53 pm
☉→♋ 7:42 pm
♂⚼♆ 8:14 pm
☽△♂ 10:29 pm
☽⚹♃ 11:10 pm

Summer Solstice

☉→♋

Sun in ♋ Cancer 7:42 pm PDT

All aspects in Pacific Daylight Time; add 3 hours for EDT; add 7 hours for GMT

2025 Year at a Glance for ♋ Cancer (June 20–July 22)

Who is taught how to break up? At best, some of us are taught how to formally resign from jobs that no longer align with our paths. Or we may take notes from elders on gracefully transitioning from one stage of life to another. Most of us flip, flop, and fumble over rocks and hard places. You may have been slamming cheeks to the pavement and landing in challenging areas despite attempts to glide into softness. The hardest part about endings is having to experience tough breakups, practicing "goodbyes" and "I'm sorry" as if becoming fluent in conclusions makes them any easier. Planet of transformation, Pluto, solidly in Aquarius for twenty years as of November 19th, 2024, marks the beginning of a year-long dedication to deciding who does or does not get access to you. The pay-off for powering through less-than-ideal experiences is that once you learn how to advocate for yourself, you will always recognize you are worth taking a chance on. Change is always risky. Will there be a better opportunity? Someone who will be better aligned? Will you be able to manage in a new paradigm? Once you learn to jump out of the nest of comfort, flying will begin to feel like second nature. The first half of 2025 may feel like a bit of a skydive. Even if you can see land at the bottom, it does not mean that stepping off the edge becomes easier. As the year shifts into summer and fall, allow yourself to trust the process.

Monisha Holmes © Mother Tongue Ink 2024

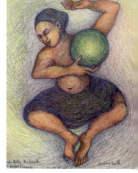

Healing Earth
© Marla Faith 2021

───── ♄♄♄ Dé Sathairn ─────

♉

Saturday
21

D□P 12:24 am
D♂♀ 10:02 pm

───── ☉☉☉ Dé Domhnaigh ─────

♉
♊

Sunday
22

♂⚹♃ 3:32 am DPrG 9:35 pm
D⚹♅ 10:44 am ♂⽊P 10:00 pm
☉□♄ 11:36 am D⚹♄ 10:33 pm
D♂♅ 6:50 pm v/c D⚹♆ 11:25 pm
D→♊ 7:57 pm

Forest Floor

Oh, I long for the unlandscaped life. Enough of these spaces that leave me craving substance, sustenance, and nourishment. That every two weeks have their potential medicine and spirit trimmed, cut, and mowed in the name of "manicured." I need that natural beautiful, bushy overgrown mess, organic realness with all constructive and deconstructive components accounted for. I need natural life-cycles and the proof of it. I like blood, mud, sticks and stones. Cobwebs are sparkling and shimmering if you look at them the right way. Decaying, damp wood and engorged grubs and fluorescent flower buds and a hummingbird's glittering throat and crystalline dewdrops all shoved onto the same square foot of mossy forest floor. They want to say it's juxtaposition but it's anything but! Life and death are supposed to live that close together.

© Kiley Saunders 2023

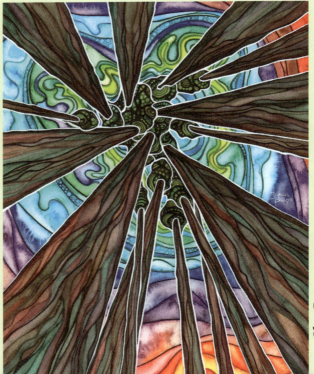

Sky Grove © *Tamara Phillips 2022*

VII. THE WILD

Moon VII: June 25–July 24

New Moon in ♋ Cancer June 25; Full Moon in ♑ Capricorn July 10; Sun in ♌ Leo July 22

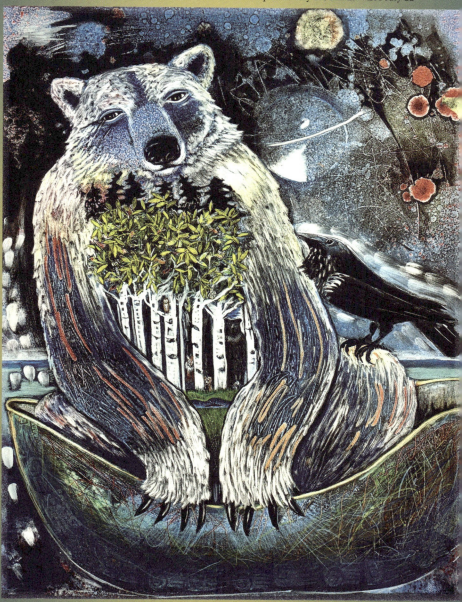

Bear and Raven in Mind © Denise Kester 2019

June
junio

─── ☽☽☽ lunes ───────────

♊

Monday
23

☽△♇ 1:18 am
☽□♂ 1:26 am v/c
☉□♆ 1:29 am
♃⊼♇ 11:16 pm

─── ♂♂♂ martes ───────────

♊
♋

Tuesday
24

☿□♄ 12:16 am
☉⊼♇ 5:59 am
☉♂♃ 8:17 am
☽→♋ 8:44 pm
☽□♄ 11:28 pm

─── ☿☿☿ miércoles ───────────

♋

Wednesday
25

☽□♆ 12:16 am
☽♂♃ 2:33 am
☉♂☽ 3:32 am
☽✳♂ 4:17 am

─── ♃♃♃ jueves ─────────── New Moon in ♋ Cancer 3:32 am PDT

♋
♌

Thursday
26

☿✳♅ 2:45 am
☉✳♂ 7:11 am
☽✳♀ 8:08 am
♃ApG 9:08 am
☿→♌ 12:09 pm
☽✳♅ 10:16 am v/c
☽→♌ 11:05 pm

─── ♀♀♀ viernes ───────────

♌

Friday
27

☽♂☿ 12:13 am
☽△♄ 2:04 am
☽△♆ 2:49 am
☽☍♇ 4:39 am
☿△♄ 8:52 pm

─────────────────────────

ALL ASPECTS IN PACIFIC DAYLIGHT TIME; ADD 3 HOURS FOR EDT; ADD 7 HOURS FOR GMT

I like my women how I like the ocean,
Unwavering and deep, full of folklore and secrets
Only decipherable by a mystic's tongue
Flowing and crashing
Wave after wave of emotional ecstasy.

I like my women
how I like the mountains,
Unapologetically
taking up space,
Stable yet crawling with life,
Unfarmed and uncultivated.

I like my women how I like me,
Authentically and achingly true
Whole-heartedly intuitive
Bravely savoring life
Faithful to divine timing
Thirsty for the moon light
Dripping with the sun's glow
Relentlessly manifesting
dreams into reality,
Wild, untamed, and free.

excerpt © Alia Alsaif Spiers 2023

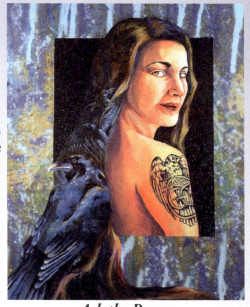

Ask the Raven
© Melissa Stratton Pandina 2009

ħħħ sábado

♌

Saturday
28

☿△♆ 4:58 am
☽□♀ 5:23 pm

⊙⊙⊙ domingo

♌
♍

Sunday
29

♅♂♇ 12:57 am ☽⚹♃ 1:13 pm
☽□♅ 4:03 am v/c ☽♂♂ 6:14 pm
☽→♍ 4:43 am ⊙⚹☽ 8:54 pm

June / July
lipanj / srpanj

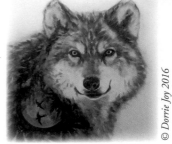

© Dorrie Joy 2016

Wolf in Motherwort

————— ☽☽☽ ponedjeljak —————

 ♍

Monday
30

No Exact Aspects

————— ♂♂♂ utorak —————

 ♍ ♎

Tuesday
1

July

☽△♀ 7:43 am
☽△♅ 1:46 pm v/c
☽→♎ 2:16 pm
☽☍♄ 5:53 pm
☽☍♆ 6:34 pm
☽△♇ 8:27 pm

————— ☿☿☿ srijeda —————

 ♎

Wednesday
2

☽□♃ 12:25 am
☽⚹☿ 3:29 am
☉□☽ 12:30 pm v/c

————— ♃♃♃ četvrtak —————

Waxing Half Moon in ♎ Libra 12:30 pm PDT

 ♎

Thursday
3

No Exact Aspects

————— ♀♀♀ petak —————

 ♎ ♏

Friday
4

☽→♏ 2:33 am
♀♂♅ 5:45 am
♀→♊ 8:31 am
☽□♇ 8:46 am
☽△♃ 2:06 pm

♆R 2:33 pm
☽ApG 7:22 pm
☽□☿ 9:29 pm
☽⚹♂ 11:20 pm

ALL ASPECTS IN PACIFIC DAYLIGHT TIME; ADD 3 HOURS FOR EDT; ADD 7 HOURS FOR GMT

Keen

No metaphors here; wolves are wolves.
A cracking twig announces the mother's presence.
Her progress parts branches. She trots out onto
the shore grass and sea asparagus,
in her mouth a black wing on its hinge of red gore.
Her fur ripples in patches of grey, black and ginger.
There is a perk in her step—
she is travelling back to her pups, successful.
She crosses the creek, enters the forest.
I can no longer see her, and I scour
every bird guide to know whose wing she carried.
Sooty grouse or raven but I'll never know, not really.
That night the whole pack troops back
over the shore rocks, pups whisper-whining
in the near-dark, their first time
back across the creek and over softer land, so much of it,
and long, long may it be so.
From a distance, the howling rises:
the pups yipping and yelping their keen
instincts and heritage, voices of family,
song of survival,
for the moment
sated and unafraid.

□ *Christine Lowther 2023*

ħħħ subota

♏ Saturday
5

☉△☽ 6:29 am

☉☉ nedjelja

♏
♐ Sunday
6

♀✶ħ 1:43 am ☽△ħ 6:54 pm
♀✶Ψ 7:46 am ☽△Ψ 7:26 pm
☽☌♅ 3:04 pm v/c ☽☌♀ 8:37 pm
☽→♐ 3:06 pm ☽✶♇ 9:06 pm

July
Asharh

Monday
7

♅→♊ 12:45 am
♀△♇ 1:44 am
☽△♅ 2:00 pm
☽□♂ 2:29 pm v/c

Tuesday
8

No Exact Aspects

Wednesday
9

☽→♑ 1:55 am
☽□♄ 5:36 am
☽□♆ 6:04 am
☽☍♃ 2:59 pm

Thursday
10

☽△♂ 3:11 am
☉☍☽ 1:37 pm v/c

Full Moon in ♑ Capricorn 1:37 pm PDT

Friday
11

☽→♒ 10:21 am
☽△♅ 10:42 am
☽⚹♄ 1:55 pm
☽⚹♆ 2:20 pm
☽♂♇ 3:41 pm

ALL ASPECTS IN PACIFIC DAYLIGHT TIME; ADD 3 HOURS FOR EDT; ADD 7 HOURS FOR GMT

What the rain in the desert is trying to tell you

Everything is allowed to thirst, even those of us most drought-adapted, shallow dreams parched like cactusroots, stretched out radicle, begging for scraps. We have made our bodies homes for birds, our fruits enjambed. Each day I offer this hollow trunk for drinking, a reservoir of self, because I know what is eventually coming—slowdown. The desert quail sip from flooding patios, rain rush arroyos fill cisterns, river down the waiting channels like oxygenated blood.

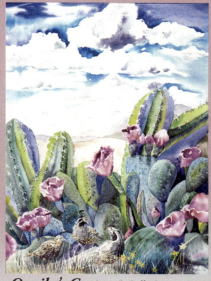

Quail & Cactus © *Sally Snipes 2013*

So you must prepare for it, lay all the dryrocks, your oldbones. Name them tender names. Impossible to predict when living water comes. Invisible seeds anticipate flower colors you have no name for, just movement—the dance a joyful creature makes when life is short in season. In the sand, trace their shapes, your bruised fingers, your bitdown nails, beewing, butterfly, hummingbird treasure hoard. The clouds gather hopeful shadows on the long horizon.

Make ready, they say; make ready and wait.

□ Katherine Hagopian Berry 2023

ᚺᚺᚺ soŋibar

♒ ○ **Saturday**
12

☽△♀ 2:07 am
☽☍☿ 12:45 pm v/c
♄R 9:07 pm

⊙⊙ robibar

♒ ○ **Sunday**
♓ **13**

☽→♓ 4:45 pm
☽□♅ 5:15 pm

July
Mí Iúil

---------- ☽☽☽ Dé Luain ----------

♓ ## Monday
14

☽△♃ 6:46 am
☽□♀ 12:53 pm
☽☍♂ 9:15 pm

---------- ♂♂♂ Dé Máirt ----------

♓
♈ ## Tuesday
15

☉△☽ 10:09 am v/c
☽→♈ 9:32 pm
☽✶♅ 10:11 pm

---------- ☿☿☿ Dé Céadaoin ----------

♈ ## Wednesday
16

☽♂♄ 12:53 am
☽♂♆ 1:15 am
☽✶♇ 2:23 am
☽□♃ 12:02 pm
☽✶♀ 9:44 pm

---------- ♃♃♃ Dé Ardaoin ----------

♈ ## Thursday
17

☽△♅ 12:21 am
☉□☽ 5:37 pm v/c
☿R 9:45 pm

Waning Half Moon in ♈ Aries 5:37 pm PDT

---------- ♀♀♀ Dé Haoine ----------

♈
♉ ## Friday
18

☽→♉ 12:58 am
☽□♇ 5:38 am
☿✶♀ 6:37 am
☽✶♃ 3:57 pm

ALL ASPECTS IN PACIFIC DAYLIGHT TIME; ADD 3 HOURS FOR EDT; ADD 7 HOURS FOR GMT

Save These Things Forever

Save the smallest
wild things,
the overlooked
ordinary things—
earthworms, baby birds,
moss, deep soil.
Hold safe the green-brown smell
of the woods in spring and fall.
Save Sequoias and their birdsongs.
Keep safe the salamanders
in the stream that leaks from
the hillside by my childhood home,
save their eggs, silent as pebbles.
Enfold with safety the magic lanterns of fireflies,
save the aurora borealis and how my feet sound
sweeping through dry leaves in autumn.
Keep forever the voices of those beloved to me—
save all the unspoken love that overflows the
bucket of my heart.
Save always the sharp awe that envelops me when
in the presence of the still and untamed beings.

Passion Flower with Bees
© Margriet Seinen 2017

□ *Jennifer Pratt-Walter 2023*

ᚻᚻᚻ Dé Sathairn

♉

Saturday
19

☽□☿ 3:08 am
☉□♇ 5:48 am
☽△♂ 8:36 am
☉⚹☽ 11:43 pm v/c

☉☉☉ Dé Domhnaigh

♉
♊

Sunday
20

☽→♊ 3:22 am
☽♂♅ 4:15 am
☽⚹♄ 6:31 am

☽⚹♆ 6:53 am
☽PrG 6:55 am
☽△♇ 7:52 am

July

julio

Monday
21

☽⚹☿ 4:36 am
☽☌♀ 11:23 am
☽□♂ 12:52 pm v/c

━━━━━━━ ♂♂♂ martes ━━━━━━━

♊
♋

Tuesday
22

☽→♋ 5:26 am
☉→♌ 6:29 am
♇PrG 7:20 am
☽□♄ 8:33 am
☽□♆ 8:57 am
☽☌♃ 9:56 pm
☉⚹♅ 10:32 pm

☉→♌

Sun in ♌ Leo 6:29 am PDT

━━━━━━━ ☿☿☿ miércoles ━━━━━━━

♋

Wednesday
23

♀□♂ 1:23 am
☽⚹♂ 5:42 pm v/c

━━━━━━━ ♃♃♃ jueves ━━━━━━━

♋
♌

Thursday
24

☉△♄ 4:23 am ☽△♆ 12:04 pm
☽→♌ 8:28 am ☉☌☽ 12:11 pm
☽⚹♅ 9:40 am ☽☍♇ 12:59 pm
☉△♆ 10:31 am ☉☍♇ 11:33 pm
☽△♄ 11:38 am

New Moon in ♌ Leo 12:11 pm PDT

━━━━━━━ ♀♀♀ viernes ━━━━━━━

♌

Friday
25

☽☌☿ 7:58 am

ALL ASPECTS IN PACIFIC DAYLIGHT TIME; ADD 3 HOURS FOR EDT; ADD 7 HOURS FOR GMT

2025 Year at a Glance for ♌ Leo (July 22–Aug 22)

Keep your senses keen, Leo. You may not have access to the full potential of all human perception. However, for the senses you can access, you must strengthen them. Mindfulness, meditation, and forest bathing are all methods of tapping into your inner beast. Despite the connotations associated with embracing your animalistic nature, 2025 is much more about becoming in tune with your instincts. When you learn how to breathe, when to rest, and why you get nervous, you can trust your intuition more confidently. Try your best to refrain from gaslighting yourself. What you think might be overthinking or thinking of the worst may be your past informing the future. Naturally, it is always worth taking a moment to assess how bias may inform your decisions. Fear can misinform you in detrimental ways. However, if you are evaluating the landscape and still sense there is reason for caution, then, by all means, be cautious! 2025 will bring you plenty of new experiences with unfamiliar faces, especially on January 21ˢᵗ, when Pluto and the Sun make an exact conjunction.

Just because someone looks friendly does not mean they have your best interests at heart, just as an unusual face is not inherently dangerous. Sure, the world is changing and may feel a bit wild and out of control—embrace change and trust that life does not need to stay the same.

Monisha Holmes © Mother Tongue Ink 2024

ꜧꜧꜧ sábado

♌
♍

Saturday
26

☽⚹♀ 4:02 am v/c
☽→♍ 1:55 pm
☽□♅ 3:20 pm

Wild Wolf Medicine
© Avalana Levemark 2020

☉☉☉ domingo

♍

Sunday
27

☽⚹♃ 9:57 am

The Promise

Oh, sweet moon, symbol of resilience!
You remind me to trust.
No matter how many times my heart breaks
I will repair.
No matter the disappointments
I will revive.
No matter the outrageous acts of destruction
and devastation and hatred
I will grow bigger and brighter
until my brilliant light illuminates
the path to
Healing.
Redemption.
Caring.
Truth.
Compassion.
The dark is here . . .
but the light will return.
It cannot be stopped.

excerpt © Bayla B Greenspoon 2021

VIII. HARVEST OF HEALING

Moon VIII: July 24–August 22

New Moon in ♌ Leo July 24; Full Moon in ♒ Aquarius August 9; Sun in ♍ Virgo August 22

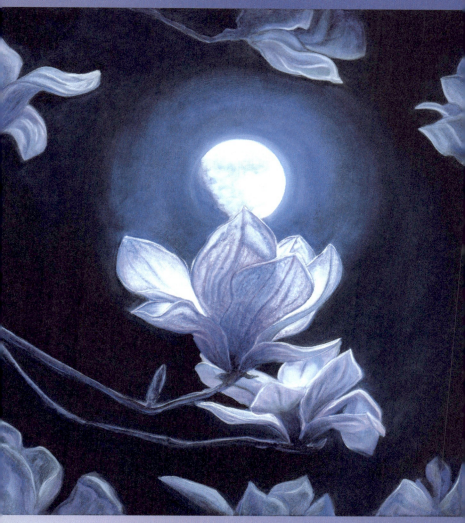

Magnolia Moon © *Rachel Cruse 2023*

July / August
srpanj / kolovoz

Monday
28

♀⚹♄ 9:55 am
☿PrG 9:59 am
☽♂♂ 11:43 am
☽□♀ 5:57 pm v/c
☽→♎ 10:43 am

Tuesday
29

☽△♅ 12:21 am
☽⚻♄ 2:04 am
☽⚻♆ 2:39 am
☽△♇ 3:35 am
☉⚹☽ 12:17 pm
☽⚹♅ 7:12 pm
☽□♃ 8:59 pm v/c

Wednesday
30

♄R 5:44 am
♀→♋ 8:57 pm

Thursday
31

☽→♏ 10:25 am
☽△♀ 11:52 am
☽□♇ 3:20 pm
☉♂♅ 4:41 pm

Friday
1

☽□♅ 3:56 am
☉□☽ 5:41 am
♀□♄ 6:34 am
☽△♃ 10:25 am
☽ApG 1:44 pm
♀□♆ 1:48 pm
♀⚹♇ 10:45 pm

August

Waxing Half Moon in ♏ Scorpio 5:41 am PDT

ALL ASPECTS IN PACIFIC DAYLIGHT TIME; ADD 3 HOURS FOR EDT; ADD 7 HOURS FOR GMT

Lammas

Benevolent and bountiful Pacha Mama sustains life. Her natural state overflows with abundance. She teaches us to give without judgment or conditions. She freely sacrifices her fruit and offers herself to feed our bodies. We honor her as we receive the gifts of harvest.

At Lammas we get a taste of Goodness yet to come. And we sit with uncertainty and vulnerability. As Sun begins to wane, we have high hopes for our crops to yield in soil and in Spirit. Spring's green is now gold, and we feel summer slipping away. Roll up the sleeves and do the work. Collect seeds for the future, preserve, freeze, dry, share with community.

There is joy in giving and receiving. We contemplate now what grows within us. What is ripe for the picking? A call from Earth Mother beckons all empaths, healers, artists, musicians, and warriors of Love to step up. Share your wisdom, your gifts, and invoke a world where all beings are nourished. It is time to turn this upside-down world, right side up.

Mahada Thomas © Mother Tongue Ink 2024

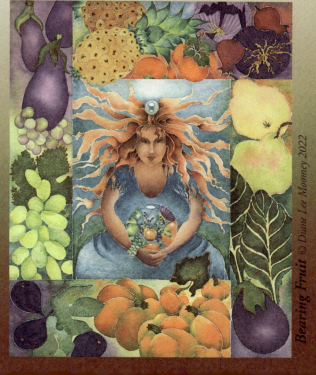

Bearing Fruit © Diane Lee Moomey 2022

Sanctified Farmer

we're like lovers, tossing and turning all night
only we're yearning for rain
to kiss and caress our vegetables
to plump apricots and cherries
for mud between our knee-high corn stalks.
by day we push down seed, sweating.
by night we plan our digging
by the moon's waxing in the right sign.
our intercessors of grace are ladybugs
and honeybees.

with this pail of water, we consecrate
with this pack of seeds, we affirm faith
bees wax candles, our scripture
in this temple called Earth, we bow
as much as we laugh and play.
our daily liturgy, maybe a pile of walnuts
a jumble of pepitas, fresh yogurt from goats
bread kneaded with our own two hands.
all the more we need for nirvana is
a diamond peach, a garnet plum
and the nectar runs like an acapella choir
testifying through our bodies.

© Stephanie A. Sellers 2023

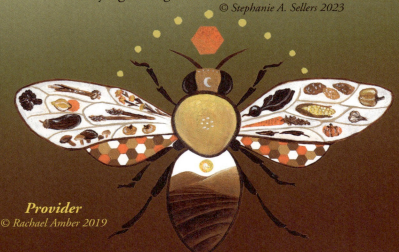

Provider
© Rachael Amber 2019

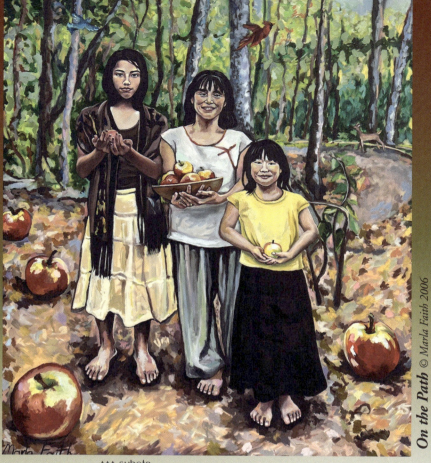

On the Path © Marla Faith 2006

♏︎
♐︎

Saturday
2

Lammas

♂︎⚹♄ 2:25 am
☽⚹♂︎ 6:07 pm v/c
☽→♐︎ 11:00 pm

☉☉☉ nedjelja

♐︎

Sunday
3

☽☍♅ 12:59 am ☽⚹♇ 3:46 am
☽△♄ 2:08 am ☽△♀ 1:00 pm
☽△♆ 2:55 am ☉△☽ 11:12 pm

August
Srabon

Monday
4

No Exact Aspects

Tuesday
5

☽□♂ 8:28 am v/c
☽→♑ 10:04 am
☽□♄ 12:54 pm
☽□♆ 1:44 pm
☽☍♀ 11:38 pm

Wednesday
6

☽☍♃ 10:40 am v/c
♂→♎ 4:23 pm

Thursday
7

☽→♒ 6:18 pm
☽△♂ 7:35 pm
☽△♅ 8:19 pm
☽✶♄ 8:49 pm
☽✶♆ 9:43 pm
☽☌♇ 10:25 pm

Friday
8

☽☍♀ 2:52 am v/c
♂△♅ 11:45 am
♂☍♄ 7:52 pm

ALL ASPECTS IN PACIFIC DAYLIGHT TIME; ADD 3 HOURS FOR EDT; ADD 7 HOURS FOR GMT

A New Movement

I am a mountain
A mountain that moves
And the wounds of time
Sculpt me
Into the shape of Great Spirit
Look at me
More beautiful each day
And each year
My friend, the water
Came to me one day
Said, Mountain, you should move
Show them steadfastness in motion
And I said, Okay
I move for those who've forgotten
Movements require inner peace
I move for those who've dug in their heels
Too deep for too long
It's a new era now, time to sing a new song
I am not weary. I am not worn
I am wondrous and wonderful
I am a moving mountain
I am joy!

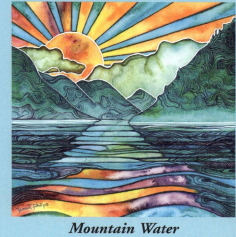

Mountain Water
© Tamara Phillips 2022

© Robin Bruce 2022

─────── ᚺᚺᚺsonibar ───────

≈
ℋ
Saturday
9

Lunar Lammas

☉☌☽ 12:55 am v/c
♂☍♆ 3:13 pm
☽→ℋ 11:50 pm

Full Moon in ≈ Aquarius 12:55 am PDT

─────── ☉☉☉ robibar ───────

ℋ
Sunday
10

☽□♅ 1:52 am
♂△♇ 5:29 am
☽△♀ 10:11 pm
☽△♃ 11:55 pm v/c

August
Mí Lúnasa

━━━ ⋆⋆⋆ Dé Luain ━━━

♓

Monday
11

ŏD 12:30 am
ħ⚹♅ 8:32 pm
♀♂♃ 10:30 pm

━━━ ♂♂♂ Dé Máirt ━━━

♓
♈

Tuesday
12

☽→♈ 3:33 am
☽♂ħ 5:34 am
☽⚹♅ 5:36 am
☽♂♆ 6:36 am
☽⚹♇ 7:14 am
☽☌♂ 9:38 am
☽△ŏ 10:59 am

━━━ ☿☿☿ Dé Céadaoin ━━━

♈

Wednesday
13

☽□♃ 3:51 am
☽□♀ 6:03 am
☉△☽ 3:54 pm v/c

━━━ ♃♃♃ Dé Ardaoin ━━━

♈
♉

Thursday
14

☽→♉ 6:22 am
☽□♇ 9:56 am
☽PrG 10:58 am
☽□ŏ 2:49 pm
☿⚹♂ 6:48 pm

━━━ ♀♀♀ Dé Haoine ━━━

♉

Friday
15

☽⚹♃ 7:14 am
☽⚹♀ 1:16 pm
☉□☽ 10:12 pm v/c

Waning Half Moon in ♉ Taurus 10:12 pm PDT

ALL ASPECTS IN PACIFIC DAYLIGHT TIME; ADD 3 HOURS FOR EDT; ADD 7 HOURS FOR GMT

Come Home

Come home to your body
You are welcome here
Forget what you've done
And what you've not
This temple
was built for you
And even if
the floors aren't clean
And the window
is broken
And there's shit
all over the place
You are welcome.

Come home
to your body
Now let's take a breath
Settle into my lungs
Melt through the fascia
That keeps you

Expand
Into this space
Contained, yet so vast
Bring your exhaustion
Your hunger
Your excess
Welcome home.

excerpt © Kirstin Olsen 2022

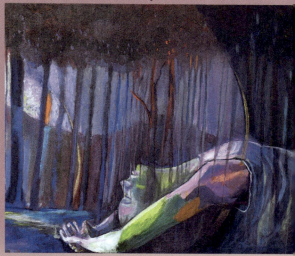

Selene *© Jill Althouse-Wood 2023*

♉
♊

Saturday
16

☽→♊	9:00 am	☽△♇	12:31 pm
☽⚹♄	10:39 am	☽⚹♅	7:33 pm
☽☌♅	11:11 am	☽△♂	7:47 pm
☽⚹♆	11:54 am		

♊

Sunday
17

☿⚹♂ 10:22 pm

August
agosto

There is wisdom in feeling deeply.
Let it bubble up to the surface as it is.
Honor it by giving it a place
Let It Be and you may see
There is beauty even in the wreckage.
excerpt © Maasa Craig 2022

――― ☽☽☽ lunes ―――

Monday
18

☉⚹☽ 4:53 am v/c
☽→♋ 12:05 pm
☽□♄ 1:33 pm
☽□♆ 2:57 pm

――― ♂♂♂ martes ―――

Tuesday
19

☽□♂ 1:29 am
☉△⚷ 10:29 am
☽♂♃ 3:02 pm

――― ☿☿☿ miércoles ―――

Wednesday
20

☽♂♀ 5:27 am v/c
☽→♌ 4:17 pm
☽△♄ 5:34 pm
☽⚹♅ 6:40 pm
☽△♆ 7:08 pm
☽☍♇ 7:47 pm

――― ♃♃♃ jueves ―――

Thursday
21

☽⚹♂ 8:43 am
☽♂♅ 11:13 am v/c

――― ♀♀♀ viernes ―――

Friday
22

☉→♍ 1:34 pm
♀□⚷ 7:29 pm
☽→♍ 10:24 pm
☉♂☽ 11:06 pm

☉→♍

Sun in ♍ Virgo 1:34 pm PDT
New Moon in ♍ Virgo 11:06 pm PDT

ALL ASPECTS IN PACIFIC DAYLIGHT TIME; ADD 3 HOURS FOR EDT; ADD 7 HOURS FOR GMT

2025 Year at a Glance for ♍ Virgo (Aug. 22–Sept. 22)

How you work needs an upgrade, Virgo. Of course, you may continue with the same endeavors, but consider how to be more efficient. Until January 28th, Mercury and the Moon will provide a gentle nudge towards creativity to help you develop ideal work habits, so jump on opportune bursts of inspiration and moments of curiosity. Ask plenty of questions and allow yourself permission to guess at the answers. Did you know great inventions can come from silly little accidents? Trust that you're flopping in the right direction, and avoid over-analyzing your decisions. Be patient with yourself. Often, the most successful people find themselves failing upwards. What doesn't kill you truly has the potential to make your efforts more successful in the future. The difference between people who succeed at their desires and those who don't is their willingness to try again. Tiptoeing around eggshells will only hinder your understanding of how to advance. Step on eggshells and respectfully manage the

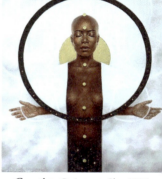

consequences. Living an authentic life can feel uncomfortable. That's how you know you're doing it correctly. Growing Edge requires discomfort and a willingness to fail and to keep going. If you're cringing, then you're growing. If you are getting tired, rest, then keep pushing. Keep in mind that breakthroughs arise from perseverance. If you feel you're going nowhere, have faith and keep going.

Monisha Holmes © Mother Tongue Ink 2024

***Creation** © Autumn Skye 2022*

ㅅㅅㅅ sábado

♍

Saturday
23

☽□♅ 12:57 am
☉⊼♄ 4:04 am

⊙⊙⊙ domingo

♍

Sunday
24

☉□♅ 12:15 am
☉⊼♆ 3:58 am
☽⚹♃ 5:14 am
☉⊼♇ 1:06 pm

Feminist

Feminist.

The word forms itself
in your mouth
Tick tick tick
Bomb like. Dangerous.
You don't know
Whether to swallow or spit

Feminist.

Patriarchy's rubbed itself
All over that word
Hasn't it?
Got you worried that all I want
Is to take your manhood
Snip snip snip

Feminist.
Feminist . . .

Is to me so far removed
From this. It redresses,
It encompasses every one of us,
Does not rest until there is respect
and inclusion for all. It resists
All & every system of oppression
And abuses of power . . .
And yes, that means you are going to lose your privilege,
Because it is rooted in oppression, and—visible to you or no—
has been the cause of murder, misery, marginalization and abuse
Of any of us that do not "fit" patriarchy's twisted terrorism.

Intersectional Feminism.
Fierce love with vision.
Feminist. This is it.

IX. SMASHING PATRIARCHY
Moon IX: August 22–September 21
New Moon in ♍ Virgo August 22; Full Moon in ♓ Pisces Sept. 7

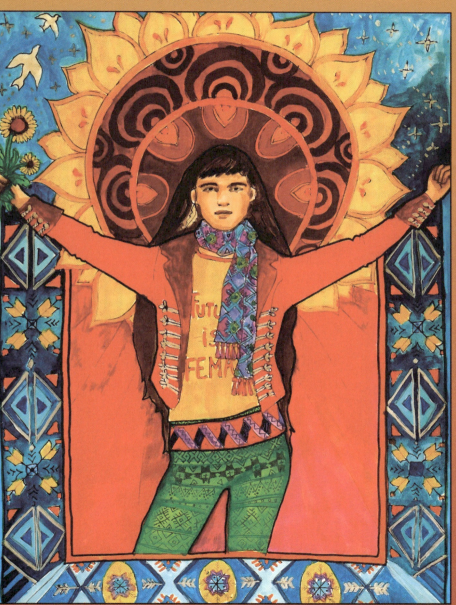

Ukrainian Goddess Berehynia © Anna Lindberg Art 2022

August
Kolovoz

Eye of Providence

--- ☽☽☽ ponedjeljak ---

 ♍
♎

Monday
25

☽✶♀	6:53 am v/c	☽△♅	9:52 am	
☽→♎	7:08 am	☽☍♆	10:04 am	
☽☍♄	8:00 am	☽△♇	10:48 am	
♀→♌	9:27 am	♀△♄	5:55 pm	

--- ♂♂♂ utorak ---

 ♎

Tuesday
26

☽☌♂	7:26 am
♀✶♅	1:58 pm
♀△♆	3:18 pm
☽□♃	4:23 pm
☽✶♅	7:06 pm v/c
♀☍♇	10:54 pm

--- ☿☿☿ srijeda ---

 ♎
♏

Wednesday
27

☽→♏	6:27 pm
☽□♇	10:10 pm

--- ♃♃♃ četvrtak ---

♏

Thursday
28

☽□♀	12:48 am
☉✶☽	5:27 am
♅✶♆	5:09 pm

--- ♀♀♀ petak ---

♏

Friday
29

☽△♃	5:38 am
☽ApG	8:36 am
☽□♅	5:47 pm v/c

ALL ASPECTS IN PACIFIC DAYLIGHT TIME; ADD 3 HOURS FOR EDT; ADD 7 HOURS FOR GMT

Death of a Martyr

Who would you be if you dropped your need to be pleasing
and instead homed your beacon to the sound
of the ground beneath your bare feet?
Drink it in—all the ease—
A hard pill to swallow?
Is that what our ancestors survived for?
So that our souls and our hopes and our loves
could be squashed under the weight
of a system that places us somewhere on par
with the livestock they raised?
Commit yourself to something less but infinitely more
and you'll see
We all reap those rewards when you say yes
to the longing in your cells
to rest, to wander, to languor in the arms of your lover
to say no so you can say yes
You better believe this is what your bloodline
had in mind for you
even if they couldn't believe it was yet true
Live their wildest evolutionary dreams
Let's save ourselves to save each other
The martyrs' time is over

excerpt © wildish tiny 2023

───── ♄♄ subota ─────

♏︎
♐︎

Saturday
30

☽→♐︎ 7:04 am	☽⚹♇ 10:42 am
☽△♄ 7:19 am	☽△♀ 8:12 pm
☽△♆ 9:53 am	☉□☽ 11:25 pm
☽☍♅ 9:59 am	

Waxing Half Moon in ♐︎ Sagittarius 11:25 pm PDT

───── ☉☉ nedjelja ─────

♐︎

Sunday
31

☿△♃ 12:44 pm
☽⚹♂ 2:52 pm

September

Bhadro

──── ☽☽☽ sombar ────

♐
♑

Monday
1

♄→♓	1:06 am
☽△♀	4:37 pm
☽□♄	6:38 pm v/c
☽→♑	6:44 pm
☽□♆	9:20 pm

──── ♂♂♂ mongolbar ────

♑

Tuesday
2

♀⊼♄	5:21 am
♀→♍	6:23 am
☉△☽	3:23 pm
♀⊼♆	10:44 pm

──── ☿☿☿ budhbar ────

♑

Wednesday
3

♀□♅	12:40 am
♀⊼♇	4:05 am
☽□♂	4:20 am
☽☍♃	5:50 am

──── ♃♃♃ brihospotibar ────

♑
♒

Thursday
4

☽⚹♄	3:08 am v/c
☽→♒	3:32 am
☽⚹♆	5:52 am
☽△♅	6:12 am
☽♂♇	6:40 am
♂□♃	7:58 pm

──── ♀♀♀ sukrobar ────

♒

Friday
5

☽☍♀	2:49 am
☽△♂	1:51 pm v/c
♅R	9:51 pm

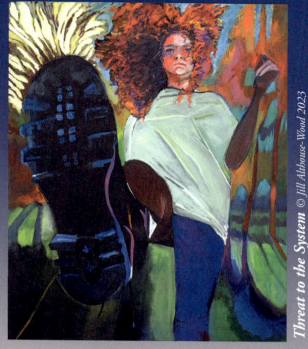

Threat to the System © Jill Althouse-Wood 2023

Necessary Rebellion

The world needs your unbelonging.
It needs your disagreements,
your exclusion,
your ache to tear the false constructions down.

excerpt © Toko-pa Turner 2017

ᚦᚦᚦ sonibar

♒
♓

Saturday
6

☽→♓ 8:54 am
☽□♅ 11:26 am

⊙⊙⊙ robibar

♓

Sunday
7

☽⚹♉ 12:41 am
⊙☍☽ 11:09 am
☽△♃ 5:24 pm

Total Lunar Eclipse 8:28am PDT*
Full Moon in ♓ Pisces 11:09 am PDT

September

Mí Meán Fomhair

───── ☽☽☽ Dé Luain ─────────────────

♓
♈

Monday
8

☽☌♄ 10:44 am v/c
☽→♈ 11:37 am
☽☌♆ 1:32 pm
☽⚹♅ 2:02 pm
☽⚹♇ 2:21 pm

───── ♂♂♂ Dé Máirt ─────────────────

♈

Tuesday
9

☽△♀ 6:06 pm
☽□♃ 7:43 pm
☽☍♂ 11:53 pm v/c

───── ☿☿☿ Dé Céadaoin ─────────────────

♈
♉

Wednesday
10

☽PrG 5:10 am
☽→♉ 1:03 pm
☽□♇ 3:43 pm

───── ♃♃♃ Dé Ardaoin ─────────────────

♉

Thursday
11

☽△♅ 7:18 pm
☉△☽ 9:29 pm
☽⚹♃ 9:39 pm
☽□♀ 11:59 pm

───── ♀♀♀ Dé Haoine ─────────────────

♉
♊

Friday
12

☉⚹♃ 12:30 am
☽⚹♄ 1:14 pm v/c
☽→♊ 2:38 pm
☿⚹♃ 2:53 pm
☽⚹♆ 4:23 pm
☽☌♅ 5:03 pm
☽△♇ 5:17 pm

ALL ASPECTS IN PACIFIC DAYLIGHT TIME; ADD 3 HOURS FOR EDT; ADD 7 HOURS FOR GMT

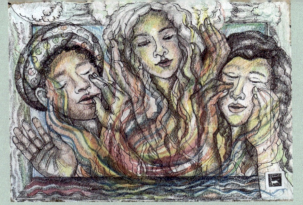

Many Hands © *Bernice Davidson 2019*

We Are Remembering

The landscapes of our bodies
are beginning to sing
the wild song of the living Earth.
She is calling us home.
Home to the shelter of the Mother Tree,
teaching us to stand in her magnificence,
to spread our arms wide,
and reach for the hands of our sisters,
as we grow a forest of the Feminine
to restore balance to our planet
and honour the sacredness of life.
excerpt © Rosalie Kohler 2022

——————— ⵣⵣⵣ Dé Sathairn ———————

♊ **Saturday**
13

⊙☌☿ 3:52 am

——————— ⊙⊙⊙ Dé Domhnaigh ———————

♊
♋ **Sunday**
14

⊙☐☽ 3:33 am ☽☐♄ 3:46 pm v/c
☽☐☿ 5:16 am ☽→♋ 5:30 pm
☽⚹♀ 7:09 am ☽☐♆ 7:13 pm
☽△♂ 8:41 am

Waning Half Moon in ♊ Gemini 3:33 am PDT

MOON IX 133

September
septiembre

Monday
15

♀⚹♂ 8:04 pm

Tuesday
16

☿⊼♄ 12:50 am	꒩□♂ 3:53 pm
♀△♄ 3:11 am	꒩⚹☿ 5:51 pm
꒩♂♄ 5:18 am	꒩△♄ 8:13 pm v/c
♂♂♄ 8:46 am	꒩→♌ 10:20 pm
☉⚹꒩ 11:52 am	

Wednesday
17

꒩△♆ 12:00 am
꒩⚹♅ 12:52 am
꒩♂♇ 1:05 am
☿♂♄ 10:47 am

Thursday
18

☿→♎ 3:06 am
♀⊼♄ 4:33 am
☉⊼♄ 12:13 pm
☿♂♆ 3:01 pm
☿△♅ 9:52 pm
☿△♇ 11:27 pm

Friday
19

꒩⚹♂ 1:40 am
꒩♂♀ 5:21 am v/c
꒩→♍ 5:23 am
♀→♍ 5:39 am
꒩□♅ 7:59 am
♀⊼♆ 10:20 pm
♂⊼♄ 10:24 pm

*Eclipse visible in Southern Australia, Antarctica, and the Pacific and Atlantic oceans.

Forest Sanctuary

Sitting amongst the trees
on Grandmother's spine
The wind absent
but for cricket's breath
August morning upon this ridge
I do not take for granted
this freedom to be here—
alone, a woman in shorts,
driving here aware
that in half the world
this is unthinkable
Astounded and bewildered
that conscious and unconscious
continue to exist side by side
how the rules of nations and religious fanatics
oppress sisters across the planet
We pray for consciousness to ascend quickly
for veils of fear and control to be shredded to nothingness
May all beings be free,
happy and safe from harm
May all women be able to walk alone,
in shorts, on Grandmother's spine

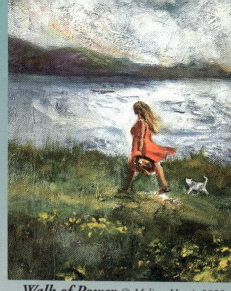

Walk of Power © Melissa Harris 2023

© Marla Faith 2018

ᚻᚻᚻ sábado

Saturday
20

♀□♅ 8:41 am
☿ApG 10:43 am
♀⊼♇ 10:59 am
☽⚹♃ 9:34 pm
☉☌♄ 10:45 pm

☉☉☉ domingo

Sunday
21

♄PrG 1:05 am ☽☍♆ 4:14 pm
☽☍♂ 11:42 am ☽△♅ 5:19 pm
☉☌☽ 12:54 pm v/c ☽△♇ 5:34 pm
☽→♎ 2:41 pm

Partial Solar Eclipse 10:29 am PDT*
New Moon in ♍ Virgo 12:54 pm PDT

the mountain at the end

when I crest that mountain
I will look down from up high
upon all of creation conspired to lift me up to myself
lineages converging, hoisting me
"be free," spoke the wind—the crystalline murmur of divinity

when I crest that mountain and look down
from the snowed apex of my own existence,
my body held here by the courtesy of Earth's love for me—gravity
I will weep in the arms of my sisters
and all who guided me home—lighthouses at sea

climb up into the seat of your own drumbeat
claim your place at the table
speak your grace to those come in your wake—
for you are their ancestor now
feel that weight
then let it go
point your feet downstream and let the current take you
follow it to the ocean and be swallowed by her waves
you belong, though it never belonged to you
your tender holy flesh the channel through which all is possible
and when your children have children and theirs after that
sit by their bedsides at night and whisper
"where would you like to go?"
I moved boulders so there would be a few less for you
I dropped my armor and toured the underworld
so that you would have my light to guide yours home
my hand is yours to hold
and when it's your time to climb the mountain at the end
I will catch your breath as you join us
in the place we always knew

X. THE GONE-BEFORES

Moon X: September 21–October 21

New Moon in ♍ Virgo Sept. 21; Full Moon in ♈ Aries Oct. 6; Sun in ♎ Libra Sept. 22

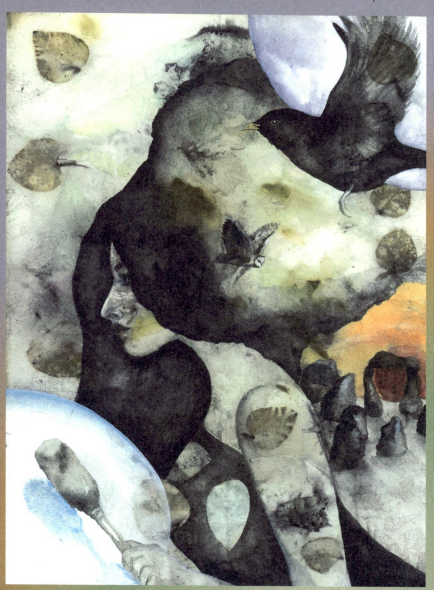

Earth Rhythm © *Lucy Tipper—Tangled Muses 2023*

September

 rujan ━━━ ⟩⟩⟩ ponedjeljak ━━━━━━━━━━━━━━━━━━

 ♎

 Monday
22

♂→♏ 12:54 am
☽☌♅ 4:36 am
♆PrG 9:20 am
☉→♎ 11:19 am

 Fall Equinox

☉→♎

Sun in ♎ Libra 11:19 am PDT

━━━ ♂♂♂ utorak ━━━━━━━━━━━━━━━━━━

♎ Tuesday
23

♂⚹♆ 4:01 am
☉☍♆ 5:53 am
☽□♃ 9:02 am v/c
☉△♅ 7:55 pm
☉△♇ 11:05 pm

━━━ ☿☿☿ srijeda ━━━━━━━━━━━━━━━━━━

♎
 ♏

 Wednesday
24

♂⚹♅ 12:15 am
☽→♏ 2:00 am
♂□♇ 4:52 am
☽□♇ 4:56 am
☽☌♂ 4:56 am
☽⚹♀ 3:17 pm

━━━ ♃♃♃ četvrtak ━━━━━━━━━━━━━━━━━━

 ♏

 Thursday
25

☽△♃ 10:06 pm

━━━ ♀♀♀ petak ━━━━━━━━━━━━━━━━━━

♏
 ♐

Friday
26

☽ApG 2:44 am
☽△♄ 10:44 am v/c
☽→♐ 2:37 pm
☽△♆ 3:57 pm
☽☍♅ 5:13 pm
☽⚹♇ 5:31 pm
☉⚹☽ 11:34 pm

ALL ASPECTS IN PACIFIC DAYLIGHT TIME; ADD 3 HOURS FOR EDT; ADD 7 HOURS FOR GMT

2025 Year at a Glance for ♎ Libra (Sept. 22–Oct. 22)

Dear Libra, may 2025 give you the peace you deserve after overcoming some necessary challenges. This year is the perfect time to throw your arms up in relief and allow yourself to relax. You were not created to be the super strong one or to remain in adversity. Your human experience was always intended to be dynamic and filled with moments of triumph and failure. Strength is a quality that we should all be encouraged to develop. However, avoid making it one of your defining characteristics. When people introduce themselves with strength as one of their defining characteristics, one must ask what they have survived. While your ability to withstand difficulties is worth admiring, it is not your essential nature. Spend this year experimenting with new reasons to be proud of yourself. Play with introducing yourself as soft, kind, and trusting. If you feel that leading with your gentleness is weak, meditate on why. Do you feel the need to have your guard up? Hyper-vigilance results from unfortunate encounters and can be an attempt to protect yourself. As you continue through 2025, reflect on the concepts of safety and threat. How do you cultivate a sense of safety? With the entry of Venus in Taurus on June 5th, stepping into a feeling of empowerment will serve you well. Signing up for meditation, an art class, or volunteering are peaceful paths toward self-confidence and awareness.

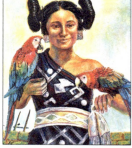

Parrot Maiden
© Suzanne deVeuve 1998

Monisha Holmes © Mother Tongue Ink 2024

ħħħ subota

♐

Saturday
27

☽□♀ 11:00 am

☉☉☉ nedjelja

♐

Sunday
28

☽⚹☿ 12:43 am
☽□♄ 10:44 pm v/c

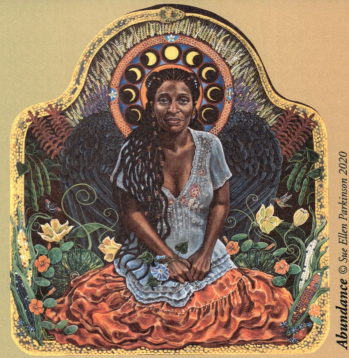

Abundance © Sue Ellen Parkinson 2020

Fall Equinox

As Sun fades, we taste its sweetness in the fruits from second harvest. The air cools; we prepare to turn inwards. We are busy processing produce from our gardens. And we grow in awareness of inequity in the world.

Cultivate an equanimous mind during this season of equal dark and equal light. Focus on what brings you peace in the moment. Stave off despair with gratitude. Sing even though the state of the world has broken our hearts. We must find a balance between our boat-rocking rage, and the harmony that both our hearts and the earth long for.

The earth leads us into fall with grace. Our colors change, and we let go. Old beliefs become compost on the forest floor. We are suspended in time between what was, and what will be. We release and receive abundance. Honor any grief that arises. Feel deeply. Look to the eagle overhead. She is calling you to shift perspective, lift your Spirits, and keep your wings expanded. Learn how to fly above it all.

Mahada Thomas © Mother Tongue Ink 2024

The Autumn Queen

The vermilion, salmon and raspberry shades of spring give way to the greens of summer. Then Autumn's tangerines, yellows, scarlets remind us about grounding. This is the place the Queen knows well, for she has harnessed all her power, her magic with the growing ripeness of spring and summer.

Autumn reminds us to celebrate our own inner Queen. While the fresh beauty of the maiden is exquisite, and the fecundity of motherhood is beautiful, I would not wish for spring in winter. Every mother who has weaned her children knows, this is the time for her.

The Queen rests in her abundance, strength and authority in this last stage of gathering before Samhain, just before the reaping of the fairies. The corn is chopped and the fields gleaned. Persephone descends, and Demeter relaxes on her throne with a goblet of wine, waiting for her winter consort to emerge. She is blessed.

I delay starting my wood stove, just like the last crickets delay the end of summer—once the crackling of the sweet smell of locust, maple, apple warm my bones, I am married to it until spring. The hint of winter is banished by the hot crackling fire. I snuggle in safety, stoking orange embers at night as the salamanders of fire wrap themselves around my farmhouse and me.

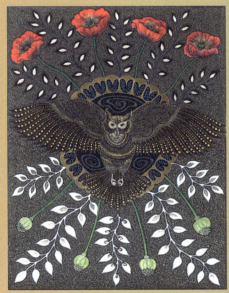

Hanging from the oak beams are comfrey, mullein, motherwort, chamomile, elderberry, calendula, nettle, sweet Annie and fragrant geranium. I have dried tomatoes and peppers, stored pumpkins, squash, potatoes, cabbages. Greens might come up all winter long—a reminder that not everything dies in the cold of winter. Luckily, in the Autumn of my life, I am aware of my place in the wheel of the year, and I celebrate. This is a sweet place to be. Honor your Queen.

© *Margaret Sophia Marangione 2023*

I Bring Gifts © *Schehera VanDyk 2017*

September / October

Bhadro / Ashshin

Monday
29

☽→♑ 2:55 am
☽□♆ 4:05 am
☽✶♂ 12:55 pm
☉□☽ 4:54 pm

♂♂♂ mongolbar — Waxing Half Moon in ♑ Capricorn 4:54 pm PDT

Tuesday
30

☽△♀ 5:20 am
☽□♅ 8:38 pm
☽☍♃ 10:40 pm

☿☿☿ budhbar

Wednesday
1

October

☽✶♄ 8:33 am v/c
☽→♒ 12:51 pm
☽✶♆ 1:51 pm
☿□♃ 1:59 pm
☽△♅ 3:05 pm
☽♂♇ 3:29 pm

♃♃♃ brihospotibar

Thursday
2

☽□♂ 1:28 am
☉△☽ 6:41 am

♀♀♀ sukrobar

Friday
3

☿☍♄ 11:05 am
☽△♄ 11:15 am v/c
☽→♓ 7:07 pm
☽□♅ 9:06 pm

ALL ASPECTS IN PACIFIC DAYLIGHT TIME; ADD 3 HOURS FOR EDT; ADD 7 HOURS FOR GMT

Feral Dogs

I wonder who tells the stories of the forgotten? Of those who do not make it into the history books. Do their stories disappear never to be heard again? Does the land tell their stories? Does it speak of the long marches through jungles to the shore? Of earth ruddled by a thousand dusty footprints walking in step? Does it speak of those who stumble and fall?

Do their bones tell stories? A finger, a thigh bone, bleached white—glimmering like a jewel in sunlight marooned in sadness. And Wind, does she remember the stifled, stale smell in the ship's belly? The musky taste of cargo transported from shore to shore? Did she churn the waters showing displeasure?

In West Africa, tales are shared, passed down from generation to generation through the spoken word, told by the griots (pronounced gree-oh) who are storytellers, poets, historians, genealogists, musicians. Do they sing of us? Do they sing of our disappearance, fetching water by the river, or visiting kin in another village? Are our names still sung by our ancestors? Who tells our stories? Who tells the stories of the forgotten?

A story untold makes us wild, untamed spirits—feral dogs of history.

© Belinda A. Edwards 2023

——— ᚻᚻᚻ sonibar ———

♓ ◯ Saturday
4

☽△♂ 9:36 am
☿ᚿᚻ 5:32 pm

——— ☉☉☉ robibar ———

♓ ◯ Sunday
♈ 5

☽☌♀ 4:34 am ☽→♈ 9:48 pm
☽△♃ 10:15 am ☽☌♆ 10:28 pm
☽☌ᚻ 5:30 pm v/c ☽⚹♅ 11:35 pm

October
Mí Deireadh Fomhair

ᗷᗷᗷ Dé Luain ————————————————————————

♈ Monday
6

☽⚹♇ 12:04 am
☿→♏ 9:41 am
☿⊼♆ 3:53 pm
☉☍☽ 8:47 pm

———————————————————— ♂♂♂ Dé Máirt ————————

Full Moon in ♈ Aries 8:47 pm PDT

♈
♉ Tuesday
7

☿⊼♅ 2:41 am
☿□♇ 7:41 am
☽□♃ 11:23 am v/c
☽→♉ 10:12 pm

———————————————————— ☿☿☿ Dé Céadaoin ————————————————————

♉ Wednesday
8

☽□♇ 12:24 am
☽☍☿ 2:15 am
♀⚹♃ 4:41 am
☽PrG 5:39 am
☽☍♂ 4:16 pm

———————————————————— ♃♃♃ Dé Ardaoin ————————————————————

♉
♊ Thursday
9

☽⚹♃ 11:38 am
☽△♀ 2:12 pm
☽⚹♄ 5:31 pm v/c
♀⊼♂ 5:46 pm
☽→♊ 10:12 pm
☽⚹♆ 10:41 pm
☽♂♅ 11:48 pm

———————————————————— ♀♀♀ Dé Haoine ————————————————————

♊ Friday
10

☽△♇ 12:25 am

Older, Wiser, Wilder

Older, wiser, wilder. Transformed by the moon shadow
in the white trees, the mud and the leaves, the eyes in the night,
the screech owl and the sea, she rises.
She who has danced in the fire
and not been burned,
She who has held the moon in her eye,
birthed the world
and lived to tell the tale.
She who has died
and been reborn many times.
Here she stands,
moon-streaked, wild-eyed.
No longer scared of the other worlds.
No longer afraid of the darkness.
She knows she belongs here. And there.
That she can cross between them.
Eclipsed, occulted, reborn.
The woman of darkness
who knows the power of flight.
Steps forward, places her cloak over her shoulders,
picks up a stick, claims it to be a magic wand,
and begins to beat the drum.

Grandmother
© Cherlyn—Mystic Art Medicine 2001

© Lucy H. Pearce 2023

──────────── ♄♄♄ Dé Sathairn ────────────

♊
♋

Saturday
11

♀☊♄ 4:10 am
☉△☽ 4:14 am
☽□♄ 6:29 pm
☽□♀ 7:56 pm v/c
☽→♋ 11:37 pm

──────────── ☉☉☉ Dé Domhnaigh ────────────

♋

Sunday
12

☽□Ψ 12:02 am
☽△☿ 3:10 pm

October
octubre

♋

Monday
13

☽△♂	12:07 am
☉□☽	11:13 am
♀→♎	2:19 pm
☽♂♃	4:49 pm
♀⚻♆	6:16 pm
ᛒD	7:53 pm
☽△♄	10:05 pm v/c

Time to order We'Moon 2026!
Free Shipping within the US October 13–17!
Go to: wemoon.ws Promo Code: **Lucky13**

Waning Half Moon in ♋ Cancer 11:13 am PDT

♋
♌

Tuesday
14

☽→♌	3:47 am
☽△♆	4:08 am
☽⚹♀	5:10 am
☽⚹♅	5:21 am
☽☍♇	6:14 am
♀△♅	7:10 am
♀△♇	4:45 pm

♌

Wednesday
15

☽□♅	2:41 am
☽□♂	8:50 am
☉⚹☽	10:06 pm v/c

♌
♍

Thursday
16

☽→♍	11:05 am
☽□♅	12:37 pm
☉□♃	10:43 pm

♍

Friday
17

☉☍♭	4:40 pm
☽⚹♉	6:10 pm
☽⚹♂	9:01 pm

O Ancestors

I wonder where you are.

You, who held a song for every moment—for the first snow,
for the nettle patch, the vegetable garden, and the deer hunt,
for the birth of your first child, and your last—

I pass a small candle around the circle to offer thanks
for the sun's long walking
and now here,
a standing still—

Are you here
to light this candle with me?
Everyone takes turns
holding the candle,
watching the flicker,
all silent,
because no one knows
what to say,

And then,
there you are

and I start to sing.

© Geneva Toland 2023

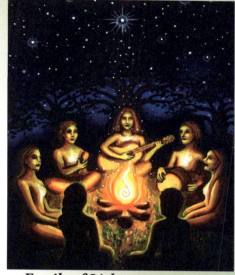

Family of Light ▢ *Hope Reborn 2023*

ꜗꜗꜗ sábado ───────

♍ ☽ **Saturday**
♎ **18**

☽✶♃ 9:43 am ☽ℰΨ 9:10 pm
♄PrG 11:25 am ☽△⚷ 10:27 pm
☽♂♄ 2:10 pm v/c ☽△ℰ 11:43 pm
☽→♎ 9:01 pm

─────── ☉☉☉ domingo ───────

♎ ☽ **Sunday**
 19

☉⚹♄ 7:31 am
☽♂♀ 11:26 am
☿♂♂ 11:51 pm

The Witch in the Forest

I am the witch in the forest. Want a cookie?
I'm famous for my gingersnaps. No one can eat just one.
They may have transformative properties.
You may stop hiding your wings, or scales or fur-tipped ears
and let your wildness out.
You may realize the power of your voice or the balm of your kindness.
Or they may reveal your greed, small mindedness and secret hatreds.
Look into my magic mirror,
it will mock your patronizing self-importance
until you lose all your hot air. Or it will reflect your true beauty.

I am the witch in the wilderness. Sometimes I taste the future.
Sometimes I dream true dreams. I speak the stories
the world needs to hear, revealing the pain,
the art, the injustice, and the beauty.

I am the witch in the wasteland. I have danced with Death
in the moonlight, the kindest of the Endless.
I sat in the lap of the Goddess, orbiting the outer reaches
of the solar system, singing to the rhythm of the spheres.

I am the witch in the wild wood. Let me give you tea.
I make potions and lotions, spells and cantrips.
I break hexes and curses, I bandage knees,
and sing broken souls to sleep.

I am the witch of hidden glades. I have a book of secrets
to excavate dark desires and free you from the pain of longing.
I know blood and bone and sinew. Let me open you
to the pleasure of being alive.

When I am called to adventure, I bring the forest with me
as boon and protection. I know star charts and moon phases,
the best times for planting, harvesting, and reaping.
I can help put your garden to sleep when winter comes.
I have a compass and amulets.

My pen is sharp and ready for battle. Call on me.

XI. BEYOND THE VEIL

Moon XI: October 21– November 19

New Moon in ♎ Libra Oct. 21; Full Moon in ♉ Taurus Nov. 5; Sun in ♏ Scorpio Oct. 22

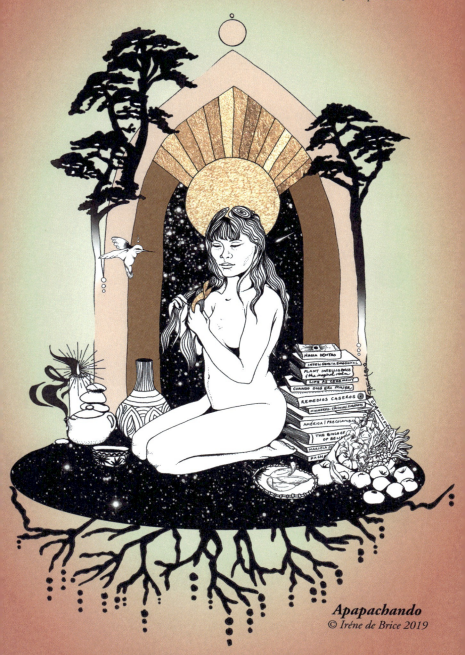

Apapachando
© Iréne de Brice 2019

October

listopad

© Elspeth McLean 2012

Genesis Mandala

ⅮⅮⅮ ponedjeljak

Monday
20

☽□♃ 9:29 pm

♂♂♂ utorak

Tuesday
21

☉☌☽ 5:25 am v/c
☽→♏ 8:42 am
☽□♇ 11:29 am

☿☿☿ srijeda

New Moon in ♎ Libra 5:25 am PDT

Wednesday
22

Ψ→♓ 2:48 am
☉☌Ψ 8:26 pm
☉→♏ 8:51 pm

☉→♏

♃♃♃ četvrtak

Sun in ♏ Scorpio 8:51 pm PDT

Thursday
23

☽☌♂ 3:55 am
☽☌☿ 7:57 am
☽△♃ 10:18 am
☉☌♅ 10:47 am
☽△♄ 1:38 pm

♃□♅ 3:18 pm
☽ApG 4:29 pm
☽△Ψ 9:14 pm v/c
☽→♐ 9:19 pm
☽☍♅ 10:27 pm

♀♀♀ petak

Friday
24

☽⚹♇ 12:08 am
☉□♇ 6:24 am
☿⚹♄ 6:43 am
☿△♃ 8:08 am

ALL ASPECTS IN PACIFIC DAYLIGHT TIME; ADD 3 HOURS FOR EDT; ADD 7 HOURS FOR GMT

2025 Year at a Glance for ♏ Scorpio (Oct. 22–Nov. 21)

How does it feel to let loose? Sometimes, allowing ourselves to be silly and childish can feel painful, awkward, and even sad. During 2025, take care of yourself. If you experience anger or grief when you allow yourself to be goofy, take time to journal—ask yourself why. Are you upset because of past experiences or expectations? This year may bring up memories from childhood and remind you of the angst of your teenage years. Simply practicing gratitude for your ability to recall childhood feelings is a surefire way to begin healing wounds from the past. You'll gain a sense of joy by cultivating light from the darkness of repressed pain. If you are still navigating without a sense of illumination, trust that you are the light. Even though you may not be able to see your luminescent aura, trust that those around you appreciate your glow. Smile, laugh, and allow yourself to play. If ever you find your fist clenching and your eyes tearing, permit yourself to unwind. You are neither broken nor flawed, and it is okay to be less than perfect. As 2025 comes to a close, you can think through how to heal relationships within your family. Then, on October 13th, when Pluto turns direct, you can put action alongside your thoughts. Offer forgiveness as it comes—there is no need to force yourself to let go prematurely.

Monisha Holmes © Mother Tongue Ink 2024

Visioning © Melissa Harris 1989

♄♄♄ subota

Saturday
25

☽⚹♀ 2:17 am
☿△♄ 2:17 pm

☉☉☉ nedjelja

Sunday
26

☽□♄ 2:00 am
☽□♇ 9:41 am v/c
☽→♑ 9:53 am
☉⚹☽ 5:35 pm

October
Ashshin

Monday
27

♂⊼♃ 9:40 am
)□♀ 9:11 pm
♂△♃ 11:19 pm

Tuesday
28

)☍♃ 10:56 am)⚹Ψ 8:38 pm v/c
)⚹♂ 11:36 am)→≈ 8:55 pm
)⚹♄ 1:06 pm)△♅ 9:39 pm
)⚹♀ 8:17 pm)♂♇ 11:39 pm

Wednesday
29

☿△Ψ 12:26 am
☿→♐ 4:02 am
⊙□) 9:21 am
♂△♄ 12:05 pm
☿☍♅ 12:36 pm

Waxing Half Moon in ≈ Aquarius 9:21 am PDT

Thursday
30

)△♀ 12:34 pm
☿⚹♇ 3:06 pm
)□♂ 11:15 pm v/c

Friday
31

Samhain / Hallowmas

)→♓ 4:46 am
)□♅ 5:18 am
)□♀ 8:32 am
⊙△) 8:42 pm

Samhain

Chilly winds blow, time slows down, and magical dark returns. At Samhain we welcome the wild witch within. We unleash her and all her Power.

We call on owl medicine to lead us into the mystery of Shadow. Journey through the mist, beyond the veils, to visit with our Beloved Dead. The ones gone before, and the ones yet to come. We do work to clear ancestral trauma, and heal old wounds left to us as a kind of inheritance. The Ancestors live in our hearts as remembrance. Let them lead us to where the wounds originated so we may heal. Together we right wrongs of the past, in unseen spaces and places.

When the old is cleared away, invite future Ancestors to come forth. Ask, "What do you need to prepare for your arrival? How can we create the world you wait to live in?"

An ever-flowing river of Love weaves through all generations. Sometimes we may need to dive deep beneath the pain to find it. Trust that when all else fades and is gone, Love remains.

Mahada Thomas © Mother Tongue Ink 2024

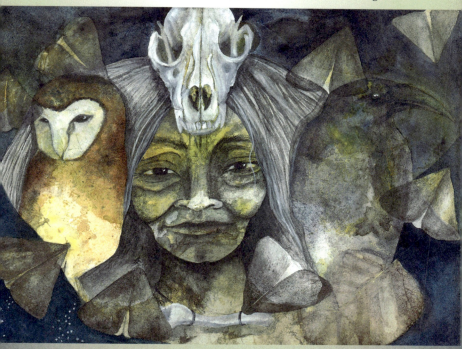

Bone Woman *© Lucy Tipper—Tangled Muses 2022*

Samhain

This is the time of the deepest In, the darkest moon,
the fertile void, the waiting womb.
This is the time when silence roots, trees unleaf,
the land is stripped back to bone, bone-fires on hills,
wood smoke at dusk, wet leaves in layers stuck to our boots,
the spider, the web, the bread of the dead,
pumpkin soup in pumpkin bowls,
a purple candle in the heavy hung window
for our beloved dead returning home.

This is the time of the raddled rook, the exposed root,
the vulnerable wound.
This is the time to be soft with our hearts, protect our scars,
gather in close to the welcoming hearth.

This is the night to respect things unseen,
Hallowe'en, the time in between, when nothing is as it seems.
This is the night of the shore left behind,
the burial tomb, the ancestral mound.
This is the night to slow to stone,
to speak the truth as hollow bone.
This is the night the night hag rides.

This is the night of the husk of light.

This is the night to stop stirring the cauldron.

This is the night when the pattern is lost.

This is the night when the veil is thin
and a wolf must die in her own skin.
And this is the night when they come again
and we welcome them in,
Old friends, ancestors, family members,
Great, great grandmothers, animal kin.
This is the night to ask them wise questions
and hear unexpected answers.
This is the night for our beloved dead.

© Debra Hall 2018

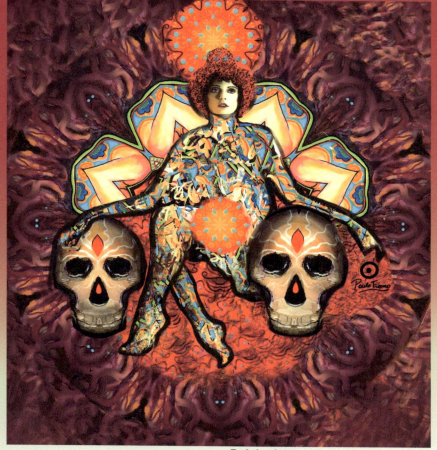

Initiations © *Paula Franco 2023*

♓ 🌓 **Saturday**
1

November

♀☍♇ 11:37 pm

♓
♈ 🌗 **Sunday**
2

☽△♃	12:17 am	☽⚹♅	8:01 am
☽☌♄	1:30 am	☽⚹♇	10:05 am
☽△♂	5:17 am	☽△♅	2:18 pm
☽☌♆	7:15 am v/c	♀□♃	3:16 pm
☽→♈	7:39 am		

Daylight Saving Time Ends 2:00 am PDT

November
Mí na Samhna

all my bones belong to you
Earth my mother
my skeleton inscribed
"return to sender"
with the scarlet ink
of my blood.
excerpt ▢ Jennifer Pratt-Walter 2023

♈

Monday
3

♀⚹♄ 3:57 am
♂△♆ 7:59 pm

♈
♉

Tuesday
4

☽□♃ 12:25 am
☽☍♀ 3:21 am v/c
♂→♐ 5:01 am
☽→♉ 8:15 am
♂☍♅ 9:30 am
☽□♇ 10:36 am

♉

Wednesday
5

☉☍☽ 5:19 am
☽PrG 2:40 pm
☽⚹♃ 11:40 pm

Full Moon in ♉ Taurus 5:19 am PST

♉
♊

Thursday
6

☽⚹♄ 12:24 am ☽△♇ 9:42 am
☽⚹♆ 6:51 am v/c ☽☍♂ 9:49 am
♂⚹♇ 7:11 am ♀→♏ 2:39 pm
☽→♊ 7:20 am ♀⚹♅ 3:31 pm
☽☌♅ 7:26 am ☽☍☿ 5:19 pm
♀⚹♆ 8:37 am

♊

Friday
7

♅→♉ 6:22 pm
♀□♇ 7:44 pm
☽□♄ 11:49 pm

Death

We've known about this day as long as we've been alive—my departure, yours. But now, I can't stop the tickle of fear. The Other Side lies just beyond that door. Lifelong we've knocked on it, carved our initials in it, been sure of its sweet release. But now I wonder?

I only know that change is coming; change is here. But I'm not sure, my love, I can't see. Are you passing through the door—or is it me?

excerpt of 13 Death *from* 100 Word Tarot
© *Hynden Walch 2022*

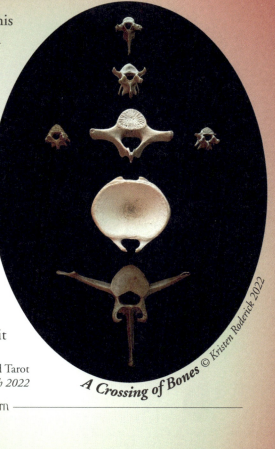

A Crossing of Bones © Kristen Roderick 2022

ᚻᚻᚻ Dé Sathairn ───────────

♊
♋
Saturday
♉

☽□♆ 6:32 am v/c
☽→♋ 7:06 am
☽△♀ 10:52 am

◉◉◉ Dé Domhnaigh ───────────

♋
Sunday
9

☿R 11:01 am
☉△☽ 12:26 pm

November
noviembre

Joy

))) lunes

♋
♌

Monday
10

☽ ☌ ♃	1:09 am	☽ ☍ ♇	12:16 pm
☽ △ ♄	1:39 am	☽ △ ♂	5:48 pm
☽ △ ♆	8:54 am	☽ □ ♀	6:43 pm
☽ ✶ ♅	9:22 am v/c	☽ △ ☿	9:21 pm
☽ → ♌	9:34 am		

♂♂♂ martes

♌

Tuesday
11

♃ R	8:41 am
☉ □ ☽	9:28 pm

Waning Half Moon in ♌ Leo 9:28 pm PST

☿☿☿ miércoles

♌
♍

Wednesday
12

☿ ☌ ♂	3:15 pm
☽ □ ♅	3:29 pm v/c
☽ → ♍	3:52 pm

♃♃♃ jueves

♍

Thursday
13

☽ □ ☿	2:49 am
☽ □ ♂	4:03 am
☽ ✶ ♀	7:47 am

♀♀♀ viernes

♍

Friday
14

☉ ✶ ☽	11:20 am
☽ ✶ ♃	4:09 pm
☽ ☍ ♄	4:30 pm

All aspects in Pacific Standard Time; add 3 hours for EST; add 8 hours for GMT

Descending

The Autumn winds have come,
keeping their contract with the trees.
They are still heavy with memories of rain,
but soon their sluggishness will turn
brittle, crisp.
Soon they will tear leaves from limbs,
many yet unturned.
Soon the sleeping forests will shudder
from the ache in the air,
and the windows will rattle,
and the mountainsides will roar
as all is laid bare beneath the moon.

The winds do not whisper
of the darkening.
They are mad with it, ecstatic,
dancing like Maenads
through the barren branches,
invoking, crying out,
ripping away the veil as we descend
into the shadow lands of Winter.

© Megan Welti 2013

ħħ sábado

♍
♎

Saturday
15

☽☍♆ 12:50 am
☽△♅ 1:08 am v/c
☽→♎ 1:43 am
☽△♇ 4:55 am

☉⊼♄ 9:24 am
☽⚹☿ 9:40 am
☽⚹♂ 6:16 pm

☉☉☉ domingo

♎

Sunday
16

☉△♃ 9:07 pm

Hecate Said

I sing to you
of the dark moon,
when the stars are ablaze
with a different kind of light—
five thousand spindles
on the great spinning wheel
reaching out
to prick your mind awake.
Think, child, think!
You always have three choices:
continue down
the path you are on,
go back,
or step onto new ground.

The truth
is that the mind
is wider than the sky,
and full of doors outnumbering
the stars,
and you are not really moving
in circles around the sun.
It is a spiral you climb,
higher and higher
into brighter and brighter light
without end.

© Megan Welti 2013

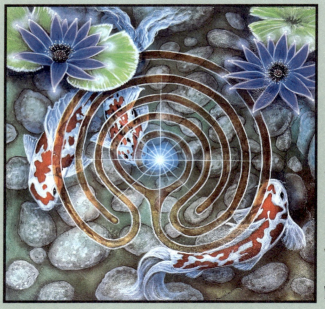

The Light Deep Within © Cathy McClelland 2022

XII. JOURNEY

Moon XII: November 19–December 19
New Moon in ♏ Scorpio Nov. 19; Full Moon in ♊ Gemini Dec. 4; Sun in ♐ Sagittarius Nov. 21

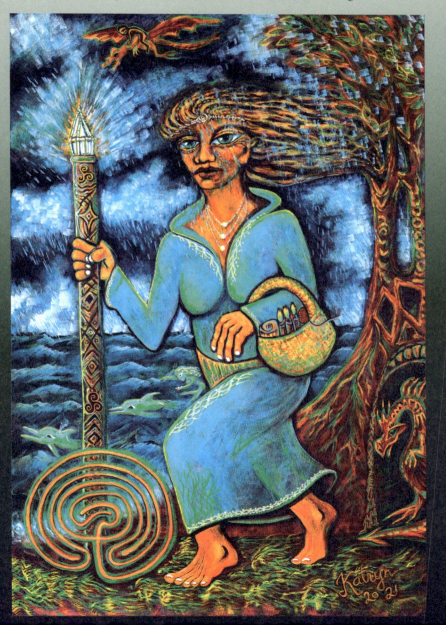

November
studeni

Ecstatic Motion
I will always be
perfectly incomplete.
Imagine not having
any space left to explore.
© Ashley J Nordman 2023

——— ☽☽☽ ponedjeljak ———

Monday
17

☉△♄ 12:56 am
☽□♃ 3:51 am v/c
☿✶♇ 12:36 pm
☽→♏ 1:44 pm
☽□♇ 5:05 pm

——— ♂♂♂ utorak ———

Tuesday
18

☿→♏ 7:20 pm
☽☌♀ 8:49 pm

——— ☿☿☿ srijeda ———

Wednesday
19

Lunar Samhain

☿☍♅ 3:44 am ☽△♄ 4:45 pm
☿△♆ 4:21 am ☽ApG 6:53 pm
☿PrG 11:11 am ☉☌☽ 10:47 pm
☽△♃ 4:23 pm ☽☌☿ 11:15 pm

——— ♃♃♃ četvrtak ———

New Moon in ♏ Scorpio 10:47 pm PST

Thursday
20

☉☌☿ 1:23 am
☽△♆ 1:23 am
☽☍♅ 1:24 am v/c
☽→♐ 2:26 am
☽✶♇ 5:52 am
♅✶♆ 6:39 am

——— ♀♀♀ petak ———

Friday
21

♅PrG 2:19 am
☽☌♂ 3:13 am
☉☍♅ 4:25 am
☉△♆ 5:05 am
☉→♐ 5:35 pm

☉→♐

Sun in ♐ Sagittarius 5:35 pm PST

ALL ASPECTS IN PACIFIC STANDARD TIME; ADD 3 HOURS FOR EST; ADD 8 HOURS FOR GMT

2025 Year at a Glance for ♐ Sagittarius (Nov. 21–Dec. 21)

What a time to reflect on what you want, Sagittarius! Sometimes, we are asked, "What do you want?" as if we are expected to know. That question can feel very daunting. How are you supposed to know what you want from now to forever? What if what you want is the opposite of what you need? How about you make your wishes one day at a time? Accepting that everything in life is temporary can be challenging, especially if you fear abandonment or loss. Naturally, accepting the end can feel foolish and might not inspire motivation. However, consider recognizing acceptance of the future as freedom to live your authentic truth. Instead of trying to commit to tomorrow and a day, trust that the best you can do is authentically express what you need today. As 2025 ends, you will recognize that the present is plenty, and who you are today results from incremental growth, not radical change. What you are great at came after years in the making. Your interests likely followed you to today, as did your hobbies and some of your beliefs. When in doubt, trust that who you are today knows where you plan on going. Perhaps the most challenging part of discerning what you want is breaking up with what you no longer desire. Even though there may never be a right time to say goodbye, when Jupiter turns direct on February 4th, you may begin to understand why you have to let go.

Monisha Holmes © Mother Tongue Ink 2024

ᚺᚺᚺ subota

Saturday
22

☽□♄ 5:13 am
☿△♄ 10:45 am
☽□♆ 1:48 pm v/c
☽→♑ 2:52 pm
☿△♃ 3:37 pm

⊙⊙⊙ nedjelja

Sunday
23

⊙⚹♇ 11:19 am

Wanderer © Nina Rose 2022

November
Kartik

Hope is taking
the first step
If only a fragment
of your being believes,
Take it!

excerpt © Jenna E. Jaffe 2018

---))) sombar ---

♑

Monday
24

☿⚹♄	4:04 am
☽⚹♀	11:24 am
☽⚹☿	12:28 pm
☽☍♃	4:12 pm
☽⚹♄	4:48 pm
☿♂♀	5:51 pm

--- ♂♂♂ mongolbar ---

♑
♒

Tuesday
25

☽△♅	12:52 am
☽⚹♆	1:10 am v/c
☽→♒	2:15 am
♀⚹♄	3:25 am
☽♂♇	5:45 am
☉⚹☽	9:27 am

--- ☿☿☿ budhbar ---

♒

Wednesday
26

♀△♃	8:31 am
☽⚹♂	9:21 am
♀△♄	3:48 pm
☽□☿	7:12 pm

--- ♃♃♃ brihospotibar ---

♒
♓

Thursday
27

☽□♀	3:32 am
☽□♅	9:53 am v/c
☽→♓	11:24 am
♄D	7:52 pm
☉□☽	10:59 pm

Waxing Half Moon in ♓ Pisces 10:59 pm PST

--- ♀♀♀ sukrobar ---

♓

Friday
28

| ☽□♂ | 7:58 pm |

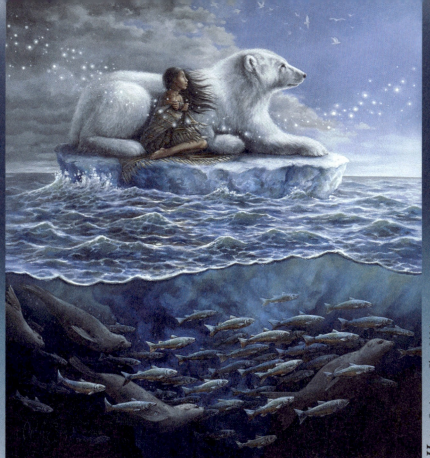

Hope © Autumn Skye 2021

♓
♈

Saturday
29

☽△♅	12:54 am	☽⚹♅	3:33 pm
☽△♃	7:45 am	☽☌♆	4:05 pm v/c
☽♂	8:42 am	☽→♈	5:07 pm
♅D	9:38 am	♀☍♅	6:48 pm
☽△♀	3:13 pm	☽⚹♇	8:22 pm

♈

Sunday
30

♀△♆	12:48 am
♂ApG	2:47 am
☉△☽	7:59 am
♀→♐	12:13 pm

December
Mí na Nollag

In this Time of Almost,
the world waits as the
Dying Ways and the New
pass one another
under the waxing moon.
excerpt © Nan Brooks 2023

))) Dé Luain

♈
♉

Monday
1

D △ ♂ 2:14 am
D □ ♃ 10:14 am v/c
D → ♉ 7:13 pm
D □ ♂ 10:20 pm

♂♂♂ Dé Máirt

♉

Tuesday
2

♀ ⚹ ♇ 1:07 am

☿☿☿ Dé Céadaoin

♉
♊

Wednesday
3

D ☍ ♉ 6:06 am
D ⚹ ♃ 9:56 am
D ⚹ ♄ 11:15 am
D ♂ ♅ 5:07 pm
D ⚹ ♆ 5:50 pm v/c
D → ♊ 6:48 pm
D △ ♇ 9:53 pm

♃♃♃ Dé Ardaoin

♊

Thursday
4

D ☍ ♀ 1:49 am
D PrG 3:06 am
☉ ☍ D 3:14 pm
☿ ⚼ ♇ 7:35 pm

♀♀♀ Dé Haoine

Full Moon in ♊ Gemini 3:14 pm PST

♊
♋

Friday
5

D ☍ ♂ 6:23 am
D □ ♄ 10:19 am
♂ △ ♇ 2:03 pm
D □ ♆ 4:55 pm v/c
D → ♋ 5:54 pm

ALL ASPECTS IN PACIFIC STANDARD TIME; ADD 3 HOURS FOR EST; ADD 8 HOURS FOR GMT

We're All Downstream

Upwind or downstream.
It doesn't much matter.
We're all affected.

See, that's the way it is with a living being. Life can't be compartmentalized. It can be divided up with railways, roads, flight paths, fences, imaginary borders, all. But the air, the water, the soil, the blood . . . is all connected, either way. It all moves downstream, borders be damned. That's the way it is. It can't be regulated, only protected or invaded.

Blood and breath move. What moves in to the Earth out of us, moves back into us, out of the Earth. In the end it's all one thing. Upwind, downwind. Upstream, downstream. It's all one living, breathing, blood-pumping, flesh and soil, water and oil creature of being. We're connected, and not by the roadways so much as the waterways, the Earth ways. Like it or not . . . we're all downstream.

¤ *Earthdancer 2023*

Moonstone Heart © *Fiona McAuliffe 20*

♄♄♄ Dé Sathairn

♋ ◐ **Saturday**
6

☿△♃ 5:05 am

☉☉☉ Dé Domhnaigh

♋ ◑ **Sunday**
♌ **7**

♂⚹♃	1:55 am	☽⚹♅	4:44 pm
☽♂♃	8:51 am	☽△♆	5:45 pm v/c
☿△♄	8:58 am	☽→♌	6:48 pm
☽△♄	10:50 am	☽☍♇	10:17 pm
☽△♀	10:59 am		

December
diciembre

♌

Monday
8

☽△♀ 11:55 am
♂□♄ 4:15 pm

♌
♍

Tuesday
9

☉△☽ 12:59 am
☽△♂ 4:06 pm
☽□☿ 7:26 pm
☽□♅ 8:56 pm v/c
☽→♍ 11:20 pm

♍

Wednesday
10

♆D 4:23 am
☿⚹♅ 11:59 am
☽□♀ 11:47 pm

♍

Thursday
11

☿△♆ 2:19 am
☉□☽ 12:52 pm
☿→♐ 2:40 pm
☽⚹♃ 7:44 pm
☽⚹♄ 11:00 pm

Waning Half Moon in ♍ Virgo 12:52 pm PST

♍
♎

Friday
12

☽□♂ 3:56 am
☽△♅ 5:19 am
☽⚹♆ 6:51 am v/c
☽→♎ 8:04 am
☽⚹☿ 10:02 am
☽△♇ 12:20 pm

ALL ASPECTS IN PACIFIC STANDARD TIME; ADD 3 HOURS FOR EST; ADD 8 HOURS FOR GMT

Sankofa*

I am Sankofa
feet planted forward
head turned backwards
moving through space

out of the corner of my eye
I glimpse the shimmering veil
between past and future

what is ahead
what is behind
meets here
at this ghost bridge
in the glimmering
shadows of time

tell me the secrets
spin the threads of hope
of prosperity
into silvery strands
to be woven into
luminous patterns
of new life

© Belinda A. Edwards 2023

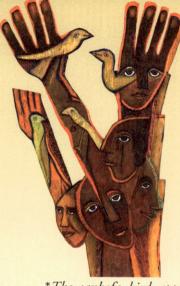

No Justice, No Peace © Betty LaDuke 2022

* *The sankofa bird appears frequently in traditional Akan art, and has also been adopted as an important symbol in an African-American and African Diaspora context to represent the need to reflect on the past to build a successful future. It is one of the most widely dispersed symbols, appearing in modern jewelry, tattoos, and clothing.*

───── ঽঽঽ sábado ─────

Saturday
13

♂ ⊼ ♅	1:43 am
♀ ⋆ ♇	8:32 am
☽ ⋆ ♀	4:54 pm

───── ⊙⊙⊙ domingo ─────

Sunday
14

♂ □ ♆	3:44 am	⊙ ⊼ ♃	6:30 pm
⊙ △ ⚷	4:36 am	☽ ⋆ ♂	7:36 pm v/c
⊙ ⋆ ☽	5:20 am	☽ → ♏	7:51 pm
☽ □ ♃	6:33 am	♂ → ♑	11:34 pm

Shell Woman Speaks for the First Time

I am the undertow
dragging you out to sea
 I am the belly of a rattlesnake
 warm against desert sand
 I am the April moon
 rising over the ridge
 I am the unruly child
 throwing a tantrum

I am the fossil at your feet
Eagle watching from a high cliff
Coyote cry
 and devoured rabbit
 Fungus on dying birch
 Fly on spoiled meat
 a sudden updraft, spinning milkweed
 Pause of stone on sea bottom
 Fool veering from the path—

 I am the shadow you cast as you walk toward the sun.

 I am all that you dream of
 When you dream all that you are—
 I am all that you truly need
 When your heart fully desires

 I am what is
 becoming
 and what is
 ending—

You see, I am the whole cycle of these things.

There is no difference
 in the deep well
 between the bright clear waters of love
 and the dark muddy waters of love
no difference between us, my friend,
no difference at all.

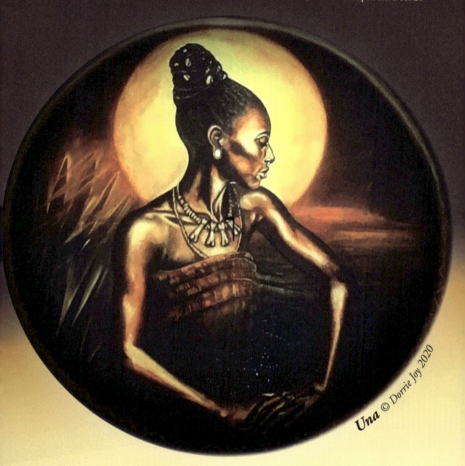

Una © *Dorrie Joy 2020*

project unknown

it is not whether
the chalice is half empty
 half full
it is whether one can pour
 shadow-light
from both

© *patti sinclair 2020*

December
prosinac

─── ♌♌♌ ponedjeljak ───

♏

Monday
15

☽□♇ 12:24 am

─── ♂♂♂ utorak ───

♏

Tuesday
16

☽△♃ 6:46 pm
☉□♄ 8:33 pm
☽ApG 10:09 pm
☽△♄ 11:30 pm

─── ☿☿☿ srijeda ───

♏
♐

Wednesday
17

☽☍♅ 5:25 am
☽△♆ 7:24 am v/c
☽→♐ 8:38 am
☽⚹♇ 1:19 pm

─── ♃♃♃ četvrtak ───

♐

Thursday
18

☽♂♅ 2:01 am
♀△♄ 1:17 pm
♀⛢♃ 5:45 pm

─── ♀♀♀ petak ───

♐
♑

Friday
19

☽♂♀ 8:19 am
☽□♄ 12:04 pm
☉⛢♅ 3:34 pm
☉♂☽ 5:43 pm
☽□♆ 7:41 pm v/c
☽→♑ 8:52 pm

New Moon in ♐ Sagittarius 5:43 pm PST

ALL ASPECTS IN PACIFIC STANDARD TIME; ADD 3 HOURS FOR EST; ADD 8 HOURS FOR GMT

2025 Year at a Glance for ♑ Capricorn (Dec. 21–Jan. 19)

How have you felt adultified? That may sound like a silly question, especially if you are already all grown up. However, I challenge you to journal the definition of adulthood. How do you define what it means to be mature? When did you find yourself having to assume the role of being grown? Taking time to reflect on the idea of maturity might feel cathartic. You may have moments when you mourn certain decisions or regret a few choices. Try to find relief in the fact that, as a species evolves, we can observe firsthand that true strength is in adaptation (not perfection)—use this evidence of scientific allowance to give ourselves grace. Many of us grew up far faster than we should have, and what we considered as grown-up may have been maladaptive and hurtful. Permit yourself to acknowledge how you might have missed the mark. Chances are you are the sum of those around you, and those around you did their best with what they were afforded. We can never relive our experiences—however, we can always rejoice that each day brings new opportunities. Take each day in 2025 with optimism and childlike wonder, especially during Taurus' season, which runs from April 19th until May 20th. In moderation, try indulging in behaviors that you were taught were immature. Let yourself rediscover youthful wisdom. How were your words minimized or ignored when you were a child? Now is the time to be an adult who hears their inner child out.

Monisha Holmes © Mother Tongue Ink 2024

Peace Prayer
© Avalana Levemark 2019

☩☩☩ subota

♑

Saturday
20

☽♂♂ 4:42 am
☉□♆ 5:02 pm
♀□♄ 9:09 pm

☉☉☉ nedjelja

♑

Sunday
21

♃□♇ 2:09 am
☉→♑ 7:03 am
☽☍♃ 5:26 pm
☽⚹♄ 11:27 pm

Winter Solstice

☉→♑

Sun in ♑ Capricorn 7:03 am PST

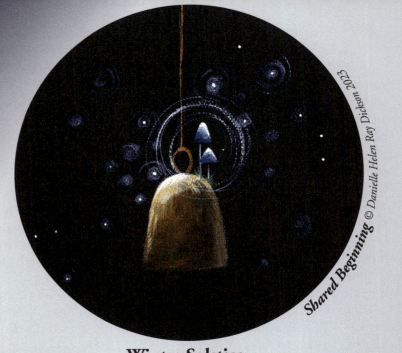

Shared Beginning © Danielle Helen Ray Dickson 2023

Winter Solstice

Stillness and Silence descend upon the land. We turn to the void and befriend the dark, where dreams are born. Slither with Snake to the other side of suffering. She finds a lightless space, becomes still, without sight, and sheds her old skin. Travel down deep into the belly of the Mother. Feel Earth envelop you like a midnight blanket. Hush. The wisdom of Gaia is heard only when we become quiet and still.

Love and Harmony reign in the collective dream of a new world. We are challenged with the task to forgive what has been. Making peace with what is, we make space to create something new. Brave the unknown path ahead. Our intentions and manifestations must not be limited by our own imagination. What awaits is beyond our wildest dreams and wondrous imaginings.

Allow the hand of the Goddess to work in our world and hearts. Greet the flicker of ever-present light within. This heart flame will grow through the season and deliver us and our kin to Spring when the light of Sun returns.

Mahada Thomas © Mother Tongue Ink 2024

indigo

the dark night holds
the stars in place, and i see
that they are pinpricks
in the fabric of creation—
i hear the song of the woman
who, in the time before,
stepped forth from the light.
the stories tell of her singing,
how her songs unraveled
her heavy robes of black
velvet and indigo,
how her voice had wings,

carrying the fabric to
the edges of existence—
how she stood, proud,
alone, and naked in
the emptiness of the void,
how she laughed and sang
as she took the pin from
her hair, piercing the fabric
that enveloped all time,
creating the stars—
creating the spaces where
the light enters.

© Julia Flint 2023

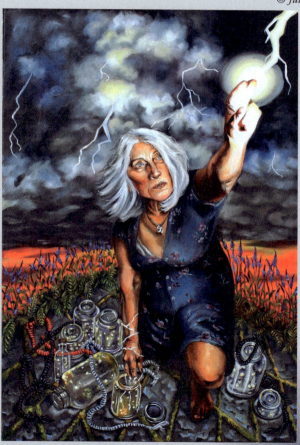

Tempestratti © Melissa Stratton Pandina 2023

December
Ogrohaeon

♈︎
≈

Monday
22

☽△♅ 4:26 am
☽⚹♆ 6:44 am v/c
☽→≈ 7:52 am
☽☌♇ 12:37 pm
♀⚻♅ 10:22 pm

≈

Tuesday
23

☽⚹♉ 3:54 pm
♀□♆ 9:31 pm

≈
♓

Wednesday
24

♀→♈︎ 8:26 am
☽□♅ 1:42 pm v/c
☽→♓ 5:09 pm
☽⚹♀ 6:06 pm

♓

Thursday
25

☉⚹☽ 12:13 am
☽⚹♂ 7:45 am

♓

Friday
26

☽□♉ 7:02 am
☽△♃ 9:43 am
☽☌♄ 4:41 pm
☽⚹♅ 8:37 pm
☽☌♆ 11:03 pm v/c

ALL ASPECTS IN PACIFIC STANDARD TIME; ADD 3 HOURS FOR EST; ADD 8 HOURS FOR GMT

on the pyre

we are sitting on a precipice
—and there are many ways to fall
we are sitting on the edge of
a system that is more fragile
than we can ever imagine.

we are sitting amongst
the most ancient wisdom
that seeps up from the
earth carrying particles
of the past into the now
we are sitting beneath
a source of knowing
that shines down on us
from a place
we might only see.

let us not forget
that we are capable
of caring in ways
that we cannot
yet even imagine.

we hold the capacity
to shift our trajectory
one degree or two
or how ever many degrees
it might take
to ignite a pyre of resiliency.

and so it shall be.

excerpt ¤ morgan leigh callison 2020

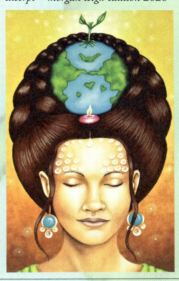

Un autre monde
© Nolween LM 2021

ꓥꓥꓥ sonibar

♓︎
♈︎

Saturday
27

☽→♈︎ 12:02 am
☽⚹♇ 4:37 am
♀☌♃ 5:16 am
☽□♀ 6:33 am

☉□☽ 11:10 am
☿△♆ 4:15 pm
☽☌♂ 5:05 pm

Waxing Half Moon in ♈︎ Aries 11:10 am PST

◯◯◯ robibar

♈︎

Sunday
28

☽□♃ 1:59 pm
☽△☿ 6:13 pm v/c

Dec. 2025 / Jan. 2026

Mí na Nollag / Mí Eanair

ꝺꝺꝺ Dé Luain

♈
♉

Monday
29

☽→♉	3:57 am
☽□♇	8:24 am
☽△♀	3:03 pm
☉△☽	6:21 pm
☽△♂	10:54 pm
☿□♄	11:15 pm

♂♂♂ Dé Máirt

♉

Tuesday
30

☽⚹♃	3:27 pm
☽⚹♄	10:58 pm

☿☿☿ Dé Céadaoin

♉
♊

Wednesday
31

☽♂♅	1:56 am
☽⚹♆	4:25 am v/c
☿⚻♅	5:08 am
☽→♊	5:13 am
☽△♇	9:34 am

♃♃♃ Dé Ardaoin

♊

Thursday
1

January 2026

☿□♆	5:33 am
☿→♑	1:11 pm
☽PrG	1:55 pm
☽□♄	11:09 pm

♀♀♀ Dé Haoine

♊
♋

Friday
2

☽□♆	4:23 am v/c
☽→♋	5:09 am
⚷D	5:41 am
☽☍♉	6:58 am

This Place

We walk around this place
Pretending that we don't know what we're doing
Collecting feathers and flowers and rocks
And curating our altars As if we hadn't the slightest clue
Of the sacredness of our movements, we fill our spaces
With papers and words and questions we don't remember
That we are the answers
That we are the poetry
The stories. The Grace
That even in our disillusioned state
Delivers us Over And over
And over, again
As we birth our ephemeral selves
Like the seasons
Bloody and screaming and beautiful
Back into the world
To play another round
Of hide and go seek with our Selves
Duly and sincerely searching for our radiance
Collecting feathers
And flowers
And rocks.

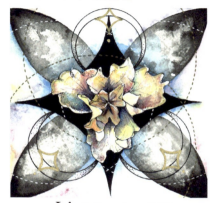

Iris © *Dana Lynn 2017*

© *Kirstin Olsen 2023*

ꜱꜱꜱ Dé Sathairn

Saturday
3

☾☍♀ 12:40 am
☉☍☽ 2:03 am
☾☍♂ 4:37 am
☾♂♃ 2:54 pm
☾△♄ 11:44 pm

◎◎◎ Dé Domhnaigh

Full Moon in ♋ Cancer 2:03 am PST

Sunday
4

☾⚹♅ 2:11 am
☾△♆ 4:59 am v/c
☾→♌ 5:43 am
☾☍♇ 10:25 am

WE'MOON EVOLUTION: A COMMUNITY ENDEAVOR

We'Moon is rooted in womyn's community. The datebook was originally planted as a seed in Europe where it sprouted on women's lands in the early 1980s. Transplanted to Oregon in the late '80s, it flourished as a cottage industry on We'Moon Land near Portland in the '90s and early 2000s, and now thrives in rural Southern Oregon.

The first We'Moon was a handwritten, pocket-size women's diary and handbook in Gaia Rhythms, translated in five languages! It was self-published under the name of Mother Tongue Ink, by me and my partner Nada in 1981, in France—in collaboration with friends from Kvindelandet ("women's land") in Denmark. We'Moon was inspired by our experience of living there together in a lively international community of 20–40 lesbian feminists in the late 1970s.

The first five editions of We'Moon were created by friends in different countries in Europe, voluntarily, as a "labor of love"—publicized mostly by word-of-mouth and distributed by backpack over national borders. When I returned to America with We'Moon, it changed to a larger, more user-friendly format as we entered the computer age. We grew into the business of publishing by the seat of our pants, as a community-run cottage industry on We'Moon Land, from 1988–2008. Starting with a little seed money, we recycled the proceeds into printing the next We'Moon, each year. By the early '90s, we finally sold enough copies to be able to pay for our labor. We'Moon Company was incorporated (dba) Mother Tongue Ink, and it has grown abundantly with colorful new fruits ever since! For a full listing of current We'Moon publications, see pp 233–235.

Whew! It was always exciting, and a lot more work than we ever imagined! We learned how to do what was needed. We met and overcame major hurdles that brought us to a new level each time. The publishing industry has transformed: independent distributors, women's bookstores and print-based publications have declined. Nonetheless, We'Moon's loyal and growing customer base continues to support our unique womyn-created products. This home-grown publishing company is staffed by a resilient and highly skilled multi-generational team—embedded in women's land community—who inspire, create, produce and distribute We'Moon year in and year out.

Every year, We'Moon is created by a vast web of womyn. Our Call for Contributions goes out to thousands of women, inviting art and writing on that year's theme (see p. 236). Women are invited to attend

Selection Circles to review submissions and give feedback—now online, since 2020, when the pandemic required turning these circles into virtual Zoom meetings . . . which has now extended our outreach world-wide! The We'Moon Creatrix then collectively selects, designs, edits, and weaves the material together in the warp and woof of natural cycles through the thirteen Moons of the year. All the activity that goes into creating We'Moon is the inbreath; everything else we do to get it out into the world to you is the outbreath in our annual cycle. To learn more about the herstory of We'Moon, the art and writing that have graced its pages, and the Spirit that has breathed through it for 43 years now, check out the 2011 Anthology: *In the Spirit of We'Moon* on page 233.

WE'MOON LAND

We'Moon Land (where the We'Moon was originally published in the U.S.) is a residential womyn's land community—a nature sanctuary for womyn ("wemoon" by nature) that has been held by and for wemoon, since 1973—one of the longest surviving intentional wemoon land communities in the world. Generations of wemoon (primarily lesbians) have made home here for over 50 years, in a community committed to living together in harmony with one another and all our relations. We live in wemoon-built houses, on 52 beautiful acres of forests and fields, an hour from Portland, Oregon. We host individual and group events, retreats, visitors, camping, workshops, land workdays, seasonal holy days, Moon circles, celebrations and gatherings of, by and for wemoon.

Founded on feminist values, ecological practices and earth-based women's spirituality, we are calling for a more diverse, generationally interwoven community of wemoon-who-love-wemoon, and who share our vision of creative spirit-centered life on the land, to come join us! We are at a crucial point of generational succession, transitioning to collective ownership, and looking for new residents with shared values, and the resources and commitment necessary to carry We'Moon Land community on in a sustainable way—for years to come. Do you have experience in community living, wemoon culture and spirituality, healthy communication, conflict-resolution, organizational skills? Are you good at land work, fixing things, earth-friendly building, organic gardening, permaculture, natural healing, the creative arts? If so, contact us! FFI: wemoonland@gmail.com, wemoonland.org

Musawa ▢ Mother Tongue Ink 2023

IX. Hermit / Crone

Jewel of the Night © Tanainu Phillips 2017

Wisdom

9 of Fire

I Overcome, Not Without Help © Sophia Kelly Shultz 2009

Creative Fire

9 of Air

Remembering Joy © Nancy Watterson 2005

Prayer Flags Flying

A We'Moon Tarot Reading for 2025

If we apply the numerology of the year 2025 (ie., adding up the numbers = #9) to the theme for this year, what clues does that give you about what to expect this year? The cards identified by the number nine, on this page illustrate a We'Moon interpretation of what that number signifies in different element suits. Although the numbers on the cards, and the number of cards in each suit are the same in all "tarot decks"... different images are used to portray different perspectives on the meaning of the numbers in each suit—with different underlying values being portrayed, accordingly. So it makes a big difference what deck you are using! What do the images on the number nine cards in the *We'Moon Tarot* deck displayed here say to you about what's happening in your life, and in the world at large, this year?

Musawa © Mother Tongue Ink 2024

9 of Earth

Cosmic Walking © Denise Kester 2015

All Our Relations

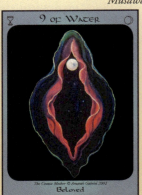

9 of Water

The Cosmic Mother © Amanah Gabriel 2002

Beloved

XVIII. The Moon

Luna, by Cathy McClelland © Mother Tongue Ink 2020

Lunar Power

see pages 18 and 19 for an interpretation by Joanne M. Clarkson of the four #9 cards in each suit of conventional tarot.

STAFF APPRECIATION

Let's shine the light on our exceptional team whose unwavering dedication and remarkable talents have moonifested yet another brilliant book of daily devotions—a gorgeous work of creativity and inspired offering for you, our blessed We'Moon devotees.

Bethroot, our clever special editor, brings her keen insight and meticulous attention to detail, polishing each treasured edition. The tireless efforts of our graphic designer, Sequoia, has brought creativity and vibrancy to the pages, making We'Moon ever more visually stunning. Claire's dedicated and consistent marketing and customer relations has amplified our reach, connecting We'Moon with a diverse audience. Sue's attention to detail and loving collaboration with our bookstore clients keeps our bread buttered and the administrative cogs flowing smoothly. Together we make up the Creatrix team, each lending her creative eye and savvy opinions as we put together each new edition.

In the shipping department, we say *thank you and see you around* to Erin, who has moved on to pursue her calling as a massage therapist. Our time with you here in the office has been bright and joyful! And in turn, we give a warm welcome to the newest member of our team, Maya Lila. We are excited to have you along on this journey! And Susie, we are all in deep gratitude for your reliability, resourcefulness, and the positive energy you bring. Your role as shipping coordinator is an essential part of our mission to spread beauty and inspiration. Your efforts are truly valued.

I want to give each and every one of us kudos for maintaining this collaborative, inspiring work environment that fosters innovation and inspiration. The love that we see reflected for We'Moon is a testament to the collective passion and expertise of our incredible team. Thank you for the parts that you play to shine this beacon of light that is We'Moon!

Barbara Dickinson © Mother Tongue Ink 2024

Left to Right: *Susie, Barb, Sequoia, Sue, Bethroot, and Claire*

We'Moon Ancestors

Reverence
◻ *Lisa J. Rough 2014*

We honor wemoon who have gone between the worlds of life and death recently, beloved contributors to wemoon culture who continue to bless us from the other side. We appreciate receiving notice of their passing.

Alice Kahn Ladas (1921–2023) was a pioneering sexologist, psychiatrist, and body psychotherapist. Her graduate studies dissertation was on breast feeding, centering the La Leche League. She was proud that her doctoral work influenced more women to breast feed. She cared about connecting the body and mental health, and as an educator, she focused on childbirth and women's sexuality. She was one of the first Lamaze childbirth instructors in the US. Alice co-authored the 1982 sensation *The G Spot.*

Alice Shalvi (1926–2023), educator and activist, did ground-breaking work to create and galvanize the feminist movement in Israel. She integrated her wisdoms as a teacher and mother, with reverence for Jewish religious texts—and with defying the rabbinate's traditional discriminations against women. She founded an experimental school with egalitarian teachings for orthodox girls, and was founder of the Israel Women's Network, mobilizing feminist insistence on equality for women in Israeli society. She dared to dialogue with Palestinian and Israeli women together.

Armita Geravand (2006–2023), a young Iranian woman, was accosted by Iran's Morality Police for not wearing a headscarf/hijab—required of women by Islam's strict Sharia law. Details are unclear, but during a struggle, Armita fell, hit her head, went into a brain coma. She was hospitalized and unconscious for four weeks until declared dead. Armita is the second young Iranian woman to die in similar circumstances and to be remembered in We'Moon.

Cheri Pies (1949–2023), author of *Considering Parenthood: A workbook for Lesbians*, and mentor/advocate for women's health and social justice. She was a teacher emeritus at UC Berkeley, published dozens of papers, and was beloved by students. Cheri was perhaps proudest of her role reducing infant mortality rate with the Best Babies Zones Initiative. In all of her work, she focused on repairing the impacts of racial and economic inequality on health.

Dianne Feinstein (1933–2023) was an American politician, serving as a California senator From 1992 until her death. A life-long Democratic Party member, she served as mayor of San Francisco from 1978 to 1988. A San Francisco native, Dianne graduated from Stanford University in 1955. She used her political position to fight for women's reproductive rights, gun control, climate protection, and to support the LGBTQ community.

Evelyn Fox Keller (1936–2023) was a physicist, author, and feminist. She was born in Queens, New York to Russian Jewish immigrants. She taught at MIT and UC Berkeley. As a philosopher of science, Evelyn re-visioned ideas of science, gender, and biological determinism. She authored a copious number of published works and received at least 16 honors and awards, among them, the MacArthur Foundation Genius Grant in 1992.

An unusual convergence guides us to place together our honoring of Orinthia Montague and Joanne Epps. Both Black women, and both university Presidents. Both died suddenly within three days of each other. This sad coincidence has led some women of color in academia to call attention to the multiple and acute stresses that often challenge BIWOC teachers and administrators in academic life.

Orinthia Montague (1967–2023), a beloved college administrator, was President of Volunteer State Community College in Tennessee. She had been a community college President in New York, and had over 30 years of experience in higher education administration. Orinthia was passionate about helping students achieve their dreams through education. She brought enthusiasm, and compassion to her work with students and colleagues.

JoAnne Epps (1951–2023) was a prominent legal scholar and President of Temple University in Pennsylvania. She served on the faculty at Temple Law School for many years, and was a potential Supreme Court candidate during Barack Obama's presidency. JoAnne was nationally acknowledged as an influential leader in legal education, experiential learning, and social justice, working internationally with lawyers who assisted victims of violence in Rwanda and Darfur.

Judy Heumann (1947–2023), mother of the Disability Rights Movement, was a tenacious, and imaginative pioneer for disability rights. She contracted polio as a young child and, wheelchair bound, was denied opportunity everywhere. Her mother fought hard for Judy to attend school, and modeled the dogged success that Judy perfected in a lifetime of protests and campaigns, lawsuits and lobbying, developing legislation, sitting in, writing and teaching. She co-founded disability rights organizations, and worked within and despite governments to insure equality.

Minnie Bruce Pratt (1946–2023) was an American poet, educator, activist, professor, mother, and essayist. In 1977, Minnie helped to found WomanWrites, a Southeastern lesbian writers conference. She was the mother of two sons and wrote *Crime Against Nature*, a book of poetry chronicling losing custody of her children after coming out as a lesbian. She taught Women's Studies and developed the first LGBT studies program at Syracuse University. Minnie was the widow of author Leslie Feinberg. They shared 22 years together.

Patricia Schroeder (1940–2023) was the first woman elected to the Colorado House of Representatives, serving from 1973–1997. Pat fought for gun control and reduced military spending, and was instrumental in passing the Family Medical Leave Act. "I have a brain *and* a uterus, and they both work." Pat authored two memoirs: *24 Years of Housework...and the Place Is Still a Mess: My Life in Politics* and, with co-authors: *Champion of the Great American Family: A Personal and Political Book*.

Sandra Day O'Connor (1930–2023) was the first woman to be appointed to the US Supreme Court, serving from 1981 to 2006. Noted for her meticulous research and carefully phrased opinions, she was a moderate conservative, sometimes joining liberal colleagues in significant opinions. She wanted to demonstrate that women could do the job of justice. Thank you, Sandra, for living that example!

Wyrda/Laura Cook (1961–2023), was famous among West Coast lesbians for her song that began: "I went to a lesbian potluck; all my ex-lovers were there..." Funny, ironic, and brilliant; an iconic butch: tough, and soft. Wyrda lived on women's land (OWL Farm) for five years, and enlivened lesbian culture as a singer, actor, writer, comedian. Her 1994 booklet *Surviving My Mother's Virginity and Other Stories* and her *Lesbian Potluck* album vibrate with her unique voice.

© Copyrights and Contacting Contributors

Copyrights for most of the work published in We'Moon belong to each individual contributor. Please honor the copyrights: ©: do not reproduce without the express permission of the artist, author, publisher or Mother Tongue Ink, depending on whose name follows the copyright sign. Some wemoon prefer to free the copyright on their work: ¤: this work may be passed on among women who wish to reprint it "in the spirit of We'Moon." In all cases, give credit to the author/artist and to We'Moon, and send each a copy. If the artist has given permission, We'Moon may release contact information. Contact mothertongue@wemoon.ws or contact contributors directly.

Contributor Bylines and Index
See page 236 for info about how YOU can become a We'Moon contributor!

Abby Buchold (Houston, TX) lives in a lovely little house full of books and tea with her scientist husband and three cats. She paints with gouache and experiments with mixed media, always focused on nature (and the spirits that may hang out there). You can find her on IG: @the_paint_witch_ **p. 29**

Alia Alsaif Spiers (Erie, CO) is a queer Saudi American spiritual alchemist, oracle reader, and philosopher who is passionate about divine evolution through self-discovery, cyclical living, and decolonization. IG: @alchemicvigor **p. 105**

Amy Allen—Mandalamy Arts (Topeka, KS) is a visual artist, homeschooling mom, and former clinical psychologist. She incorporates a sense of wonder, connection, and inner healing into her art. She can be found as Mandalamy Arts on social media and at mandalamy-arts.square.site **p. 232**

Ann Filemyr (Santa Fe, NM) PhD, is the President of Southwestern College in Santa Fe and founder/director of the doctoral program in Visionary Practice and Regenerative Leadership. For more see: swc.edu **p. 170**

Anna Lindberg Art (Maui, HI) I am a professional Swedish artist working from my studio in Hawaii. I often use the Divine Feminine as my source of inspiration, depicting Goddesses from many different cultures, using different techniques in my artwork. I wish to inspire and empower women all over the world through my art. Annalindbergart.com, IG: @anna.lindberg.art **p. 79, 127**

Ardis Macaulay (Yellow Springs, OH) Artist, Poet, Art Therapist, Art Educator, Workshop Facilitator, inspired by Jungian thought and global travels to sacred sites. Guided by dreams, she enters a trance allowing spontaneous imagery to emerge. macaulay.3@wright.edu **p. 47**

Ashley J Nordman (Powell River, BC) is a narrator of wonder and storyteller of Self. She lives as a professional educator, leader, writer and emerging artist in the qathet region on the Sunshine Coast. Mother of multitudes and Nature escapist, find her @ashleyjnordman **p. 162**

Autumn Skye (Powell River, BC) I offer my art as a mirror, both an intimate personal reflection and a grand archetypical revelation. Within these visions, may each viewer recognize their own sacred heart and cosmic divinity, and through this recognition, may we remember our innate grace. autumnskyeart. com, FB: Autumn Skye ART, Etsy: AutumnSkyeART **p. 89, 125, 165**

Autumn Willow (GA) is the author behind the blog *Flying the Hedge* where she has been documenting her journey in hedgecraft, spirit communication, and folklore since 2014. With 20 years of magical experience, Willow strives to fill the gap in hedgecraft knowledge, taking a practical approach rooted in science and history. flyingthehedge.com **p. 16**

Avalana Levemark (Devon, UK) Illustrator and gardener, open for commissions and collaborations. deviantart.com/trollabunden **p. 113, 173**

Barbara Dickinson (Sunny Valley, OR) is trundling happily along on this adventure of life, ever curious, always learning, constantly course-correcting. May we all harvest every last drop of joy from each moment. **p. 4, 183**

Barbara Landis (San Francisco, CA) is a fine art photographer creating images locally and abroad. Practicing Nichiren Shoshu Buddhism since 1968, she belongs to Myoshinji Temple. Barbara is also a member of San Francisco Women Artists and ArtSpansf. IG: barbara_landis_photography **p. 40**

Bayla B Greenspoon (Mt. Shasta, CA) Labels I claim today: activist, artist, aunt, crone, dog mom, friend, gardener, immigrant, Jew, kitchen creatrix, lesbian, middle child, musician, overeater, pagan, partner, privileged, seeker, sister, teacher, traveler, writer . . . and fierce lover of the magnificently diverse expressions of all life. **p. 114**

Beate Metz (Berlin, Germany) was an astrologer, feminist, translator and mainstay of the German edition of We'Moon's, as well as of the European astrological community. **p. 207**

Belinda A. Edwards (Santa Fe, NM) is an African American writer. She was recently nominated for the 2023 Pushcart Prize. She is an Amherst Writers and Artists group Facilitator and offers writing groups. belinda2edwards.com **p. 143, 169**

Bernice Davidson (Summertown, TN) is a civil rights artist who creates murals and public works in a small southern town, pointing to heroes of heart. She also keeps sketch diaries of dreams and mystical musings. bernicedavidsonart.com **p. 133**

Beth Budesheim (Santa Fe, NM) Artist, Energy Healer, Intuitive Guide, Body Tuning. Prints, Originals, Guided Meditations, PrayerCards Oracle, In-Person & Remote Healing Sessions and Events: bethbudesheim.com IG: bethbuddha YouTube: @bethbuddha08 **p. 41**

Bethroot Gwynn (Myrtle Creek, OR) 29 years as We'Moon's Special Editor & 49 at Fly Away Home women's land, growing food, theater & ritual. For info about spiritual gatherings, summertime visits send SASE to POB 593, Myrtle Creek, OR 97457. For info about her book of poetry and plays, *PreacherWoman for the Goddess*, see p. 233. **p. 23, 25**

Betty La Duke (Ashland, OR) "Your creations are filled with joy, delight, and hope, all of which we desperately need right now."—Gov Kate Brown, 2020. bettyladuke.com **p. 169**

Brigidina (Elgin, IL) is the Visionary Advisor for MUSEA University, an Eco-Artist, Earth Activist, Curator, Creative Doula Coach and Teacher. Her Sacred Eartistry is created using natural Earth pigments, sacred cedar & rose oils, 700 yr old peace fire coals, local honey, and healing waters from 54 sacred sites around the world. brigidina.com **p. 73**

Carolyn Sato (Cave Creek, AZ) creates sculptures that celebrate life; convey meaningful messages; lift spirits; and bring newness, connectedness, and the Feminine Voice to the world of bronze. soulartbycarolynsato.com **p. back cover, 42, 81**

Cathy McClelland (Kings Beach, CA) Cathy paints from inspirations that stir her heart and imagination. Nature, the stars, moon cycles, cross cultural mythology, and magical themes all fuel the fire of her creative spirit. cathymcclelland.com **p. 160**

Cherlyn–Mystic Art Medicine (Sedona, AZ) is a self-taught visionary artist painting in daily dedication for over three decades. mysticartmedicine.com **p. 145**

Chris Cavan (Almonte, ON) I am a grandmother, poet, writer, watercolour and mixed media artist who stays rooted to the sky among trees and by water. I create to delight and promote reflection and healing. chris.cavan@rogers.com **p. 73**

Christine Lowther (BC, Canada) Editor of *Worth More Standing: Poets and Activists Pay Homage to Trees*, and author of four poetry collections. From unceceded Tla-o-qui-aht Territory on so-called Vancouver Island. raggy@island.net christinelowther.blogspot.com **p. 109**

Chylene Crow (Jasper, AR) lives in a holler in the Ozarks. Her "Growing Edge" is to submit writing for the first time for publication. Health and help abound, all the world round. **p. 85**

Colleen Koziara (Itasca, IL) Artist, muralist, portrait artist, children's book writer & illustrator. colleenkoziara.com **p. 38**

Dana Lynn (Indianapolis, IN) is a mid-west artist who is inspired by the intricacies and beauty of nature, herbalism, and astrology. You can follow her artistic endeavors on IG & FB @danalynnartistry and Etsy: DanaLynnArtistry **p. front cover, 62, 179**

Danielle Helen Ray Dickson (Nanaimo, BC) I am drawn to the inherent beauty and spirit of the natural world. My artwork is a personal dialogue that reaches through the chaos to the spirit. I create dreamscapes, a collection from the journey we call life that speaks of life cycles, reflection, shadow, light, growth, loss, dreams, and the passage of time itself. danielledickson.com **p. 64, 174**

Debra Hall (Dumfriesshire, Scotland) I am a poet, artist and Soulmaker. My audio meditations for women can be found at InsightTimer.com on my teacher's page. I enjoy collaborating and hearing from We'Moon women. Herwholenature.com, IG: @her_whole_nature **p. 29, 154**

Denise Kester (Ashland, OR) is an artist, writer, and teacher. She is author of, *Drawing On The Dream*, a book about her unique art process and printmaking. Sign up for Art Lifts and Musings for new art, events, and classes. drawingonthedream.com **p. 85, 103**

Diane Lee Moomey (Half Moon Bay, CA) is a writer of poetry and painter of watercolors. Her work celebrates the Divine Feminine seen through the lens of the natural world. Please visit her at dianeleemoomeyart.com **p. 1, 117**

Diane Suzuki (Chico, CA) is an amateur basketmaker, a dreamer of peace, a justice advocate, and respects the earth and life. **p. 90**

Dorrie Joy (Somerset, UK) is a prolific intuitive artist working in many mediums. Grandmother, builder, Moon lodge dweller, she is committed to active decolonization and teaches traditional craft and ancestral skills. Books, prints, wildcraft, original art: dorriejoy.co.uk **p. 37, 108, 171**

Earthdancer (Golconda, IL) is a forest dweller and protector of the Shawnee National Forest, co-creator and multi-tasking mystic at Interwoven Permaculture Farm. FB: The Poetry of Earthdancer, interwovenpermaculture. com **p. 35, 167**

Elspeth McLean (Pender Island, BC) creates vivid, vibrant paintings completely out of dots. Each dot is like a star in the universe. Elspeth hopes her art connects the viewer with their inner child. elspethmclean.com **p. 150**

Elyse Welles (Honey Brook, PA) is a Greek-Egyptian American intuitive witch, podcaster & author. An initiate of the eclectic Faery Tradition, her practice is centered on land spirits and sacred places (numina). She is a monthly columnist for various witchy publications. seekingnumina.com **p. 87, 172**

Fiona McAuliffe (Eugene, OR) is a textile and lapidary artist living in central Oregon. She mixes painting, hand dyeing, drawing and embroidery with self cut and polished gemstones for truly unique handmade art. **p. 167**

Francene Hart Visionary Artist (Honaunau, HI) is an internationally recognized visionary artist whose work utilizes the wisdom and symbolic imagery of sacred geometry, reverence for the Natural Environment and interconnectedness between all things. francenehart.com **p. 20, 34, 66, 98**

freda karpf (Neptune, NJ) I am jealous of birds, and I love them. It's complicated. I write about the mystery of relationships in our world, grief, and its transformations, environmental woes, and those I love, while steeping in nature waiting to fledge. linktr.ee/fredakarpf **p. 68**

Gaia Orion (Sebright, ON) is a successful international artist. With her art, she envisions a peaceful and flourishing world. Join her monthly New Moon Zoom gatherings, a place for artists to support each other, connect, learn and flourish with our careers. gaiaorion.com **p. 3, 26**

Geneva Toland (Ames, IA) is a writer, singer, farmer and current student in Iowa State University's Creative Writing and the Environment MFA program. Find more of her work at genevatoland.com. **p. 147**

Gina Valdés (Lakeside, CA) poetry has been widely published in journals and anthologies in the United States, Mexico, and Europe. **p. 178**

Heather Roan Robbins M.Th. (Ronan, MT) is a practical, intuitive, choice-oriented astrologer and author of *Starcodes-Choice-Based Astrology*, the *Starcodes AstroOracle Deck*, the weekly Starcodes astrological forecast, and the books *Moon Wisdom* and *Everyday Palmistry*. She organizes the Shining Mountains Grove for the Order of Bars, Ovates, and Druids, and has an on-line global practice. roanrobbins.com **p. 8, 204, 205**

Helen N Hill (Ringwood, NJ) writeinkpaint.blogspot.com **p. 95**

Helen Smith (Herefordshire, UK) is a therapist and creative from the Welsh Marches. Her work is inspired by mythology, melancholy, and the relationship between people and nature. She prefers spending time in the woods rather than on her computer, but you can probably reach her at earthbodyart@gmail.com **p. 54**

Hope Reborn (Hana, HI) Every Creation a Meditation . . . Art is my favorite way to play and pray! Check out my instagram or website for more Art, Music and info about my "Artist Awakening" Creative Empowerment Course: @hope.reborn.creations, hopereborncreations.com **p. 15, 18, 147**

Hynden Walch (Los Angeles, CA) is an actress and writer. **p. 157**

Iréne de Brice (Saint Thomas, Virgin Islands) is a Costa Rican visionary artist and bioscientist. She integrates training in holistic health, herbal medicine, transformational art, and yogic science into all of her creative meditations. To learn more, visit puraprana.com **p. 149**

Ishka Lha (Medford, OR) is an internationally celebrated visionary artist, musician, writer, ritualist, and mentor from northern California. To learn more about her creative process and the meaning behind her work, please visit ishkalha.com & IG/FB @the.art.of.ishka.lha **p. 45**

Jacqueline Lois (Detroit, MI) is a poet first and foremost. In 2025, she celebrates the 50th Jubilee anniversary of her graduation from College. In gratitude, she returns to claiming space as a Writer, Elder and Healer who follows the seasons, wisdom cycles of the moon. jacquelinelois.com, breastfeeding365.com **p. 82**

Jakki Moore (Leitrim, Ireland) lives and works in her 300-year-old cottage in the west of Ireland. She is fascinated with ancient Irish history and occasionally conducts small tours to some of these magical places. She is the co-creator of The Sheela Cards. jakkimooreart@yahoo.com, jakkiart.com **p. 86, 99, 158**

Jeanette M. French (Gresham, OR) My purpose—inspiring relationship with spirit through portals of light, love, beauty, joy, hope & gratitude. jeanette-french.pixels.com **p. 57**

Jenna E. Jaffe (Asheville, NC) is a Jewish Queer Creatrix, multi-instrumentalist, educator, Gender Vocal/Life Coach, Lightworker and more. She is a social activist for justice, equality, and the preservation of our Mother Earth. linktr.ee/jennajaffe consciouscreating.org **p. 164**

Jennifer Nevergole (Glenside, PA) MA, LCSW, SEP somaandthesoul.com **p. 51**

Jennifer Pratt-Walter (Vancouver, WA) is a modestly proud Crone who marvels at the small daily miracles all around us. She is active in poetry and digital photography and is a professional harpist. Jennifer has three grown children, a husband and a small farm. fearnopoetry.blogspot.com **p. 77, 111, 156**

Jill Althouse-Wood (Wilmington, DE) is an author/artist living and working in the artist colony of Arden, Delaware. For more information on her art and writing visit jillalthousewood.com **p. 123, 128, 131**

Joanne M. Clarkson (Port Townsend, WA) is a palm and Tarot reader who also writes poetry. Her 6th collection, *Hospice House*, was published by MoonPath Press in 2023. Retired, she worked for many years as a Hospice Nurse. See more at joannethepsychic.com **p. 18, 31**

JoAnne Dodgson (Medanales, NM) offers ceremonial healing, apprenticeships, and throwing the bones. She loves the healing medicines of stories, art, and ceremony to awaken our hearts and weave balance on our earth. joannedodgson.com **p. 99**

Jonah Ruh Roberts (Unify, NH) jonahruhroberts.com **p. 42**

Julia Flint (Point Pleasant, WV) is a writer. She can be reached at june.poems@gmail.com **p. 175**

Kaitlin Ilya Wolf (Black Mountain, NC) is an ordained Priestess, ritualist, communitarian, spiritual counselor, and teacher. She loves supporting women on their journey into earth centered ritual & ceremony and leading women's circles & Red Tents. priestessofcycles.com **p. 93**

Karen L. Culpepper (DC, Maryland, Virginia tri-state area) is a momma, creative, dreamer, herbalist and practitioner. She loves depth in her relationships, sunshine, being in saltwater, and laughter. Let's connect: IG: @rhythmicbotanicals, rhythmicbotanicals@gmail.com **p. 22**

Katherine Hagopian Berry (Bridgton, ME) (she/her) is the author of *Mast Year* (Littoral Books, 2020), *Landtrust* (NatureCulture, 2022) and *Orbit* (Toad Hall Editions, 2023). **p. 107**

Katy Morse (Port Townsend, WA) AKA Katryn is a *Color of Woman* teacher and *Red Thread Circle* guide, following in the stardust lineage of Shiloh Sophia and *Intentional Creativity™*. She awakens healing through creativity. katymorse.com, creativespiritexpressions.com **p. 161**

Kelly Beth Bonsall (Austin, TX) kellybethbonsall.com **p. 53**

Kersten Christianson (Sitka, AK) Poet, Moon Gazer, Raven Watcher, Northern Trekker, Teacher. Kersten derives inspiration from wild wanderings, and road trips. She is the poetry editor of *Alaska Women Speak*, and author of *Curating the House of Nostalgia (Sheila-Na-Gig)*. kerstenchristianson.com **p. 59**

Kiley Saunders (Los Angeles, CA) has kept a journal since she could hold a pen. She loves to write about nature, sisterhood, and her connection to spirit. yeahwritekiley.com **p. 102**

Kirstin Olsen (Calgary, AB) finds magic in the mundane; steals inspiration from her night dreams; sources meaning from the depths of her deep lived experience; and embodies her radiance as a creative, mystic, yoga practitioner and teacher, and devotee of a sensual life. **p. 100, 123, 179**

Kitty Riordan (Albuquerque, NM) is a native New Mexican poet and visual artist who uses the creative process to continue the journey of self, earth and spirit. kittyriordan@hotmail.com **p. 32**

Koco Collab (Denver, CO) is the coalescence of artists Aiko Szymczak and Corinne Trujillo. We seek to unravel the complexity of our history by taking various elements of our heritages and weaving them back into new stories. kococollab.com **p. 65**

Kristen Roderick (Toronto, ON) is a ceremonialist, rites of passage guide, writer & mama. When she's not designing courses, she's foraging through the woods, beachcombing at the shore, or apprenticing herself to the ancient ways of fibre art. spiritmoving.org **p. 157**

KT InfiniteArt (Freeport, NY) Creatrix, artist, writer inspired by sensuality and spirit. Check out more artwork, prints and merchandise: InfiniteArtWorld.com & IG: @KTInfiniteArt **p. 74, 202**

L. Sixfingers (Sacramento, CA) is an intersectional herbalist and witch who helps folks to come home to their magick. She hosts online courses for starry-hearted healers as well as teaching and offering in-person services grounded in inclusivity and hope. wortsandcunning.com **p. 80**

Laura C. Mace (Pueblo, CO) Through mythic stories, art and yoga, Laura seeks to deepen our connection to Nature and to each other. See more of her invocations at lauracmace.com **p. 63**

Laura Mowbray (Stratford, ON) runs a multi-disciplinary creative studio in Canada, that creates visuals for businesses, creators, interiors, and soul. This artwork also apears in *Sage, Huntress, Lover, Queen* in collaboration with the book's author, Mara Branscombe. lauramowbs.ca **p. 93**

Leah Marie Dorion (Prince Albert, SK) An interdisciplinary Métis artist, Leah's paintings honour the spiritual strength of Aboriginal women, the Sacred Feminine. She believes women play a key role in passing on vital knowledge for all humanity, which is deeply reflected in her artistic practice. Visit her at leahdorion.ca **p. 17, 91**

Lena Moon (Earlton, NY) is an astrologer, flower essence practitioner, dancer, poet, storyteller, ceremonial song catcher, art model, as well as a performance and visual artist. Her song "Wise In Her Ways" is an underground classic sung the world over in honor of women. lenamoon.com **p. 41, 67**

Lindsay Carron (Los Angeles, CA) lindsaycarron.com **p. 13**

Lisa Hau (Powell River, BC) IG: @lisa.hau.art & lisahau.com **p. 82**

Lisa J. Rough (Black Mountain, NC) is a self-taught visionary artist, writer, mama & muse. Connect with her at lisajrough.com **p. 184**

Lisa Wells (Portland, OR) (she/her) is a Portland-based artist who is inspired by nature, dreams, and human complexity. She is passionate about mental wellness and loves to birdwatch. To find out more, visit lisawellsart.com or follow her IG: @artist.lisawells **p. 56, 69**

Lori Felix (Picayune, MS) lorifelixartwork.etsy.com **p. 55**

Lorinda Peel-Wickstrom (Wynndel, BC) Lorinda's sense of biophilia inspires her work to re-wild our hearts. She creates art and homesteads with her family, learning old skills like herbalism, blacksmithing, horse-logging, goat-milking and slow-crafting. **p. 22**

Louie Laskowski (Brookstone, IN) is a visual artist, writer, & activist, and a member of WCA and Woman Made Gallery, Chicago. Once a high school art teacher, now a Reverend of the Arts ordained by the Reformed Congregation of the Goddess, International (RCGI), Louie teaches art as a spiritual path. louielaskowski.com **p. 37**

Lucy H. Pearce (Cork, Ireland) Author of non-fiction books including: *Crow Moon, She of the Sea, Moon Time* and Nautilus Award silver winners *Medicine Woman, Burning Woman*, and *Creatrix*. Her artwork appears on many book covers and internal illustrations. Founder of Womancraft Publishing. lucyhpearce.com **p. 145**

Lucy Tipper—Tangled Muses (Southampton Hampshire, UK) I collect natural elements from sacred landscapes. Boiled in a cauldron, the plants spill out colour & meaning. I ponder their stories & highlight the tales of this alchemical process with natural pigments, minerals & myth. @tangledmuses & tangledmuses.co.uk/#/ **p. 137, 153**

Maasa Craig (Nelson, BC) My canvas is a mirror reflecting my internal terrain. Innate wisdom transmits from my heart and is expressed through my hands which informs my mind. The medicine is in what is revealed. maasa.ca **p. 61, 97, 124**

Mahada Thomas (Penticton, BC) is a healing artist, writer, song leader, Munayki Earth Keeper and ceremonial priestess. She loves holding sacred space, and shares her healing journey to inspire others. Find her on facebook and her youtube channel: Mahada Thomas Healing Arts, or email madathomas@yahoo.ca **p. 20, 45, 62, 81, 98, 117, 140, 153, 174**

Margaret Sophia Marangione (Shenandoah, VA) Her novel, *Across the Blue Ridge Mountains*, was published in August 2022. Additionally, her poetry has been published in *Appalachian Journal, Lumina Journal*, the *North Shore Womens Paper* and *Sage Woman* magazine. msmarangione.com **p. 141**

Margriet Seinen (Garberville, CA) discovered silk painting in the early 80s. She painted scarves, pillow covers and then moved into fine art, with images of mermaids, nature devas, scenery and mandalas. She also teaches mandala classes where students learn silk paint. seinensilk.com **p. 111**

Marla Faith (Nashville, TN) is a visual artist who also writes poetry, and has published three books of her art with poems. Please enjoy her work at marlafaith.com **p. 101, 119, 135**

Maureen Sandra Kane (Bellingham, WA) is a mental health therapist. She is a winner of the 2022 Sue C. Boynton Poetry Award and her work has been published in anthologies. Her book of poetry is called *The Phoenix Requires Ashes*. maureenkanecounseling.com **p. 57**

MBE OLE (Chicago, IL) shares her home with Wooly Mammoth & 2 black male, unrelated, rescued felines. She's hoping to learn more about environmental stewardship and urban planning as she starts a new chapter in her life. Email: marianneeberhardt@protonmail.com **p. 71**

Megan D. Robinson (Fairfield, IA) is a witchy poet, visual artist, performance artist, journalist, gluten-free kitchen witch, Druid and empty-nester. She is passionate about the healing power of stories, the magic of nature and embracing the inner Hag. Find her at faegyrl.wixsite.com/meganrobinson **p. 46, 148**

Megan Welti (Clarksburg, MA) is an artist, poet and energy worker living in Western Massachusetts with her husband, four children, and many fur babies. You can find prints of her original watercolors at redrootrising.squarespace.com **p. 159, 160**

Melissa Harris (West Hurley, NY) Artist, author and intuitive. Join me in one of my Art and Spirit Retreats in magical locations. Author of *100 Keys to a Creative Life* (Amazon), *Anything is Possible* and *Goddess on the Go* card decks. melissaharris.com **p. 135, 151**

Melissa Kae Mason, "MoonCat!" (EARTH) Traveling Astrologer, Artist, Radio DJ, Photographer, Jewelry Creator, PostCard Sender, Goddess Card Inventor, Seer of Patterns, Adventurer & Home Seeker. Visit me on the web: lifemapastrology.weebly.com and email me: LifeMapAstrology@gmail.com **p. 206**

Melissa Stratton Pandina (Westborough, MA) is an award winning artist. An illness led her to animism. Her work centers on bringing folklore into life. She primarily works in oil and pen and ink and watercolor. deshria.com **p. 25, 43, 105, 175**

Monisha Holmes (Fort Myers, FL) (she/her) is a multi-talented model, writer, and psychotherapist dedicated to promoting mental wellness and exploring spirituality for personal growth. With a Master of Science degree in Social Work from Columbia University, Monisha addresses the complex challenges of today's society. Her refreshing perspective on well-being can be found in publications like *Cosmopolitan Magazine, TeenVogue, ShondaLand*, and *Bustle*. Informed by Humanistic Psychology, she inspires self-care and personal development through a magical lens. Monisha's dynamic background and commitment to holistic growth make her a powerful voice for authentic living. **p. 11, 39, 53, 65, 75, 89, 101, 113, 125, 139, 151, 163, 173**

morgan leigh callison (Allenville, NS) i spend most of my days along the shores of the bay of fundy and amidst the trees and on the land of mi'kma'ki / nova scotia. i live a deeply creative and inspired life. morganleighcallison.com and social media: @morganleighcallison **p. 177**

Musawa (Estacada, OR and Tesuque, NM) We'Moon Land is one of the first intentional women's land communities in this country! Having started it in 1973, when I was in my 20s, I am now in my 70s, and am looking for new generations of wemoon who wish to support carrying on this intergenerational land dyke community in the spirit of We'Moon—for the next 50 years! FFI: wemoonland@gmail.com **p. 6, 180, 181, 182, 198**

Nan Brooks (San Antonio, TX) is a lesbian crone, Dianic priestess, and retired theatre artist. She writes to empower women and foster hope. She is the author of *Ceremonies for Our Lives, a Ritual-Making Workbook for Women*. saganan.brooks@gmail.com **p. 26, 166**

Nancy Watterson (Oakland, OR) I am an artist, mother and grandmother. In my work I explore and celebrate the connections between humans and nature. I am curious about time and about how differently we all perceive things. nwattersonscharf.com **p. 70**

Nell Aurelia (Devon, UK) is a writer, performer, author and counselor. She writes of trauma; transformation; grief, grace and grit; radical self-love; smashing the patriarchy; love affairs with nature. IG: @nellaureliapoetry, thesingingdark.wordpress.com **p. 126**

Nina Rose (Silver City, NM) My creations are a blend of cosmic and personal visions that call out to the deep and abstract truths of life. I hope they call out to the wild soul within each of you. Find me on IG: @honey.xy. Feel free to drop me a line, I am always searching for connection. **p. 163**

Nissa Jordan (Macungie, PA) is an intuitive painter, utilizing self-expression as a powerful form of evolution. Inspired by the depth of our human experience, she hopes to share light with others as a creative vessel. IG: @nissa.jordan **p. 4**

Nolween LM (Le Faouet, France) is a French painter and author. For her, art is a sacred and healing path, it can change problems into solutions and well-being. Such is the purpose of her healing paintings: to create harmony. nolwenhozho.wixsite.com/del-pueblo **p. 39, 177**

patti sinclair (Edmonton, AB) gratefully creates on the land of the People of the Papaschase First Nation. Author of one memoir, five poetry chapbooks & a long poem to be published with At Bay Press. IG: @locating the beauty & poet-at-large.blogspirit.com **p. 171**

Paula Franco (Buenos Aires, Argentina) Italo-Argentine Artist Shaman woman, visual and visionary illustrator, Minister of Sacred Arts writer and poet, astrologer, tarot reader, creator of goddess cards and coloring book: *The Ancestral Goddess & Heaven and Earth*. azuldavinci@gmail.com paulafranco.net **p. 155**

Paula Love (Bowen Island, BC) paulalove.art **p. 9**

Pi Luna (Santa Fe, NM) From a distance her artwork looks like paintings, but get up close and you'll start to see the shapes and textures. She cuts up tiny pieces of paper from recycled magazines and assembles them into imaginative visual stories. pilunaart.com **p. 97**

Qutress (Evanston, IL) Let's collaborate! Reach me via IG: @Qutress or through my website qutress.com **p. 49, 59**

Rachael Amber (Philadelphia, PA) is a queer, latine artist & intuitive who channels nature-centric healing tools to raise awareness & foster connection between all living beings. Their main focus includes *Cycles Journal*, *Cyclical Mindfulness* & the *Embodied Ecosystems Oracle*! Find her at rachaelamber.com, cyclesjournal.com, IG: @rachael.amber & @cyclesjournal **p. 118**

Rachel Cruse (Duncan, BC) Artful dispatches for your wild nature soul. Artist, IG: @wildsidenaturestudio, rachelcruse.com **p. 115**

Robin Bruce (Fayetteville, AR) robindianebruce.com **p. 121**

Rosalie Kohler (Buchenbach, Germany) spiralshores.com **p. 133**

Sally Snipes (Julian, CA) has been inspired by natural wonders for all her life. Painting from an early age, she still loves the thrill of the images that pop up in her mind. **p. 107**

Sandra Pastorius (Ashland, OR) has been a practicing Astrologer since 1979, and a Featured Writer for We'Moon since 1990. Look for her collected We'Moon essays, "Galactic Musings" under Resources at wemoon.ws. With Sun in Gemini, she delights in blending the playful and the profound. Sandra offers individual and couples charts, readings and transit updates in person or by phone. Email her about astrology classes at: sandrapastorius@gmail.com, and read more articles here: wemoon.ws/blogs/sandras-cosmic-trip. Peace Be! **p. 12, 14, 208**

Schehera VanDyk (Bolinas, CA) Inspired by the sea, I go there for perspective, peace of mind, and fresh thoughts. I have seen the most profound beauty and magic on the beaches, in the waves, between the sky and water. My artwork is nature-inspired. Art is magic, healing, essential and relevant. Art is Life! **p. 141**

Signe Urdskilde (Brovst, Denmark) I am a Danish woman working for the healing of humanity and the Earth from the tyranny of patriarchy. Join me in a daily vision quest meditation at the Facebook page "The Dreaming Tree of Life Sisterhood." **p. 63**

Sophia Rosenberg (BC, Canada) etsy.com/ca/shop/BluebeetleStudio **p. 31**

Stephanie A. Sellers (Fayetteville, PA) So happy to be part of the We'Moon community! My new book is out! *Daughters Surviving Family Mobbing: Stories and Approaches to Heal From Shunning, Aggression, and Family Violence* (Penguin Random House). Gaia Blessings to all! **p. 118**

Sue Ellen Parkinson (Willits, CA) is an icon painter who honors the Sacred Feminine in all Her glory. Her website is: sueellenparkinson.com. She is a proud member of Northcoast Artists Gallery, a co-op in Fort Bragg, CA **p. 140**

Susa Silvermarie (Chapala, Mexico) Let's see, who am I now at 78? An old-time dyke, ready every day to die happy and soft. And, a wild witch just as juicy to LIVE. Everything is now. Everything is once. Look online for my newest collection of poems, *Who Will Board the Silver Boat*. Visit me at susasilvermarie.com **p. 49, 78**

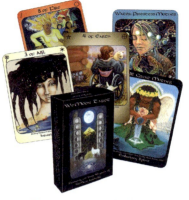

We'Moon Tarot!

Forty years of We'Moon art distilled into a unique deck of beautiful We'Moon Tarot cards from women around the world. A boxed set of 78 cards with accompanying 130 page booklet, designed by We'Moon's founder Musawa.
Full color, 3½x5, $45

PreacherWoman for the Goddess:
Poems, Invocations, Plays and Other Holy Writ

A spirit-filled word feast puzzling on life and death mysteries—rich with metaphor, surprise, earth-passion. By Bethroot Gwynn—longtime editor for the We'Moon Datebook.
Paperback, 120 pages with 7 full color art features, 6x9, $16

In the Spirit of We'Moon
Celebrating 30 Years:
An Anthology of We'Moon Art and Writing

This unique Anthology showcases three decades of We'Moon art, writing and herstory from 1981–2011, includes insights from founding editor Musawa and other writers who share stories about We'Moon's colorful 30-year evolution. Now in its fourth printing!
Paperback, 256 full color pages, 8x10, $26.95

The Last Wild Witch
by Starhawk, illustrated by Lindy Kehoe
An Eco-Fable for Kids and Other Free Spirits.

In this story, the children of a perfect town found their joy and courage, and saved the last wild Witch and the forest from destruction. A Silver Nautilus Award winner, this book is recognized internationally for helping readers imagine a world as it could be with abundant possibilities.
Paperback, 34 full color pages, 8x10, $9.95

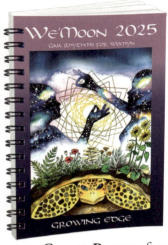

We'Moon 2025: Growing Edge

• **Datebook** The best-selling astrological moon calendar, earth-spirited handbook in natural rhythms, and visionary collection of women's creative work. Week-at-a-glance format. Choice of 3 bindings: Spiral, Sturdy Paperback Binding or Unbound. We proudly offer a full translation of the classic datebook, in Spanish, too! 240 pages, 8x5¼, $22.95

• **Cover Poster** featuring "*Spirit Weavers*," by Dana Lynn—weaving ancestor blessings and nourishment for all beings. 11x17, $10

• **We'Moon on the Wall** A beautiful full color wall calendar featuring inspired art and writing from *We'Moon 2025,* with key astrological information, interpretive articles, lunar phases and signs. 12x12, $17.95

• **We'Moon Totes** made with organic cotton, proudly displaying our cover art. Perfect for stowing all of your goodies in style.
Sm: 13x14x3", $13.95 & Lg: 18x13x6", $15.95

• **Greeting Cards** An assortment of six gorgeous note cards featuring art from *We'Moon 2025*, with writings from each artist on the back. Wonderful to send for any occasion: Holy Day, Birthday, Anniversary, Sympathy, or just to say hello. Each pack is wrapped in biodegradable cellophane. Blank inside. 5x7, $13.95

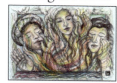
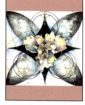
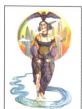
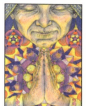

Check out page 233 for details on these offerings:

• *The We'Moon Tarot* by the founder of We'Moon, Musawa.

• *The Last Wild Witch* by Starhawk, illustrated by Lindy Kehoe.

• *In the Spirit of We'Moon ~ Celebrating 30 Years: An Anthology of We'Moon Art and Writing*

• *Preacher Woman for the Goddess: Poems, Invocations, Plays and Other Holy Writ* by We'Moon Special Editor Bethroot Gwynn.

ORDER NOW—WHILE THEY LAST!
Take advantage of our
Special Discounts:
• We'll ship orders of $75 or more for **FREE** within the US!

• Use promo code: **25Edge** to get 10% off
orders of $100 or more!

We often have great package deals and discounts.
Look for details, and sign up to receive regular email updates at
www.wemoon.ws
Email mothertongue@wemoon.ws Toll free in US 877-693-6666
Local & International 541-956-6052 Wholesale 503-288-3588
SHIPPING & HANDLING:
Prices vary depending on what you order and where you live.
See website or call for specifics.
To pay with check or money-order,
please call us first for address and shipping costs.

*All products printed in full color on recycled paper
with low VOC soy-based ink.*

Become a We'Moon Contributor!

Send submissions for
We'Moon 2027
the 46th edition!

Call for Contributions: Available in the spring of 2025
Postmark-by Date for all art and writing: August 1, 2025
Note: It is too late to contribute to
We'Moon 2026

We'Moon is made up by writers and artists like you! We welcome creative work by women from around the world. We'Moon is dedicated to amplifying images and writing from women with diverse perspectives, and is committed to minority inclusion. We seek to hold welcoming, celebratory space for all women, and are eager to publish more works depicting Black, Brown, Indigenous, Asian, Latine, and all voices from the margins, *created by* women who share these lived experiences. By nurturing space for all women to share their gifts, we unleash insight and wisdom upon the world—a blessing to us all.

> **We invite you to send in your art and writing for the next edition of We'Moon!**

Here's how:

Step 1: Visit wemoon.ws/pages/submissions for instructions and to download a Call for Contributions. Alternatively, you may send a request for The Call to **We'Moon Submissions, PO Box 187, Wolf Creek, OR 97497.** The Call contains current information about the theme, specifications about how to submit your art and writing, and terms of compensation. There are no jury fees. The Call comes out in the early Spring every year.

Step 2: Fill in the accompanying Contributor's License, giving all the requested information, and return it with your art/writing by the due date. *No work will be accepted without a signed license!* We now accept email submissions, too. See our website for details.

Step 3: Plan ahead! To assure your work is considered for ***We'Moon 2027***, get your submissions postmarked by August 1, 2025.

> **Help us choose the work that we publish in these pages!**
> Sign up online to receive emails about our
> virtual Selection Circles that we hold every summer.

Wanderer
© Nina Rose 2022

Peace Prayer
© Avalana Levemark 2019

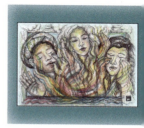

Many Hands
© *Bernice Davidson 2019*

Iris
© *Dana Lynn 2017*

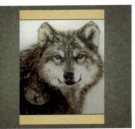

Wolf in Motherwort
© Dorrie Joy 2020

Quail & Cactus
© Sally Snipes 2013